CHINESE JADE

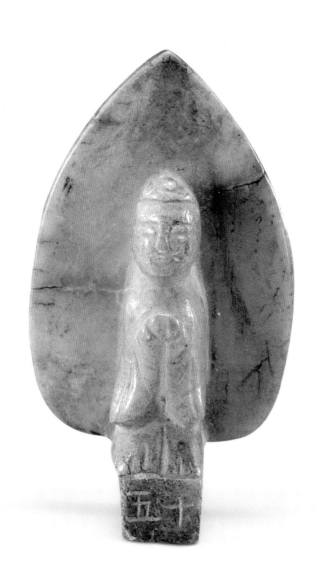

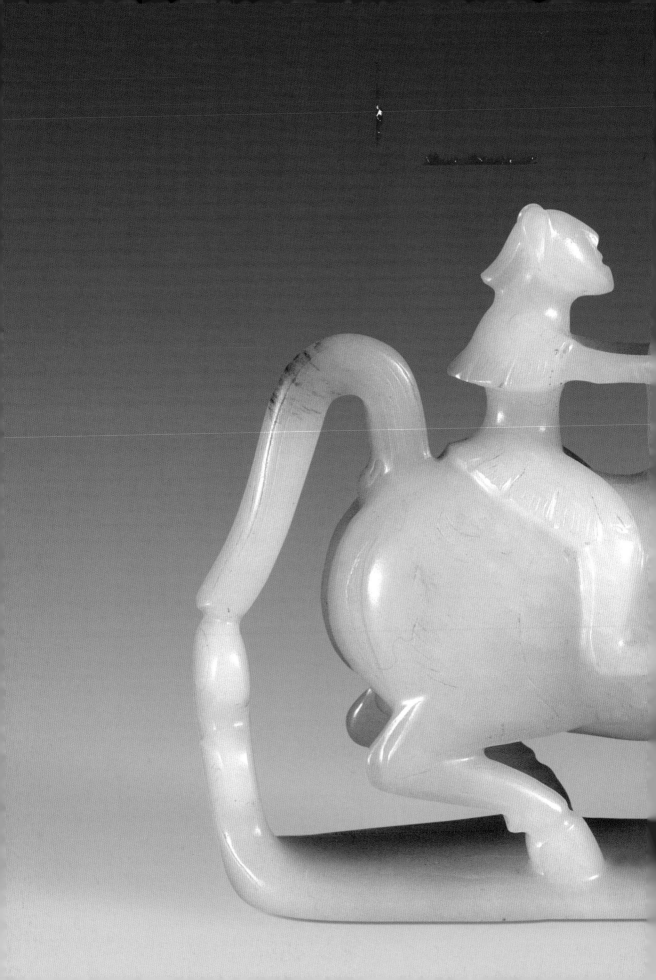

CHINESE JADE

The Spiritual and Cultural
Significance of Jade in China

GU FANG AND LI HONGJUAN
TRANSLATED BY TONY BLISHEN

Better Link Press

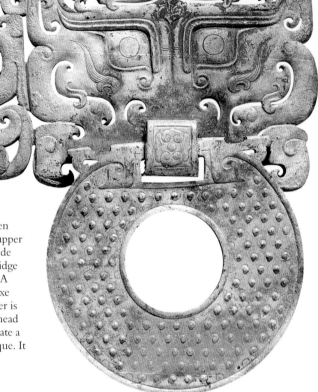

▶ **Door Knocker in the Form of the Head of an Animal with a Jade Disc (*bi*) in Its Mouth**

Overall length 18.2 cm. Length of animal head 11.3 cm. Width 13.8 cm. Thickness 0.7 cm. Diameter of disc 8.9 cm, diameter of hole 3.4 cm. Thickness 0.4 cm. Color blue-green.
Western Han funerary jade
Guangdong province, Guangzhou city, Xianggang, Tomb of the Nanyue King
Museum of the Mausoleum of the Nanyue King

Severe water damage has turned this piece to a chicken bone color. There is slight cinnabar coloring on the upper face. The head itself is almost square, the left-hand side carved with a *chi* dragon, the nose in the form of a bridge shaped eye of an axe with a pattern of flowers above. A moveable disc (*bi*) is suspended from the eye of the axe and richly decorated with a grain pattern. The knocker is made from a single piece of jade. The reverse of the head is plain and the piece was probably intended to decorate a vessel. The shape and appearance of this piece is unique. It was found by the head of the occupant of the tomb.

English edition © 2013 Shanghai Press and Publishing Development Company

Chinese edition © 2009 Cultural Relics Press

This book is edited and designed by the Editorial Committee of *Cultural China* series

Managing Directors: Wang Youbu, Xu Naiqing
Editorial Director: Wu Ying
Editor (Chinese): Wang Jian
Editors (English): Zhang Yicong, Yang Xiaohe
Editing Assistant: Wu Yuezhou

Compiled by Gu Fang and Li Hongjuan
Translated by Tony Blishen

Cover Design: Diane Davies
Interior Design: Yuan Yinchang, Li Jing and Hu Bin

ISBN: 978-1-60220-129-3

Address any comments about *Chinese Jade*: *The Spiritual and Cultural Significance of Jade in China* to:

Better Link Press
99 Park Ave
New York, NY 10016
USA

or

Shanghai Press and Publishing Development Company
F 7 Donghu Road, Shanghai, China (200031)
Email: comments_betterlinkpress@hotmail.com

Printed in China by Shenzhen Donnelley Printing Co., Ltd.

1 3 5 7 9 10 8 6 4 2

Contents

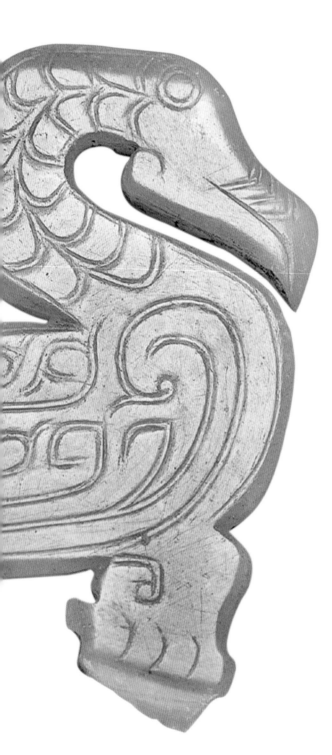

On page 1
Jade Buddha (Guanyin)

Height 4.2 cm. Width 2.3 cm. Color gray with hints of yellow.
Tang dynasty Buddhist jade
Hangzhou Historical Museum

The Guanyin stands on a square plinth. The plinth is inscribed on three sides with the six characters "*qi yue shi wu ri li*"—"put up on the fifteenth day of the seventh month." Holes have been pierced at the top of the head and in the two sleeves.

On pages 2-3
Feathered Figure Astride a Galloping Horse

Height 7.0 cm. Length 8.9 cm. Color pure white fine Hetian jade.
Western Han ornamental jade
Shaanxi province, Weicheng district, Zhoulingxiang, Xinzhuangcun
Xianyang Museum

The piece is carved in the form of an immortal riding a galloping horse. The rider's hair is bound and extends backwards and he wears a short feathered jacket. This form is frequently found in the decorations on bronze and lacquer of the same period. The rider grasps the neck of the horse with both hands, the horse's mouth is open exposing the teeth, its nostrils are flared and its galloping body is decorated with feathers in the style of a heavenly horse. The flat strip upon which the horse stands is decorated with a cloud pattern. This piece came from the ruins of the Palace of Longevity (*chang shou gong*) and may have been on display there.

◀ Jade Swan

Color green
Late Shang dynasty
Henan province, Anyang city, Tomb of Fu Hao
Chinese Academy of Social Sciences Institute of Archaeological Research

▶ Duck Headed Belt Hook Covered with Gold and Inset with Jade

Length 18.7 cm. Width 4.9 cm.
Mid-Warring States period jade accoutrement
Henan province, Hui county, Guweicun tomb No. 5
National Museum of China

The belt hook is in the shape of a Chinese zither (*pipa*). The surface of the piece is covered with an animal's head in relief formed from gold panels with silver supports, its mouth holding a curved jade hook in the form of a duck's head. Three white jade discs are set along its length with the upper and lower discs inset with pieces of glass in the shape of a dragonfly's eye. This belt hook covered in gold and inset with jade, with its harmonious use of materials and meticulous workmanship, unique design craft and multiplicity of skills is an example of the very best craftsmanship of the period of the Warring States.

Contents

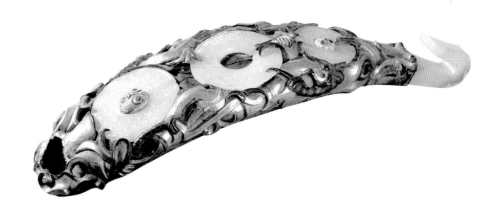

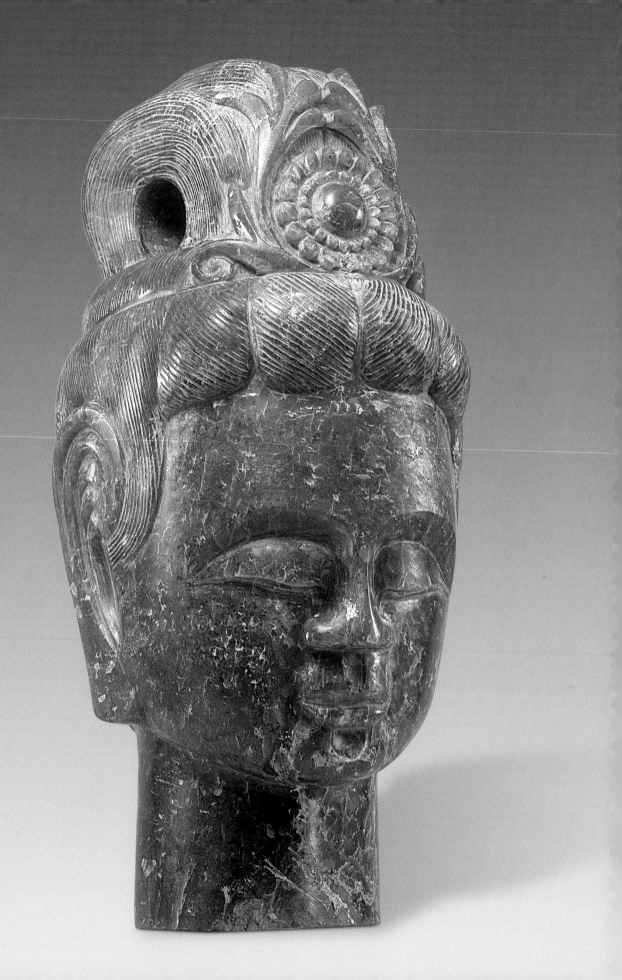

TRANSLATOR'S FOREWORD

By Tony Blishen

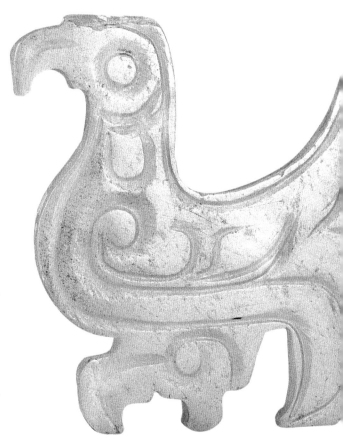

This book presents a comprehensive view of jade and its history in China from Neolithic times to the Qing, the last imperial dynasty, which fell in 1911. It differs from some studies published in the West in that it concentrates on jades that are in collections in China, and thus illustrates pieces that are on display not only in the Palace Museum, Beijing but in the many provincial and other museums across China. Western collections built up during the 19th and 20th centuries necessarily stop short of the discoveries made since the 1950s and particularly of those that derive from the eye-catching archaeological developments of the last 40 – 50 years.

The original Chinese text upon which this book is based was written for a Chinese readership with a more profound knowledge of Chinese history and culture than that generally possessed by a western readership. Nevertheless, this translation may help the reader to understand what jade means to the Chinese in China; how it is classified and described and where it is found and worked and displayed. The authors' Preface, in particular, is a passionate and highly allusive account of the cultural and spiritual significance of jade to the people of China. It has an imaginative value beyond that of a simple catalogue and places jade in its natural, and central, cultural context.

As ever, the demands of translation have been moderated by the resources of

▲ Jade Pendant in the Shape of a Phoenix

Overall height 3.5 cm. Thickness 0.25 cm. Color pure white and of exquisite texture.
Mid-Western Zhou period ornamental jade
Shaanxi province, Fufeng county, Yuntangcun
Zhouyuan Museum

The phoenix crouches with round eyes and a sharp hooked beak. Its crest is damaged. The chest protrudes and it has hooked talons. The wings point upwards and the divided tail droops. There is a small incompletely drilled hole on one side of the tail. The whole piece has been worn smooth. The decoration on each side is the same, with the outline of the body incised with a large inclined blade. This is a major piece of considerable artistic value.

◄ Head of a Buddha

Height 29 cm. Color emerald green with some white staining.
Song dynasty Buddhist jade
Zhejiang province, Hangzhou city, Jianrenli
Hangzhou Historical Museum

The head is carved from a single piece of jade. The hair is worn in a top-knot ornamented with flower-like jewels. There is a mortise slot at the base of the neck into which a tenon may be inserted.

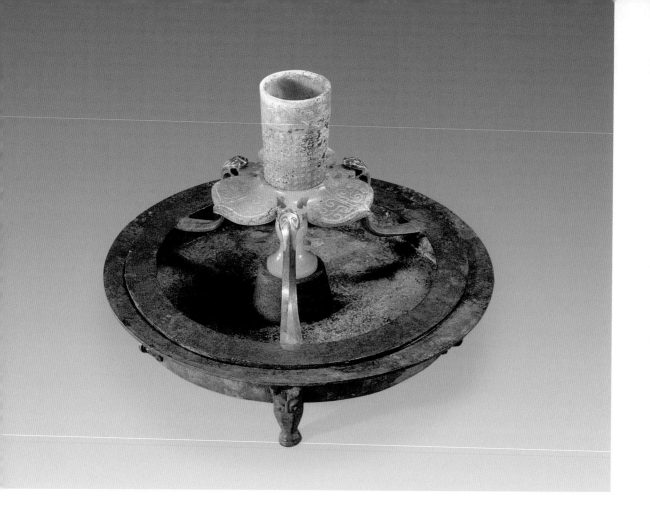

▲ Hooked Whirlpool Pattern Jade Cup on a Bronze Tray

Overall height 17 cm. Tray height 5.0 cm, diameter 23.6 cm.
Cup height 7.8 cm, diameter at mouth 4.2 cm, at base
2.0 cm, thickness of wall 0.2 cm. Height of cup foot 3.9 cm,
upper diameter 1.8 cm, lower diameter 3.0 cm. Color white.
Western Han jade vessel
Guangdong province, Guangzhou city, Xianggang, Tomb of
the Nanyue King
Museum of the Mausoleum of the Nanyue King

the Internet and the sophistication of its search engines in Chinese and English and in image as well. There is no direct English equivalent of some of the Chinese terminology of jade (as if the only way of translating "spoon" was to call it "a concave ovoid receptacle attached to a handle used for eating") and I have therefore tried, as far as possible, to stay with the terms used by Professor Jessica Rawson, formerly of the British Museum, and of Ming Wilson of the Victoria and Albert Museum in their classic studies of Chinese jade.

When it comes to colors, the Chinese language describes the spectrum rather differently and allocates a number of words to the color green, of which *qing* (青) is most commonly used in descriptions of jade. *Qing* has a long history as a variable description of color ranging from "the color of the

The body of the jade cup is carved separately from the foot. The body is cylindrical with a flat base and ornamented in three sections with a stylised cloud pattern at top and bottom and a protruding whirlpool pattern in the central section. The foot is in the form of a pillar, the upper edge level and with two small holes aligned with holes in the bottom of the cup and secured with bamboo pins. The foot is decorated with four overlapping lotus leaves and patterns of curved lines.

At the lower part of the cup is a jade stand of six alternating large and small lotus leaves decorated with a cirrus cloud pattern. A large hole in the center of the stand takes the body of the cup. The foot of the cup rests on the bronze tray which has three gold-headed silver bodied dragons that grasp the jade stand in their mouths. The piece is comprised of five different materials, jade, gold, silver, bronze and wood. With its original and novel design this elaborately conceived piece is a fine example of Han jade.

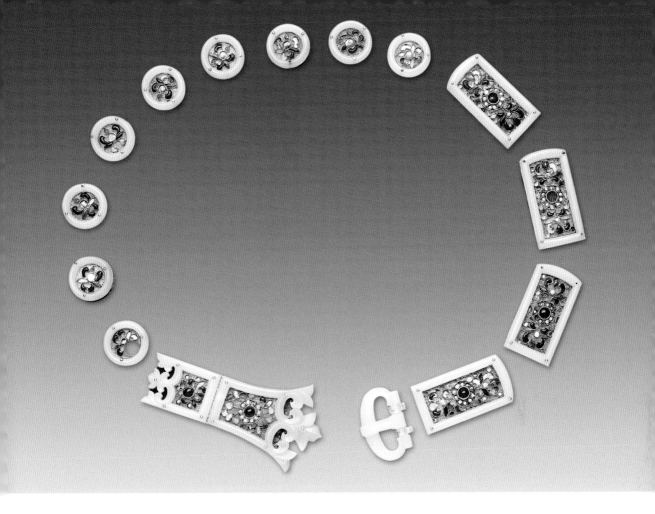

east" in the earliest Chinese dictionary of the second century, through a suggestion of the color of hills in a Tang poem of the 8th century, to plain indigo. I have uniformly translated it as blue-green accepting that it may be sometimes more blue than green and vice versa.

Where locations are concerned, I have adopted the Chinese convention where the large precedes the small, so it goes province followed by city or county in descending order to the actual site.

As before, I am grateful to Diane Davies who not only designed the cover but read and commented helpfully on the draft translation.

▲ Ceremonial Jade and Gold *Diexie* Belt with Jewel Inlay

Overall length approximately 150 cm
Tang dynasty ceremonial jade
Shaanxi province, Chang'an county, Nanliwangcun, Doujiao tomb
Shaanxi Province Institute of Archaeological Research

The plaques of the belt are all of blue-green/white jade inlaid with gold strip bearing a design of flowers as well as "jewels" of colored glass and known as "gold framed jewel inlay pearl settings."

The belt is made up of three embossed rectangular *kua* (plaque or link), a single embossed rectangular tail-piece, eight round plaques, a single flat slotted belt buckle and honeysuckle decoration. Jade plaques were known in Tang literature as "jade bridges." This belt is the only complete belt of this particular type so far discovered.

PREFACE
By Gu Fang

Eight thousand years ago the forefathers of the Chinese people, acting on a primitive artistic urge, consciously polished fine stones into simple ornaments and hung them from their bodies in personal adornment. It was this unconsciously social behavior on the part of our forbears that became the prologue to Chinese culture, digging the foundations of a building that has stood for thousands of years and establishing China as the country pre-eminent in the production, manufacture and use of jade.

After its encounter with the Chinese people, jade became a precious stone endowed with magical properties. It was regarded as the people's soul since it encapsulated all that mankind aspired to in terms of character, elegance, tranquility, reserve, purity, chastity and virtue. The Chinese love jade not merely because of its rarity or its luster but because of a deeper aesthetic value.

Over the generations, the many legends of jade gained wider currency. One legend said that in the year when the dome of heaven was split, Nüwa, the female creator of humanity, sealed the split by grinding five different colored stones together. Its dust at once covered the earth and lay there for aeons. On earth, the spirit of heaven and earth, the gods of the rivers, and the immortal honey in which flowers and plants were bathed, first gathered up the essence of life and then, when the time was ripe, manifested it in the lustrous splendor

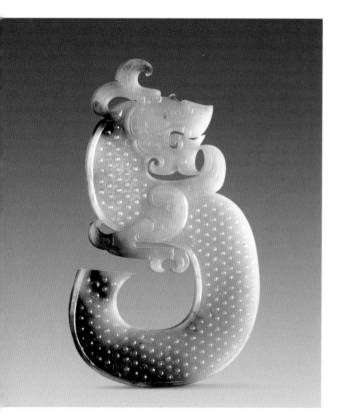

◄ Grain Patterned Jade Dragon Pendant

Length 17.5 cm. Width 10.2 cm. Thickness 0.6 cm. Color white with partial brown staining and a glassy gloss.
Western Han ornamental jade
Jiangsu province, Xuzhou city, Lion Mountain, Tomb of King of Chu
Xuzhou Museum

The piece is in the form of an "S" shaped dragon. The head of the dragon is carved with a combination of incision, relief and partial open work. There is a twisted thread pattern on the neck and the body is decorated with a grain pattern with an incised outline. The upward curled dragon's tail has been cut level at the end and the slanted inner and outer edges form a ridge.

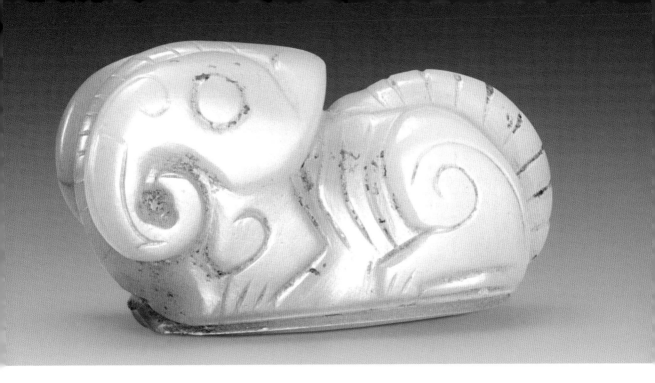

of pearls, the glowing translucence of gemstones, the skills of intricacy, and the quality of magnificence. Whereupon, jade appeared amongst mankind. The people of remote antiquity believed that the character 玉 (*yu*, jade) expressed an inner meaning and that the three horizontal lines and the single vertical pillar represented the earth and that the droplet-like dot was that utterly precious and valuable material that Nüwa had sprinkled upon the earth—jade itself.

People drew upon the beauty of jade to express their aspirations for a better quality of life. Legend also has it that when Pangu, the first of mankind died, his breath became wind and cloud, his flesh earth and his bones jade and pearls. Jade thus became an auspicious stone, credited with the magical property of warding off evil.

As the culture of jade entered the popular imagination, the honored position it occupied was fostered by successive royal houses and during the Xia, Shang and Zhou dynasties (2070 – 256 BC) it was strengthened to the point where jade became the exclusive preserve of the nobility. If you look at the oracle-bone

▲ Jade Sheep

Height 2.5 cm. Length 5.0 cm. Color blue-green/white.
Western Zhou ornamental jade
Shanxi province, Quwo county, Jinhou tomb group, Tomb No. 63
Shanxi Archaeological Research Institute

As one of the earliest domesticated animals, the sheep has always been regarded as an auspicious animal by the Chinese, standing for fortune and luckiness. The piece is a sheep recumbent with its head turned back. It has curled horns and round eyes, its feet tucked in with the hooves showing. The base forms a raised rectangle with the four limbs delineated by comparatively broad regularly incised lines. The most noteworthy characteristic is the raised ridge decorated with a pattern of regular incisions that runs from head to neck and along the back to the tail. This is a design that is both compact and concise.

inscriptions (discovered towards the end of the nineteenth century) you will see that the Shang dynasty character for 玉 (*wang*, king) is, in fact, a representation of three jade discs strung on a cord. On the basis of currently available material it is possible to assert that a king was originally one who wore jade. The character 玉 (*yu*, jade) consequently became, in the eyes of the Chinese people's forbears, those ornaments that hung like a droplet from the waist of the king or emperor. The ornaments worn by the king were without doubt objects of the greatest veneration and

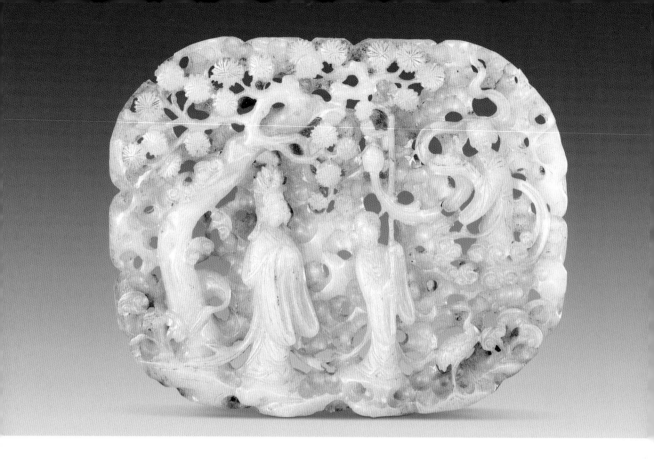

▲ Jade Pendant with a Design of an Immortal Maiden beneath a Pine Tree

Length 9.6 cm. Width 7.8 cm. Thickness 1.5 cm. Color blue-green/white with partial yellow-brown staining.
Song dynasty ornamental jade
Palace Museum, Beijing

A flat oval carved with a luxuriant pine tree beneath which stands an immortal maiden dressed in a wide-sleeved long-skirted gown with two maid-servants alongside her, one holding a lantern and the other a tray heaped with immortal peaches. An immortal crane stands beside them. A curled cloud pattern lies beneath the feet of the figures demonstrating the fairy-like nature of the scene. The back is plain with traces of carving. There are holes around the circumference allowing the passage of thread for ornamentation.

at that time only jade was so revered. The *Rites of Zhou* (*Zhou Li*) recorded that "Duke Zhou took jade discs (*bi*) and made of them a mound"—very possibly the origin of the appreciation of curious stone formations as a specific pastime. It also suggests that at this period the appreciation of beautiful jades was already a hobby for royalty and the nobility.

The Chinese system of ceremonies and rites was first established and took form during the Xia, Shang and Zhou dynasties. In order to confirm and preserve the superiority of their own position, royalty and nobility took the maxim "Do not visit punishment upon ministers nor ceremony upon the common people" as their standard of behavior. They monopolized the use of jade as a sign of their status. However, this monopoly was in no way able to eradicate the people's enthusiasm for beauty, for it was the beauty of the color of jade that stimulated their aspirations in life. Unable to possess material things, they possessed instead dreams and yearning. Jade then slowly moved towards literature and towards the people. From this period on, jade started its transition from being an object of reality to being a notion of fancy and of the imagination. Thus, the people too, endowed jade with the concept of beauty.

During the Eastern Han dynasty Xu Shen, in *Explaining Simple and Analyzing Compound Characters* (*Shuowen Jiezi*), the

earliest Chinese dictionary, defined jade as a stone of beauty. The Chinese love of jade is demonstrated by their appreciation of its natural beauty and by the importance that they attach to its inner meaning. Only the Chinese are able to successfully combine jade's natural attributes with humanity's cultural attributes and then continuously promote and expand them. It was Xu Shen, renowned as the "peerless master of the five classics" who logically compared jade's five characteristics of solidity of texture, smoothness of luster, magnificence of color, density and near translucence of composition, and chiming sound as analogous with the five virtues of Benevolence, Righteousness, Propriety, Wisdom, and Fidelity. Hence the Chinese people's respect for the saying "The virtues of a gentleman may be likened to jade."

Confucius first advanced the concept of the "jade-like virtue" of the gentleman in the *Book of Rites* (*Li Ji*) and first used the pure whiteness of jade as a metaphor for gentlemanly conduct. Thereafter, the Confucian School continued and developed the Western Zhou ideology of "liken virtue to jade" endowing jade with numerous virtues and giving it a moral quality so that the concept of a jade-like virtue came to

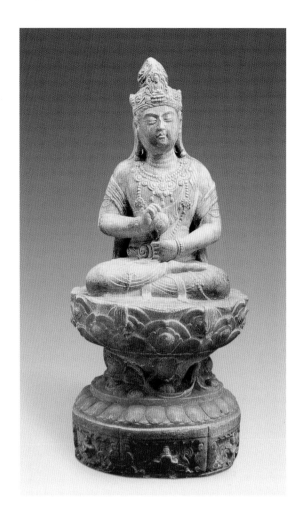

▲ Marble Buddha

Height 73.0 cm. Marble (*han bai shi*).
Tang dynasty Buddhist jade
Shaanxi province, Xi'an city, Dongguanjing, Dragon Well Temple
Xi'an Forest of Stele Museum

The Buddha wears a jewelled crown with his hair dressed in a top-knot. He holds a lotus bud in one hand, a jewelled necklace is draped around his neck, a sash over his shoulders and there are bracelets on his arms and wrists. He sits cross-legged on a lotus throne.

▶ Recumbent Jade Deer

Height 2.8 cm. Length 4.4 cm. Width 1.8 cm. Color blue-green with some patches of the jade skin color.
Tang dynasty ornamental jade
Palace Museum, Beijing

The deer gazes forward with its head raised, mouth closed and its legs tucked beneath its body. The level strip beneath the body indicates the ground. There is a *lingzhi* fungus (divine mushroom) beside the body. Emerging antlers like small pearl buttons and a tail in the form of the *lingzhi* fungus are represented by the technique of *qiaose* (exploitation of naturally occurring differences of color). There is a round hole through the body for a pendant though the piece may also have been used as a small ornament, paperweight or brush rack.

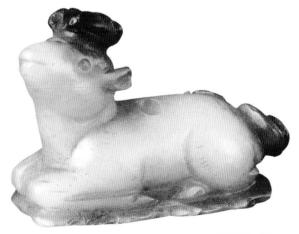

influence generation upon generation of Chinese. The *Book of Rites* also records "The gentleman of antiquity had to wear jade. Without proper reason, it never left him. He likened jade unto virtue." This, with the quotation from the *Shuowen Jiezi* dictionary, allows a partial view of the veneration in which jade was held.

The Chinese love of jade is enshrined in historical texts. The philosopher Han Fei (c.280 – 233 BC) speaks of jade in his collected writings (*Han Feizi)* and the biographies of Lian Po and Lin Xiangru in the *Record of History* (*Shi Ji*) record the tale of "Returning the jade disc (*bi*) whole to the state of Zhao" another story of a piece of jade. However, these two tales are not necessarily just praise for the tragic heroism of the one, or the resolute resourcefulness of the other protagonist, but also for the qualities of jade and the virtues of mankind inherent in the Confucian phrase "words must be kept and actions achieve results," as well as for the qualities of tenacity and resolve.

The Chinese love of jade also finds its place in the novel. A piece of pure dazzling bright stone left over from Nüwa's repair of the dome of heaven forms the cornerstone of the well-known 18th century novel, *Dream of the Red Chamber* (*Hong Lou Meng*). The hero Jia Baoyu (Precious Jade), a boy born with a piece of jade in his mouth, is the subject of some passages of magnificent writing. Both he and the heroine, the girl Lin Daiyu (Black Jade), embody a lofty distaste for the mundane that radiates something of the clarity of jade. The author, Cao Xueqin, infuses a piece of fine jade with a lifetime's ideas of perfection.

The Chinese love and veneration of jade is also displayed on the body. The emperors, kings, generals and ministers of antiquity who wore jade ornaments did so to proclaim that they were upright men of "virtue." The poets and literati wore jade as a sign of a bohemian and unconventional lifestyle. The ordinary people and servants who wore jade did so as a prayer for peace. Today with social stability and rising living standards more people than ever are wearing jade, a scene with a different appeal. The elderly who wear jade have a benevolent wisdom. Jade-wearing children are likeable and active. Men are cultivated and women graceful.

"Gentlemen should liken virtue unto jade" is an ancient Chinese precept that marks the outpouring of the love-at-first-sight that the Chinese have for jade.

◀ **Jade Arc-Shaped Pendant**

Late Western Zhou period
Henan province, Sanmenxia, Guoguo tombs, Tomb No. 2009
Sanmenxia Guoguo Museum

Color blue-green with a tint of dark yellow. Smooth and semi-translucent.

▶ **Jade Pendant Ornamented with Inlaid Jewels and Flowers**

A set consists of a pair, each 61.0 cm in length and basically the same.
Late Ming court ceremonial jade
Beijing, Changping district, Ming Dynasty Tombs (*Ming Shisanling*), Dingling tomb
Dingling Tomb Museum, Beijing

The top is a gold-plated bronze hook with an arc-shaped pendant of bronze inlaid with rubies and sapphires on both sides and decorated with two dragons playing with a pearl. Each pendant has four holes from which jade decorations in the shape of leaves, flowers, cicadas and fish are suspended in four vertical strings and 11 horizontal rows.

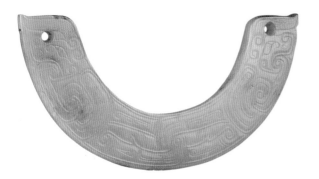

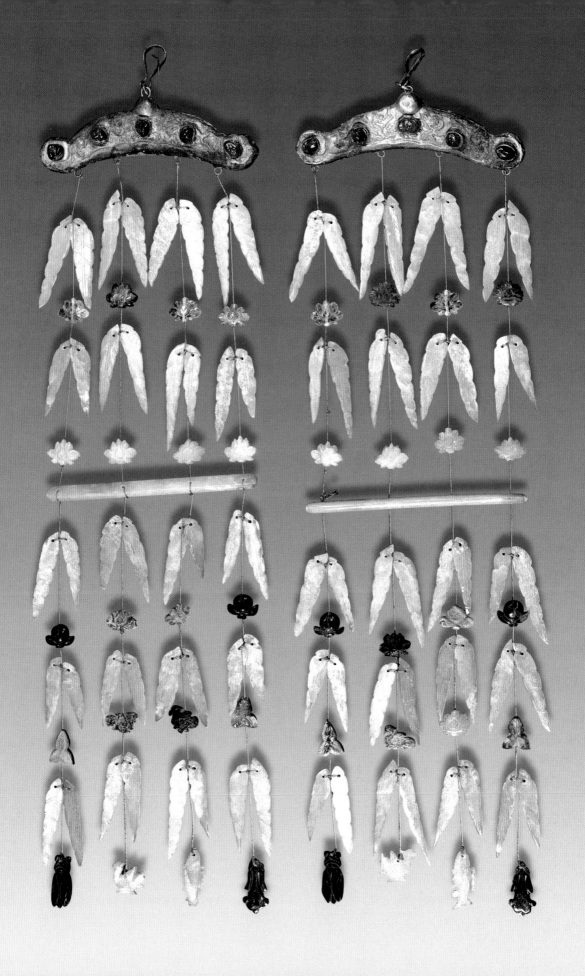

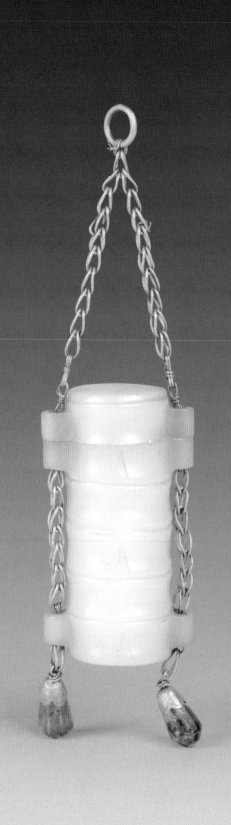

CHAPTER ONE
TYPES OF JADE

Because of the exquisite quality of its stone, the beauty of its coloring, the magnificence of its appearance and its smoothness, jade has been valued and esteemed since the earliest times. China has one of the oldest and most extensive histories of jade use.

Over the course of several thousand years, the most important sites as sources for Chinese jade have been Hetian in Xinjiang province, Xiuyan in Liaoning province, Dushan in Henan province and Lantian in Shaanxi province.

◀ Bamboo Segmented Jade Box

Height 17 cm. Diameter 4.4 cm. Color white.
Liao dynasty jade container
Liaoning province, Fuxin city, Tayingzi
Liaoning Provincial Museum

Since bamboo grows rapidly section by section and represents a modest and upward spirit it has become an important symbol for Chinese scholars. The piece is a bamboo segmented cylinder forming a box of six segments of which the top-most is the lid and the remaining five the body of the box. There are pierced ears on either side through which a gold chain is threaded. The bottom ends of the chain are attached to egg-plant droplets in glass set into leaves of gold.

▼ Jade Pendant in the Form of a Fish

Color dark green
Late Shang dynasty
Henan province, Anyang city, Yinxu
Chinese Academy of Social Sciences Institute of
Archaeological Research

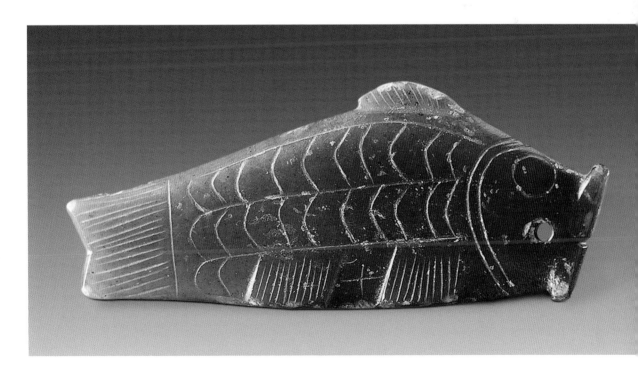

Mutton Fat Jade Vase

Ink Jade Charm for Warding off Evil

1. Hetian

This jade is mined at Hetian in Xinjiang. The use of Hetian jade has a long history and it is of excellent quality. Western scholars have called it Chinese jade as being particularly representative of the jade peculiar to China.

The basic colorings of Hetian jade are white, yellow, blue-green and ink.

White is the highest grade and can be sub-divided into blue/white jade and mutton fat jade, so-called because of the resemblance of its color to mutton fat. Its exquisite texture and liquid gloss make it one of the most precious of Hetian jades.

Yellow Hetian jade is extremely rare and has only very occasionally been found during the several thousand year history of jade excavation. In quality it is no less than mutton fat jade.

The majority of Hetian jade is blue-green, extending in color from pale blue-green to a deep shade of blue-green with many variants of the color range.

Hetian ink jade is generally divided into completely black, dense black and speckled black. The completely black, known as "pure lacquer black" is the best and is very rare.

Yellow Hetian Jade Wine Vessel (*zun*) in the Form of Three Sheep

Xiuyan Jade of Various Colors

2. Xiuyan

This jade is produced at Xiuyan in Liaoning province and is the major source material for China's modern jade carving industry. Its texture is exquisite and the jade mainly green in color. Irregular trace patterns can be found on worked examples as well as white translucent "cloud sprays." There is a long history of the excavation and use of this jade and vessels of Xiuyan jade have been excavated at Neolithic sites in the Liao river basin and in the Eastern Liao peninsula.

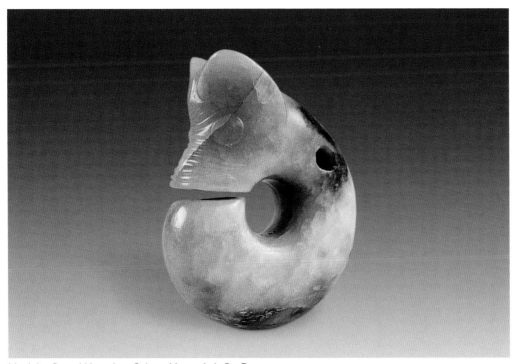

Neolithic Period Hongshan Culture Xiuyan Jade Pig-Dragon

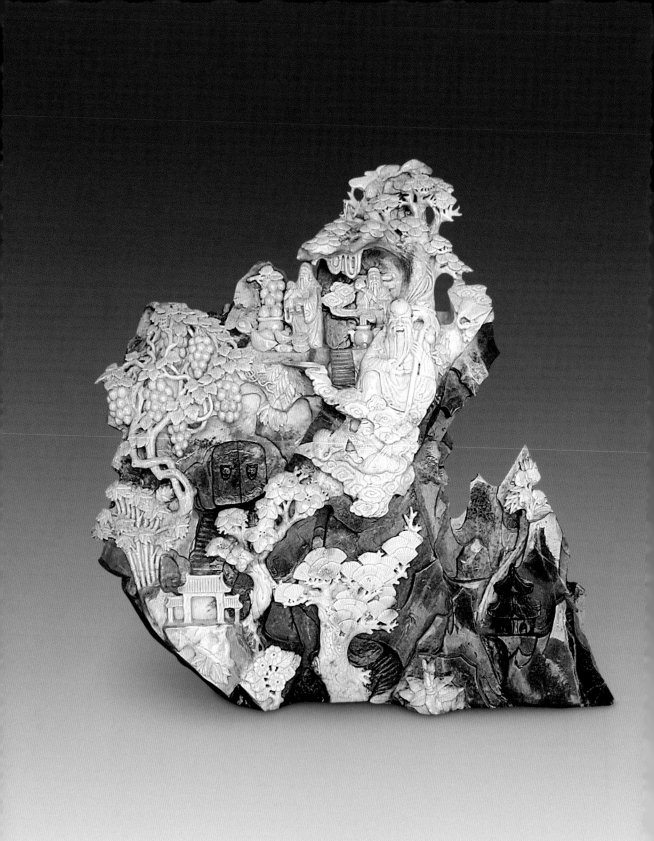

A Modern Piece Carved from Dushan Jade

3. Dushan

Dushan jade is produced at a lone hill of that name on the northern outskirts of the town of Nanyang in Henan province, hence its other name, Nanyang jade. Its color and luster are bright and the texture exquisite and glossy. Its hardness is comparable to that of emerald. It was once known in Germany as "Nanyang emerald."

The colors are relatively complicated and include white, green, yellow and purple. The texture, though exquisite, is uneven and colors criss-crossed and mingled with a multiplicity of tints. It is a major raw material for applied fine art jade carving and was often carved into representations of landscapes, flowers, and birds. It was rarely used for the manufacture of bracelets, belt ornaments and pendants.

Dushan Jade

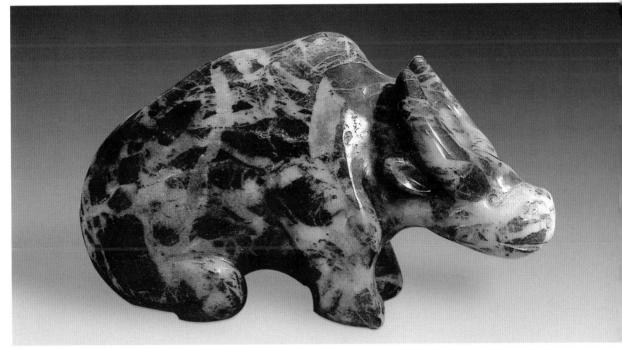

Shang Dynasty Dushan Jade Ox

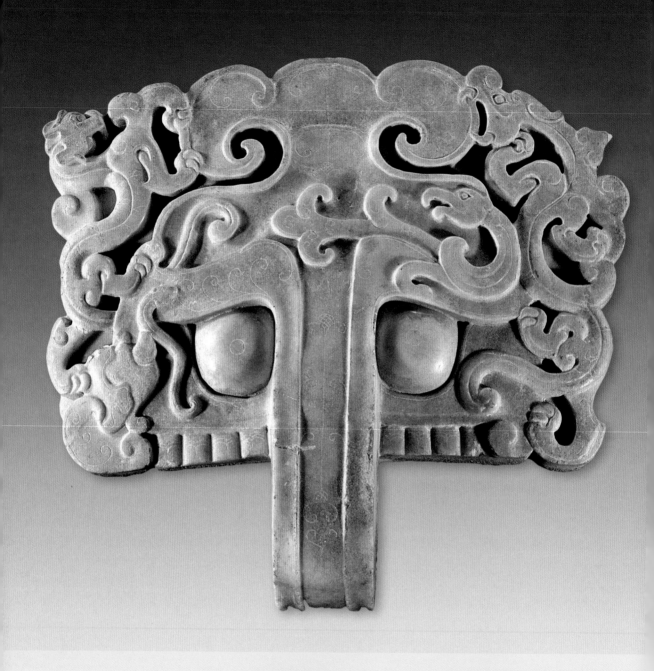

4. Lantian

Lantian jade comes from the area of the villages of Yuchuan and Hongxing in the county of Lantian in Henan province. Its colors include white, grey/white, yellow, yellow/green, grey/green, green and black. It is mostly opaque with a characteristic mix of magnificent multi-tint color. Its finest quality jade is apple green in color, relatively free of impurities and high in translucence known as "emerald green."

Historically, the development of jade production at Lantian was very early. Archaeological evidence demonstrates that the earliest known Lantian jade artefact is a jade squared tube (*cong*) dating from approximately 3,000 years ago excavated from one of the Western Zhou dynasty tombs in Xi'an, Shaanxi province. The use of Lantian jade reached its peak during the period from the Han to Tang dynasties when there were frequent mentions of its use in the literature of the time.

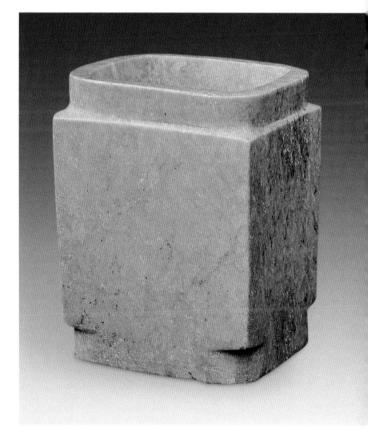

Facing page, above
Han Dynasty Lantian Jade Door-knocker Decorated with the Four Protective Spirits (Green Dragon, White Tiger, Vermilion Bird and Black Tortoise)

Facing page, below
Lantian Jade of Various Colors

Above
Lantian Jade Mine

Below
A Squared Tube (*cong*) Made from Lantian Jade in the Western Zhou Dynasty

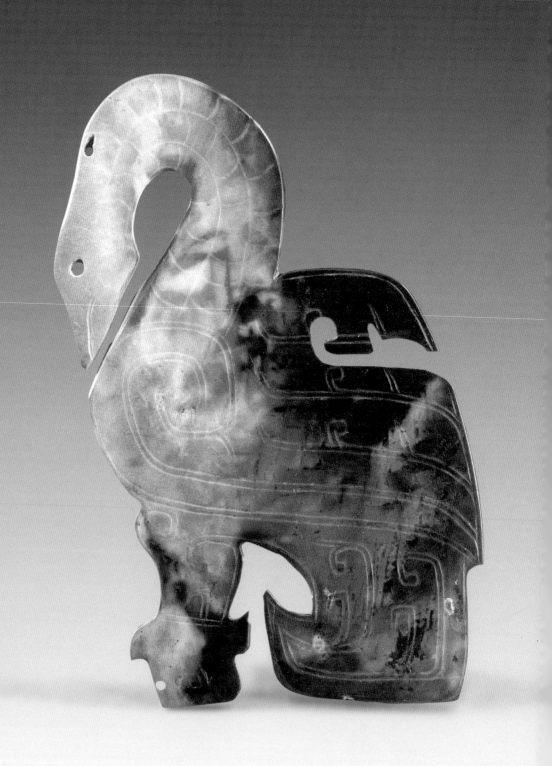

CHAPTER TWO
THE MANUFACTURE AND CARVING OF JADE

The manufacture of jade represented the peak of handicraft. Throughout the history, there are six main types of jade carving in its development. During the Ming and Qing dynasties, Suzhou and Yangzhou were the most developed jade carving centers.

1. The Process of Manufacture

There is an intimate connection between progress in the art of manufacturing jade and the development of the tools to do so. The manufacture of jade can be divided into four periods: Neolithic period, Shang and Zhou dynasties, the Warring States period to Qing dynasty, and the modern period.

During the Neolithic period the technical standard was low and tools made of animal bones and natural materials such as stone, wood, ivory, horn, and shell were of a hardness less than that of bronze and iron. Using them to carve comparatively hard jade obviously required considerable effort. However, the gleaming pre-historic jades that we see today tell us that primitive man had already mastered a set of jade manufacturing techniques that, although rudimentary, were consummately adept.

The smelting and casting of bronze was highly developed during the Shang and Zhou dynasties because of the comparatively high standard that Shang/Zhou jade manufacture had reached, whether in grinding, incision, hooked lines, carving in relief, drilling,

◀ **Jade Bird**

A fish scale pattern frequently used on the necks of birds during the Shang dynasty to indicate the presence of scales or feathers. Frequently carved into several overlapping layers with a small rotary tool and fashionable during the Late Shang period and into the Warring States.

▼ **Jade Pendant of a Paradise Flycatcher with a Flower in Its Beak**

Length 7.0 cm. Width 3.8 cm. Thickness 0.5 – 0.7 cm. Color yellow.
Jin dynasty ornamental jade
Heilongjiang province, Harbin city, Xiangfang Jin tomb
Heilongjiang Provincial Museum

A paradise flycatcher carved in the flat with outstretched wings as if in flight. There is a flower in its beak and its crest floats towards the rear. The tip of its tail is divided. Feathers are represented by incised lines.

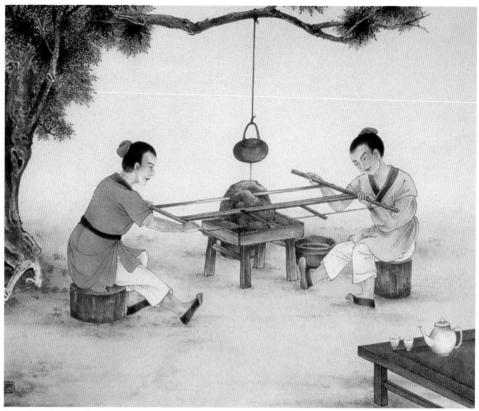

Step One: Sawing Open a Rock of Jade.

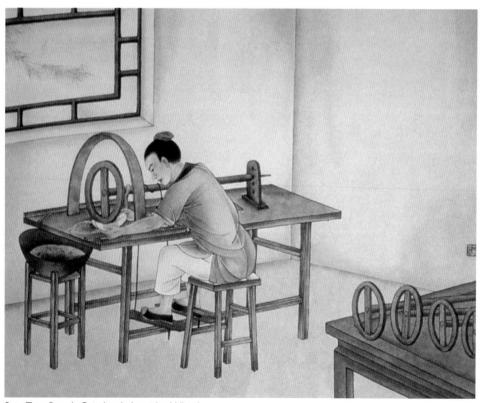

Step Two: Rough Grinding Jade with a Wheel.

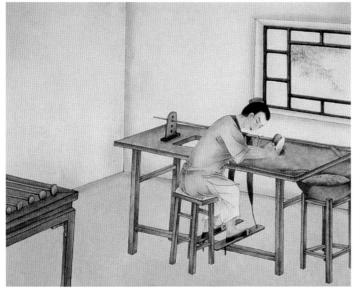

Step Three: Hollowing out Jade.

These pictures are selected from a series of late Qing dynasty illustrations of jade manufacturing techniques by Li Dengyuan.

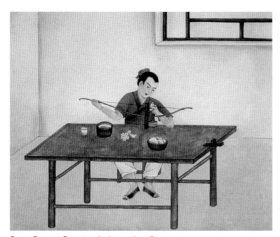

Step Four: Carving Jade with a Bow.

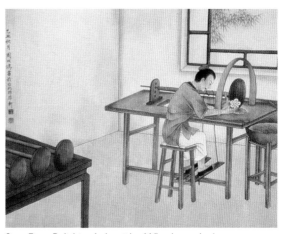

Step Five: Polishing Jade with a Wheel on a Lathe.

polishing or the use of jade as models.

Iron tools were used on a large scale in the manufacture of jade during the period from the Warring States to the Han dynasty. The combination of the use of iron tools with jade cutting techniques allowed the manufacture of complicated jades, the boring of holes of any shape, fretwork of any ground, and the articulation of links and chains of any form.

The handicraft of jade manufacture in China up to the present has been that of the artisan's workshop. From the point of view of jade manufacture during the Ming and Qing dynasties the sequence of manufacture can generally be divided into five steps:

Step One: Opening. That is, sawing open a large piece of jade and scraping away the outer coating of stone that surrounds the jade.

Step Two: Shaping the general external outline of the piece on a lathe.

Step Three: Scooping out the internal hollows of the piece to form a vessel.

Step Four: The carving of patterns on the external surface.

Step Five: Polishing the external surface of the finished piece.

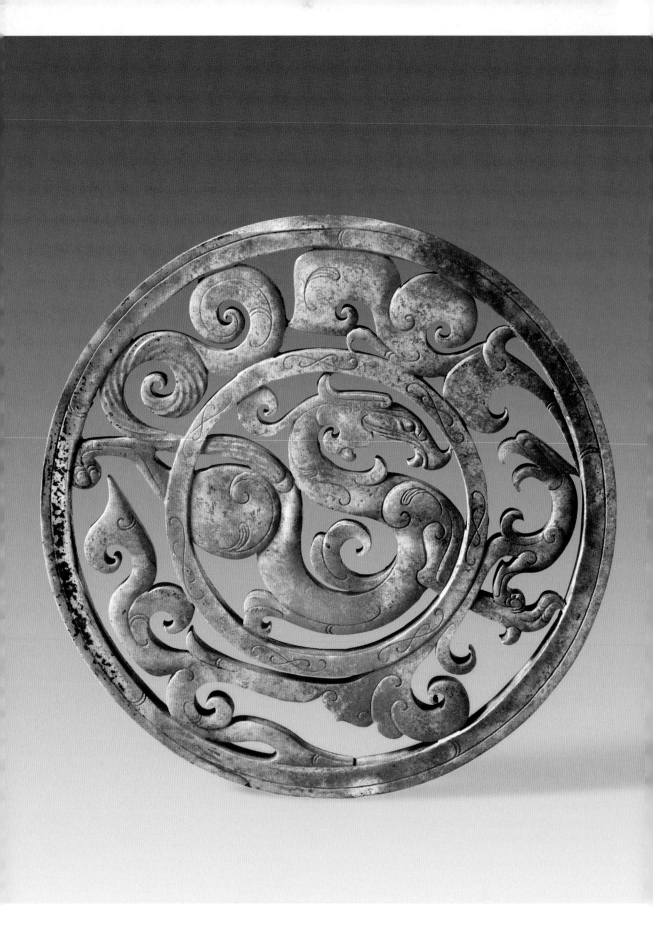

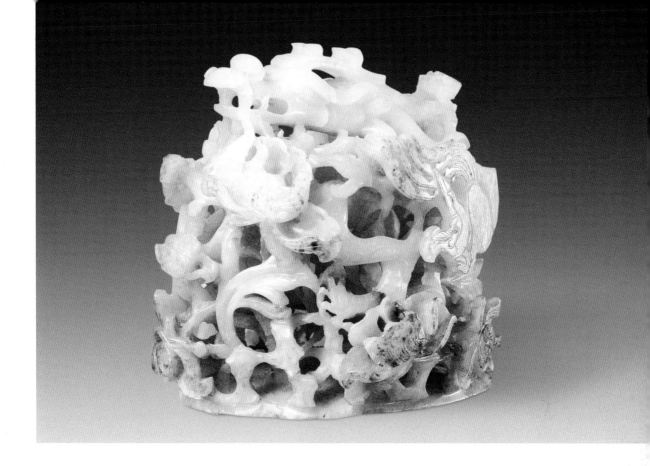

2. The Art of Carving Jade

The main types of jade carving in its development, with their successive peaks, from pre-history to the Qing dynasty are as follows:

Use of Color (*qiaose*)

The incorporation of the naturally occurring color in the jade into the finished design in order to make it appear more lifelike.

▲ Jade Incense Burner Lid—Dragon Coiled within a Peony

Height 7.5 cm. Base diameter 7 cm. White jade with partial traces of brown/yellow.
Yuan dynasty utensil
Palace Museum, Beijing

This is a classic example of Yuan dynasty *qiaose*. A hemisphere carved with a pattern of a dragon coiled within a peony. Two claws to the dragon's head which has an open mouth and bared teeth. The dragon writhes within the luxuriant foliage of the peony.

Fretwork (*loukong*)

Capable of exhibiting both the durability of the material and the accuracy of the pattern's design. Technically difficult.

◀ Jade Disc (*bi*) with Dragon and Phoenix Pattern

Diameter 10.6 cm. Diameter of central opening 5.2 cm. Thickness 0.5 cm. Color blue-green/white. Surface is water-damaged, severely in some parts.
Western Han ornamental jade
Guangzhou Province, Guangzhou City, Xianggang, Tomb of the Nanyue King
Museum of the Mausoleum of the Nanyue King

In the shape of a double circle with a dragon with its body on the inner circle and its front claws and back feet protruding into the outer, a phoenix on the outer circle standing on the dragon's front claws looking back at the dragon, the crest and tail of the phoenix extended into a cirrus cloud pattern. The twisted dragon's tail curled around the outer circle.

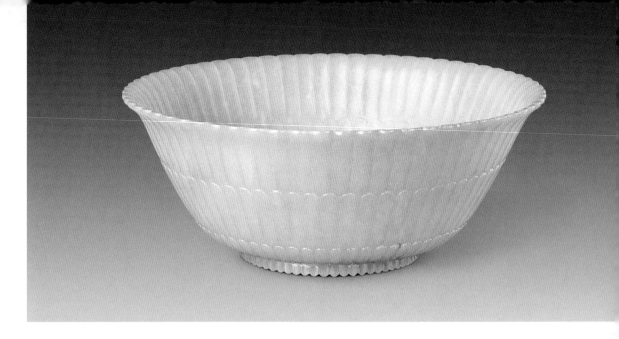

Thin Walled (*botai*)

Made by exploiting the durability of the material and the precision of scooping techniques as in the Qing dynasty Mughal jades.

▲ Jade Bowl in the Form of a Chrysanthemum

Height 5.7 cm. Diameter at mouth 14.8 cm. Diameter at foot 6.4 cm. Color blue-green, some flaws.
Mid-Qing dynasty Mughal-style jade
Palace Museum, Beijing

This bowl is in the form of a fully opened chrysanthemum, thin walled and very light, in the particular style of Mughal jades of the mid-Qing dynasty.

Pressed Thread Inlay (*yasi qianbao*)

Mainly used on white, blue-green, jasper and ink jade. The design is carved as grooves in the surface of the jade with the bottom of the groove wider than the top. Silver or gold thread is then gently and evenly hammered into the groove.

◀ Pressed Thread Inlay Jade Vase with Pattern of Leaves and Flowers

Height 20.1 cm. Diameter at mouth 1.7 cm. Diameter at foot 4.5 cm. Color blue-green/grey.

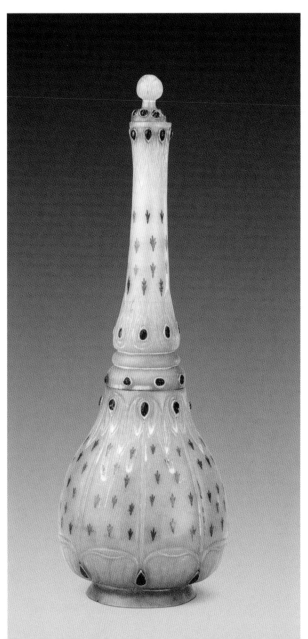

Mid-Qing Mughal jade
Palace Museum, Beijing

The circumference of the lid of the vase has a gold thread inlay of eight rubies, and the tips of the protruding flower buds in the center contain a beryl. The slender neck as well as the belly is carved with a bas-relief pattern of belladonna, and inlaid with grasses in silver. The gold thread inlay of rubies forms three loops in the middle. The foot has a silver and gold thread inlay of eight pieces of jasper.

Incised Character (*kezi*)

▶ Jade Vase Inscribed with a Poem

Height 24.5 cm. Diameter at mouth 6.8 cm. Diameter at belly 10.7 – 11.6 cm. Diameter at foot 6.3 cm.
Color blue-green, light sienna at one side.
Mid-Qing dynasty jade in ancient style
Palace Museum, Beijing

Slightly convex lid; plain undecorated jade; the ridges of the lid are decorated with four birds' heads. The belly of the vase is inscribed with a poem in the hand of the Emperor Qianlong in clerical script (*lishu*) of the *Bingwu* year (1786). The poem reflects the state of the Qing dynasty jade industry and the historical background to the popularity of ancient styles. It has considerable historical value.

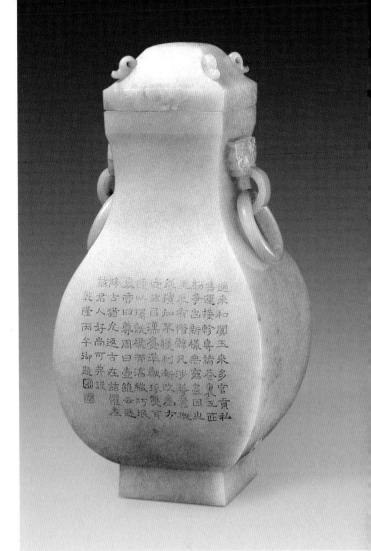

Gold Outline (*miaojin*)

Mostly used on jades of deep color such as ink jade and jasper. The ink is made of a mixture of lacquer and gold dust and the outline of the painting is sketched in with a brush.

▶ Jade Chime with Gold Outline Pattern

Drum height 17.5 cm. Drum width 6.1 cm. Section height 12.5 cm. Section width 3 cm.
Qing court jades
Palace Museum, Beijing

This set of chime stones for court use was made during the reign of Qianlong and was used during major court ceremonies and musical performances. The jade is dark-green in color and ornamented with a dragon pattern in gold outline. Dragon patterns, formerly limited in use to royalty, have come to represent nobility and esteem. Together with the patterns of floating clouds, they symbolize elevated status.

3. Jade Carving Technique in Suzhou and Yangzhou

By the time of the Song and Yuan dynasties there were already local differences in jade carving techniques and during the Ming and Qing dynasties a number of different schools of jade carving technique emerged, of which the jade manufacturing centers of Suzhou and Yangzhou were the most developed.

During the Ming and Qing dynasties Suzhou was an economically and commercially prosperous city.

Economic prosperity promoted the development of all types of handicrafts and jade manufacture was no exception. A major characteristic of Suzhou jade carving was the ability to give the feeling that in the handling of intricate detail it was possible to "see all heaven within a square inch." This was especially so in the smaller pieces where exceptional skill was displayed in the carving of fine detail of exquisite translucence and in the manufacture of fretwork, loops and chains.

From the Tang and Song dynasties onwards Yangzhou was a major economic center with highly developed commerce. It was famous for carved jade and the carving of large jades. A characteristic of Yangzhou

◀ **Lotus Pattern Jade Incense Sachet**

Height 8.9 cm. Width 7.3 cm. Color blue-green/white.
Qing dynasty ornamental jade
Palace Museum, Beijing

In the shape of a box in two curved halves fastened
in mother/child form, with both sides of open-work
sculpting with a pattern of a five-leaved lotus and
water plants. The upper portion is a lid in the form
of a cloth cover, the surface decorated with a five-
leaved lotus in bas-relief. There are two small holes at
either side of the lid. The top of the lid has a handle
in the ancient form of a double-headed, one-legged
dragon (*kuilong*), the dragon's body ornamented with
a grain pattern in bas-relief. The center of the handle
is open, there is a hole in the center and the lower
half has a tenon which slots into the holes in the lid.
A cord extends from the handle through the holes
in the lid to secure the body of the vessel. When
the cord is tightened the vessel closes, when it is
slackened it opens and incense can be placed inside.
Typical "Suzhou made" ware.

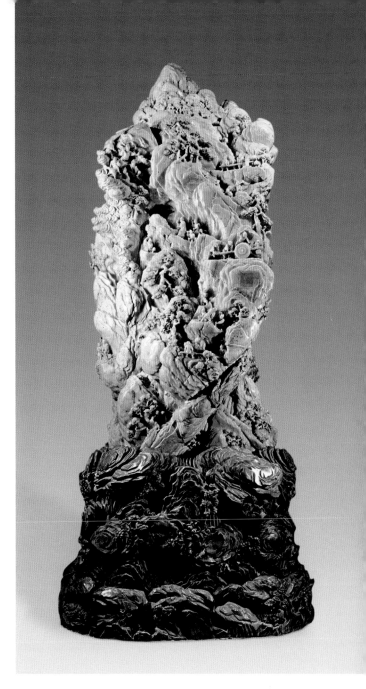

jade manufacture was the skilled
combination of the art of painting
with the craft of jade carving. Many
of the subjects of jade carving took
famous paintings or pieces of poetry as
a blueprint which was then creatively
developed into spectacular scenes
with the appearance of perspective
by enhancing the uni-dimensional
picture on the basis of the color, the
size, and the full exploitation of the
solidity and shape of the jade. At the
same time, skill in carving in high
relief and in sculpting allowed the
carving of scenes that had distance,
height and depth.

▶ **Jade Mountain Illustrating "Great Yu
Taming the Floods"**

Height 224 cm. Width 96 cm. Height of gold inlayed
copper stand 60 cm. Xinjiang Yarkand blue-green jade,
with numerous whorls.
Mid-Qing dynasty display jade
Palace Museum, Beijing

Starting from the Song original drawing the jade
carver has exercised his art by exploiting the whorls,
imperfections and splashes of color in the jade. It
is a passionate depiction of the steep mountains,
winding paths, precipitous crags and arduous toil of
the people laboring to tame the floods. According to
the Qing palace archives, this piece of jade weighed
over 5300 kg., and took over three years to reach
Beijing, hauled by 100 horses and pushed by 1,000
men, over icy roads from Miletashan near Hetian
in Xinjiang. It also took a further ten years from the
preparation of the original drawings, through the
creation of a model in wood, to transport by canal to
Yangzhou and return by canal to the Forbidden City
on completion. It is the largest ancient jade carving
in existence.

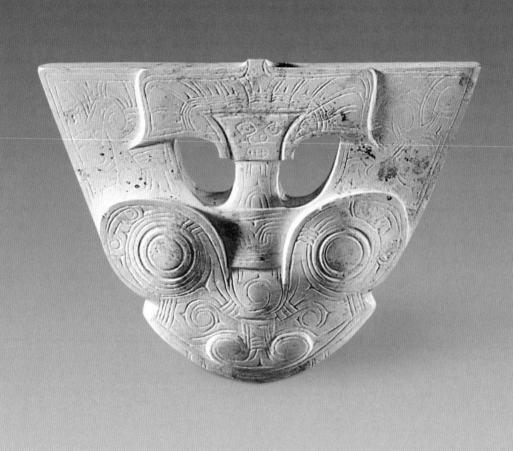

CHAPTER THREE
AN OUTLINE OF HISTORICAL CHINESE JADES

The results of current excavation and research demonstrate that the history of carving and use of jade in China stretches back over 8,000 years. From the Neolithic period to Qing dynasty, there was a rich abundance of jade forms and scope of uses.

1. Neolithic Period

The discovery of jade objects of the Xinglongwa culture in the valley of the West Liao river in Inner Mongolia was the precursor for the carving and use of jade in prehistoric China. As demonstrated by the Hongshan and Liangzhu cultures, the basins of the West Liao river and the area around Lake Tai on the lower reaches of the Yangtze (*Changjiang*) became the two great centers for the carving and use of jade in Neolithic China. At the same time, further fine Neolithic jade sites were also discovered in the upper, middle and lower reaches of the Yellow River, the middle reaches of the Yangtze, the Jianghuai area of Anhui and Jiangsu provinces and Southern China.

In the main, Neolithic jades were used as ornaments, tools and ritual objects. Of these, ornaments formed the majority and tools the minority.

Ritual jades and their significance can be divided into those that represented objects of totemic worship: for example, the Liangzhu culture jades, of considerable totemic significance, that were often carved with a pattern of figures of human and animal gods; and those jades that fulfilled the role of an intermediary between man and the gods in the worship of the gods of heaven and earth.

◀ Ornamental Jade Plaque of a God-Like Figure with the Face of an Animal

Length 8.3 cm. Width 6.2 cm. Thickness 0.6 – 1.2 cm.
Color white with some streaks of brown staining.
Liangzhu culture ornamental jade
Zhejiang province, Yuhang county, Yaoshan tomb
No. 10
Zhejiang Cultural Objects Archaeological Research Institute

The surface of the complete piece appears as an inverted triangle with the bottom corner blunted into the shape of an arch. The surface is carved with a bas-relief and incised design of a combination of the faces of a god and an animal. The upper part of the plaque forms the head of the god wearing a crown of feathers supported by a raised central spine. The face is an inverted trapezoid with olive shaped eye sockets, single-ringed eyes, a pug nose, and a flat round mouth. There are two oval incised holes either side of the neck of the god suggesting the outline of a long thin throat.

The lower portion of the plaque is comparatively thick with a raised design of an animal face with bulging round eyes, eye sockets surrounded by four circles and the sides of the nose ornamented with a cirrus cloud pattern. A wide mouth with fangs either side is carved on the bottom edge of the piece. The reverse of the piece is flat and drilled with four pairs of slanting holes probably to take a cord. The delicacy and ingenuity of this piece makes it one of the finest of the Liangzhu culture.

Xinglongwa Culture Jades

The Xinglongwa culture is distributed between the Neolithic archaeologies of 8,200 – 7,200 years ago in the basins of the West Liao river, the Daling river in western Liaoning province and the southern slopes of the Yanshan mountains in Hebei province. Xinglongwa jades are mostly small, polished throughout, plain in appearance, of relatively few types and having all the primitive characteristics of the early Neolithic period. The jade forms can be divided into tools and ornaments.

◀ Jade in the Shape of a Dagger (*bi*)

Incomplete length 3.6 cm. Color blue-green, some white spotting.
Xinglongwa culture oranmental jade
Inner Mongolia Autonomous Region, Aohan Banner, Xinglongwa settlement site
Chinese Academy of Social Sciences Institute of Archaeological Research

Dagger shaped; haft end slightly damaged; curved forward end; edge thinned by grinding; long body with one side slightly convex and the other concave. There is a small hole in the center, close to the haft.

◀ Arc-Shaped Jade Ear Pendant

Length 9.5 cm. Thickness 0.69 cm. Color gray/white.
Xinglongwa culture ornamental jade
Inner Mongolia Autonomous Region, Aohan Banner, Xinglongwa settlement site
Chinese Academy of Social Sciences Institute of Archaeological Research

The body has the shape of a curved arch. The top end is slightly convex and the bottom tapered. There is a round hole at one end.

Hongshan Culture Jades

The Hongshan culture is distributed between the Neolithic archaeologies of 6,500 – 5,000 years ago in south-eastern Inner Mongolia, western Liaoning province and northern

Hebei province. Jades are the finest of the objects left by the Hongshan culture. Generally they are small, flat and thin. The majority are polished and the products of the techniques of sculpting, relief carving, open-work carving, drilling and incision. Their outstanding characteristic is a grasp of the particular artistry of animal forms that emphasizes a feeling of vivid symmetry and accuracy. The edges of many of the ornaments are ground to a knife-like sharpness; the surfaces are covered with a fine pattern of shallow grooves of varying depth and profile and of great ornamental beauty. The jade forms can be divided into tools, ornaments, people, animals and the unusual.

▶ Jade Double-Disc (*bi*)

Length 9.5 cm. Width 4.5 cm. Color blue-green/white.
Hongshan culture ornamental jade
Liaoning Provincial Museum

Flat bodied, in the shape of two joined but irregular horizontal symmetrical discs. The upper surface has a wheel-ground groove with a hole on each side to take a thread for hanging. The surfaces of the jade are slightly convex.

▼ Hook and Cloud Pattern Jade Pendant

Length 28.6 cm. Width 9.5 cm. Thickness 0.6 cm.
Color deep green with patches of yellow. Changes in the shade of color can be very pronounced depending on the angle of light.
Hongshan culture ornamental jade
Liaoning province, Jianping county, Niuheliang No. 2 site, No.1 mound, Tomb No. 27
Liaoning Province Archaeological Research Institute

Flat and thin-bodied, the obverse has a roof tile and groove decoration (*wagou*) and the reverse is slightly curved inwards. The external contours of this piece are symmetrical; the toothed animal pattern is probably a stylized representation of a totemic animal, and the piece used at the time as a sacred object in totemic sacrifices. This pendant is so far the largest of all known Hongshan culture hook and cloud pattern pendants.

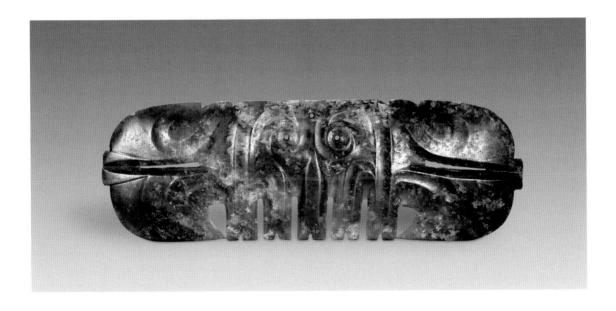

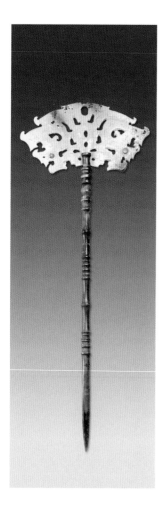

◀ Bamboo Segmented Jade Hairpin

Overall length 23 cm. Comprises two pieces. Pin head length 9.0 cm. Width 4.5 cm. Thickness 0.4 cm. Color creamy white with some brown staining.
Longshan culture ornamental Jade
Shandong province, Linqu county, Xizhufeng tomb No. 202
Chinese Academy of Social Sciences Institute of Archaeological Research

The piece is fan shaped with a symmetrical pattern of carved fretwork perforations with a decoration of incised lines between the perforations. It resembles the crown decorated pieces of the Liangzhu culture. The top curves upwards on either side into the form of a crown. The pin has a spiral decoration of three bamboo segments along its length. This kind of perforated-head pin is only seen amongst Neolithic Chinese jades and demonstrates a high standard of jade carving.

Longshan Culture Jades

The Longshan culture of Shandong province is a Neolithic culture of approximately 4,600 – 4,000 years ago with its major distribution at centers within Shandong province. The patterns on Longshan culture jades are usually simple. Types can be divided into tools, ornaments, and ceremonial objects.

▼ Jade Adze (*ben*) with Animal Face Design

Length 17.8 cm. Width of blade 4.9 cm. Thickness 0.5 cm. Color blue-green with a yellowish tinge, extremely hard, with patches of white and some white staining on the upper half.
Longshan culture ceremonial jade
Shandong province, Rizhao city, Liangcheng village
Shandong Provincial Museum

This jade was originally broken in two. Earth staining has produced different colors. The body is polished throughout. Both sides have an incised decoration of an animal god with a pattern in the shape of the character 介 over the head. In both cases they are carved with protruding eyes, nose and mouth, either as the mask of an ancient god or as an anthropomorphized animal decoration. The *ben* was a symbol of the authority of tribal leaders.

Shaanxi Longshan Culture Jades

Shaanxi Longshan culture refers to the Neolithic Longshan culture archaeology of 4,500 – 4,000 years ago found along the Wei river in Shaanxi province. The jades of this culture are fine, plain, and unadorned and fall into the categories of tools, ornaments and ceremonial objects.

▲ Jade Battle-Axe (*yue*)

Length 14.8 cm. Width at handle 8.6 cm. Width at blade 10.0 cm. Thickness 0.2 cm. Color black/green, opaque, with areas of uneven quality.
Shaanxi Longshan culture ceremonial jade
Shaanxi province, Shenmu county, Xinhuacun ritual pit K1
Shaanxi Institute of Archaeology

Flat and almost trapezoid in shape; the blade curved outward and quite thin. There is a single drilled hole of diameter 1.85 cm on the straight back. The axe is very thin and brittle, probably an imitation ceremonial weapon or a tool without practical function.

▼ Jade Toothed Disc (*bi*)

Diameter 10.3 cm. Diameter of central hole 6.2 cm. Thickness 1.2 cm. Color blue-green/yellow, slightly brown on the rim.
Shaanxi Longshan culture ornamental jade
Shaanxi province, Yan'an city, Lushanmao site
Yan'an Cultural Institute

Flat and circular; round inner hole, carved in the outer rim are four symmetrical gaps of length 2.3 cm and depth 0.3 cm. This type of jade is frequently found at Longshan culture sites in the middle and lower reaches of the Yellow River. Examples from the Yin and Zhou dynasties are also known.

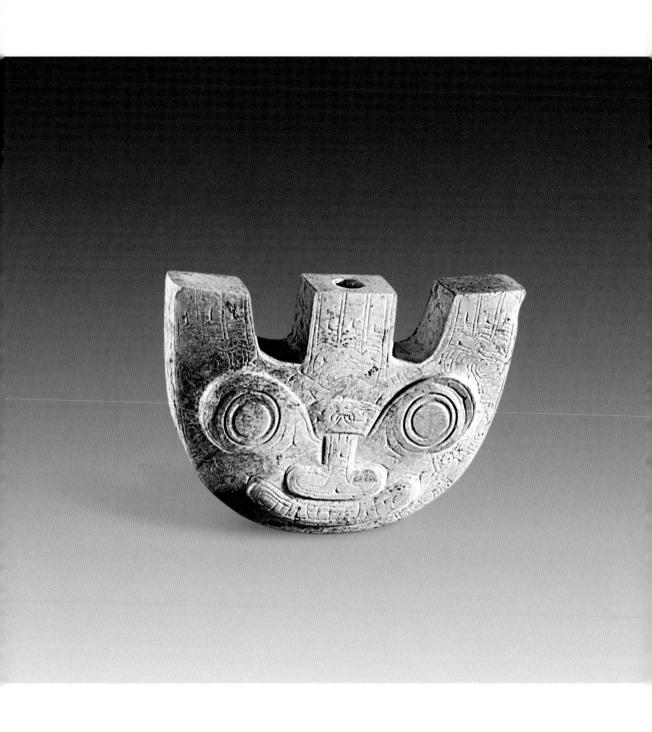

Liangzhu Culture Jades

The Liangzhu culture is the Neolithic archaeology of 5,300 – 4,000 years ago in the lower reaches of the Yangtze (*Changjiang*). Its principal distribution is in the area surrounding Lake Tai. The principal decorative motifs of the Liangzhu culture are the faces of spirits, men and animals, patterns of dragon heads and birds and decorations of straight lines. The types are tools, ornaments and ceremonial objects. The variety of type and the large number of examples are not seen in other Chinese archaeology of the same period.

◀ Three-Pronged Jade Crown Ornament Decorated with Animal Face Design

Height 7.4 cm. Total width 5.2 cm. Thickness 1.3 cm.
Color white, some dark streaks.
Liangzhu culture ceremonial jade
Zhejiang province, Yuhang county, Yaoshan tomb No.10
Zhejiang Institute of Culture and Archaeology

The whole jade has the shape of the character 山. The lower portion is curved in an arc and the upper part is sawn into three even upright prongs covered in incised feather decoration representing the feather crowns of animals. The front has an animal face carved in bas-relief and incised lines, in the midst of a cirrus cloud pattern. The back is undecorated. At the time of excavation this jade was at the head of a corpse, indicating a person of considerable status such as a tribal chief, and symbolizing the emergence of monarchy in China.

▲ Jade Belt Hook with Animal Face Design

Length 7.5 cm. Width 4.5 cm. Thickness 3.6 cm. Color whitish pink, traces of light yellow on the upper part.
Liangzhu culture jade tool
Zhejiang province, Yuhang county, Fanshan tomb No.14
Zhejiang Institute of Culture and Archaeology

Oblong in shape, one end has longitudinal holes through which the belt can be threaded. The other end has a hook with its curved head bent inwards. The obverse surface is curved outwards and the reverse is flat. The obverse is decorated with an animal face pattern. Carved decoration on belt hooks is only found in the Liangzhu culture. This belt hook was found on the abdomen of the occupant of the tomb, hence it is likely that it was used for securing the upper garment. This is a functional object and a precursor of the traditional model of belt hook.

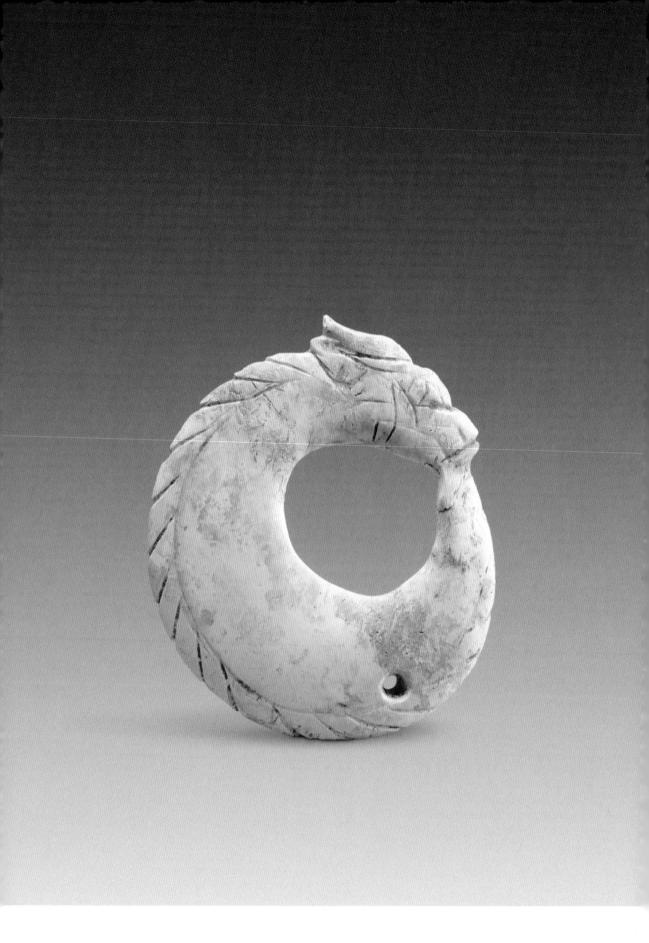

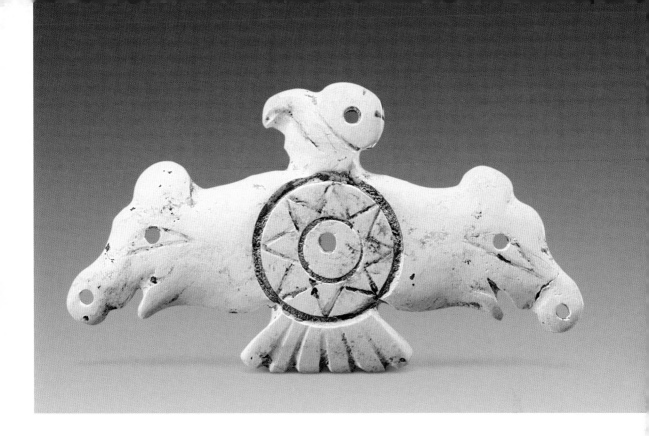

Lingjiatan Culture Jades

The Lingjiatan Neolithic site of 5,500 – 5,300 years ago is at the village of Lingjiatan, near Tongjiazhen in Hanshan county, Anhui province. Lingjiatan culture jades are mostly plain and unadorned, incised decoration being mostly found on special objects such as tiger-headed arc-shaped pendants (*huang*) and human figures, eagles, blocks, triangular pieces and dragons. The jades consist of tools, ornaments, ceremonial pieces and jade blanks.

◄ Jade Dragon

Outer diameter 4.4 cm. Inner diameter 3.9 cm. Color gray/white with specks of blue-green.
Lingjiatan culture ornamental jade
Anhui province, Hanshan county, Lingjiatan site, Tomb No. 16
Anhui Cultural Relics and Archaeological Research Institute

Flat and oval with the body of the dragon curved so that head and tail are adjacent. The lips of the dragon protrude and its head has two horns. The mouth and nose are incision carved and incised lines on the face represent folds in the skin and whiskers. The ridge along the back of the dragon is carved with regular circular arc shaped incisions rather like scales. A round hole has been drilled in the tail. The carving on both sides of the dragon is basically the same. The whole piece has been polished smooth. With its abbreviated form and rough style this extremely valuable piece is the first Neolithic jade dragon to have been discovered so far in the Jianghuai area.

▲ Jade Eagle

Length 8.4 cm. Width 3.5 cm. Thickness 0.3 cm. Color grey/white.
Lingjiatan culture ornamental jade
Anhui province, Hanshan county, Lingjiatan site, Tomb No. 29
Anhui Institute of Cultural Relics and Archaeology

The wings of the eagle are outstretched in flight. The head and beak are carved and polished and the eyes formed from two round drilled holes. Each wing is decorated with a pig's head. The body is carefully carved with a 1.8 cm diameter circle with an octagonal star within and another circle of 0.8 cm diameter within the star. One side of the circle has a pair of drilled eyes. The tail is carved with a tooth pattern decoration of feathers. Both sides of the eagle are similarly carved and highly polished. There are a total of six drilled holes, at the eyes, snout and belly of the pig, and at the eyes of the eagle. It is possible that this jade eagle was used by the Lingjiatan people as a sacred object in prayer to the stars for rain. It thus has an additional ritual significance.

Illustration	Name	Characteristics
	Trough or groove	The principal decorative feature of ornamental jades of the Hongshan culture can also be found on jades of the late Liangzhu culture. The technique of incision is used to carve a variety of shallow grooves with a curved internal profile on the surface of the jade (*wagouwen*). Delicate parallel vertical patterns are often found on the wall of the groove.
	Raised decoration	Found on ornamental jades of the Hongshan and Longshan cultures. The technique of carving in bas-relief is used to produce raised decoration on the surface of the jade by grinding away unwanted material so that the decoration stands out.
	Straight (parallel, curved) lines	Found on ornamental jades of the Liangzhu culture. Parallel straight lines are cut into the side of jade squared tubes (*cong*). The lines are characteristically neat and even.
	Dragon head	Found on ornamental jades of the Liangzhu culture. Generally found on bracelets, round plaques, arc-shaped pendants (*huang*) and tube or cone-shaped jades. Generally placed at the circumference or the edge of the jade in bas-relief or incision so that they appear two-dimensional.
	Faces of gods and animals	Found on ornamental jades of the Liangzhu culture. The complexity of this pattern differs from piece to piece. The animal eyes are relatively large with oval eye sockets slanted upwards. Between the eyes the bridge of the nose is arched over the horizontal mouth beneath. Carefully and minutely carved in a combination of bas-relief and incision. The carving of lines is so fine as to resemble silk thread.

Illustration	Name	Characteristics
	Octagonal star	Found on ornamental jades of the Lingjiatan culture. The pattern may represent the *jing* constellation of the 28 ancient constellations of Chinese astronomy. The circles and feather pattern outside the star pattern may represent the sun's rays.
	Twisted thread	Found on ornamental jades of the Liangzhu culture. It combines bas-relief and incision to form a pattern of parallel twists resembling the twisting of silk filaments into thread. This pattern starts with the Liangzhu culture and continues through the Shang, Zhou, Qin, and Han dynasties.

▶ Jade Human Figure

Length 18.6 cm. Color light yellowish green.
Hongshan culture ornamental jade
Liaoning province, Jianping county, Niuheliang site No. 16, Tomb No. 4
Liaoning Cultural Objects Archaeological Research Institute

Cylindrical shape with the eyes half-closed and both hands extended and held upwards. Roughly decorated with incised lines. Three connecting holes have been drilled at the top of the head and the back of the chest. Six human figures of jade closely resembling this figure in appearance have previously been excavated from Lingjiatan Neolithic site. All are portrayals of the shamans who acted as a channel to the gods of heaven and earth and became "gods of jade."

▶ Jade Slit Ring in the Form of a Bird

Length 5.5 cm. Greatest width 5.0 cm. Thickness 1.0 cm. Internal diameter 2.0 cm. Color blue-green but turned gray/white by seepage and erosion.
Hongshan culture ornamental jade
Inner Mongolia Autonomous Region, Balinyou Banner, Bayanhansumunasitai site
Balinyou Banner Museum

In the shape of a flattened cylinder with the head and tail curved so as to almost meet each other like an embryo chick. Very large, slightly protuberant mouth and a downward pointed beak. The forehead is raised and is carved with an eye in the form of a double circle so that it occupies almost the whole of the head. There are two sharp ridges on the body and the wing joint protrudes quite prominently outwards and the feathers downwards. The arc shaped tail curves upwards to meet the beak. There is a circular hole through the neck. The appearance of the piece is extremely unusual and the style and shape somewhat resemble the jade pig-dragons of the Hongshan culture.

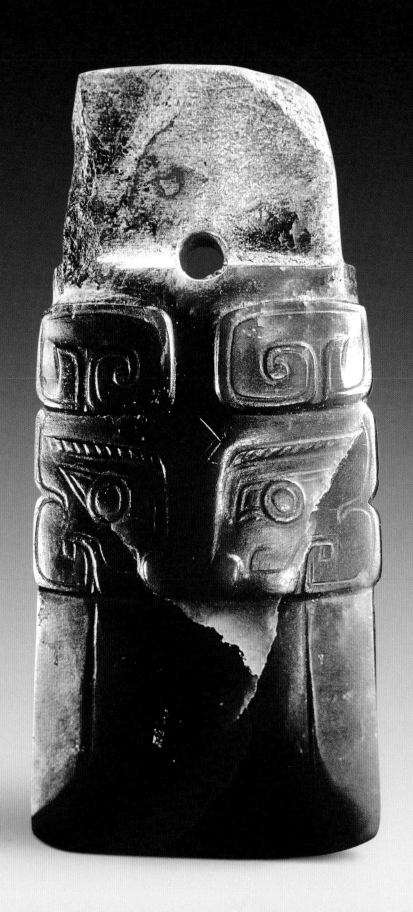

2. Xia, Shang, and Western Zhou Periods

The period from Xia to Western Zhou marks the mature development of jade objects in China in which styles tended both towards uniformity and innovation. At the same time, the historically influential system of the ritualization of jade was complete.

Excavated specimens demonstrate that the majority of Xia ritual jades are flat, plain, unadorned geometrical shapes. Most ornamentation is at the edge rather than on major surfaces. There are three principal types of decoration: toothed, where a symmetrical saw-tooth decoration is carved on both sides of the piece; incised straight line pattern, lozenge pattern and thunder-cloud pattern; and, finally, animal face pattern.

Shang period jades were developed on the basis of those of the Neolithic and Xia periods. Excavated examples are relatively plentiful and broad in scope. Scholars today now divide Shang jades into early and late periods. Early Shang (c.1600 – 1300 BC) jades are comparatively few in type and number, of simple shape and basically undecorated. The pinnacle of Late Shang (c.1300 – 1046 BC) jades is concentrated in the vigorous artistic development of the jades excavated at Yinxu near Anyang in Henan province, famous amongst them being those from the Tomb of Fu Hao, consort of the Shang emperor Wu Ding. More than 750 jades were recovered from the tomb, divided into ritual jades, imitation weapons, tools, utensils, ornaments, artistic pieces, and miscellaneous. Sculpted jades in the form of people and animals as well as ornaments and pendants are the finest. The pieces from the Tomb of Fu Hao are a mirror that reflects the glory of Shang jade carving.

It could be said that Western Zhou jades are of the same lineage as those of the Shang period. In shape, decoration and carving they follow the late Shang style although overall they exhibit a tendency towards simplification. They can be divided into four groups: ritual and imitation weapons, ornaments and artistic pieces, funerary pieces, and three-dimensional display pieces of people and animals and jade vessels. The decoration of Western Zhou jades shows symmetrical patterns with more curved than straight lines.

◀ **Jade Axe-Head (*fu*) with Animal Face Design**

Length 10 cm. Body thickness 2.6 cm. Color deep green with yellow/green at the tip.
Late Shang ritual jade
Henan province, Anyang city, Tomb of Fu Hao
Chinese Academy of Social Sciences Institute of Archaeological Research

Tablet shaped piece; oval in section; thick at the top and thin at the bottom. Ground out protrusions on both sides of the lower body; double-sided curved convex blade. Inner portion oblong in shape, relatively thin with a drilled hole for a handle in the center. Both surfaces of the body of the axe-head are finely carved with a decoration of an animal head with the mouth facing the blade, its eyebrows formed by a coarse rope pattern of single lines and double hooks, eyes in the form of the character 臣 (oracle bone script 𦥑) with the corners curled inward. No signs of use.

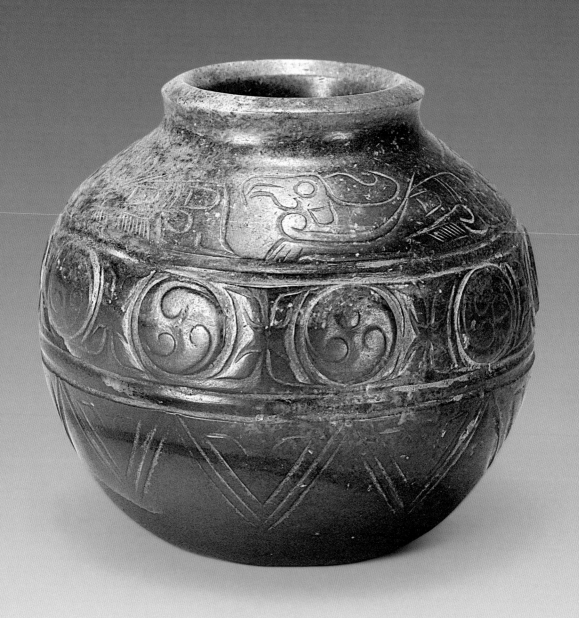

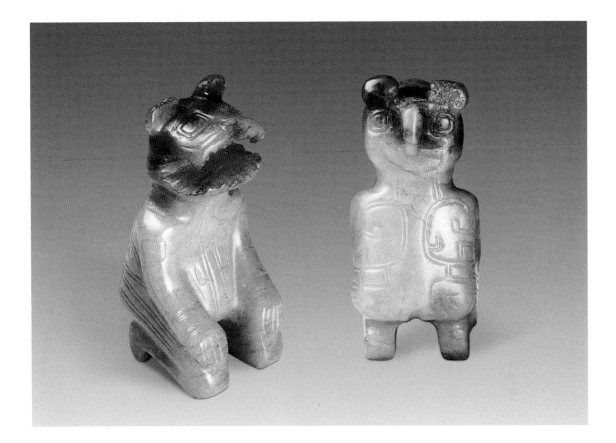

◀ Phoenix-Patterned Jade Wine Jar (*lei*)

Height 6.2 cm
Western Zhou jade vessel
Shanxi province, Quwo county, Jinhou tomb group,
Tomb No. 63
Shanxi Institute of Archaeological Research

Found in a square bronze box in the northwest corner of the coffin chamber. The box contained various kinds of jades such as human figures, bears, oxen, hawks, wine jars and turtles possibly play things of the occupant of the tomb. The wine jar is a deep green in color with a narrow mouth, round body and no bottom rim. The internal wall shows traces of grinding and the outer shoulder is decorated with a pattern of phoenixes with hooked beaks, round eyes, curled crests, outstretched wings, hooked claws and drooping tails. In Chinese mythology, the phoenix is the king of all birds. It embodies such qualities as morality, good fortune, cleanliness, beauty, love and kinship.

The upper body is carved in relief with a pattern of whirlpools interspersed with flowers. The lower body is decorated with triangular patterns of drooping flowers. This piece follows the style of bronze wine jar in both shape and decoration. Such examples are very rarely seen.

▲ Jade Figure of a Kneeling Man with the Head of a Tiger

Height 5.0 cm. Width 2.5 cm. Thickness 2.8 cm. Color yellow/green with brown patches and some water damage to the head, slightly translucent.
Late Shang dynasty ornamental jade
Henan province, Luyi county, Taiqinggong Changzikou tomb

From the front view, it is a jade figure of a kneeling man with the head of a tiger. From the back view, it looks like a bird of prey.

From the front view, the tiger head looks upwards with mouth open and displaying fangs. The upper and lower jaw each have seven teeth, those in the upper jaw appearing barbed. The nose is small and the eyes rounded oblongs. The tiger's gaze is intent and its ears are semi-circular. Beneath the tiger's head there is a human body slightly inclined to the front and kneeling with its hands on its knees with fingers extended. The body appears to be clothed and shod.

From the back view, the figure is in a crouching stance, using the drawn back tiger's ears as its ears, with a hooked nose, round eyes and protruding eyeballs, and a round hole beneath the nose. The human back becomes the bird's body with his arms as wings and the human feet as bird's feet, its head raised and chest pushed out glaring angrily to the front.

The outlines of the body are powerfully and vividly carved with double hook lines and incised straight lines. The shape and patterning of this piece are fundamentally the same as the sculpted human

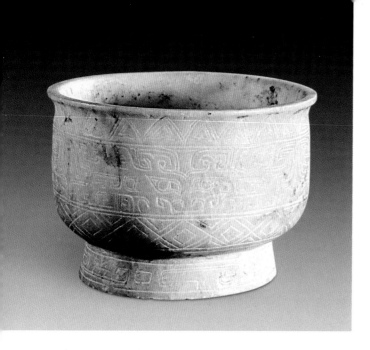

figures excavated from the Tomb of Fu Hao in Yinxu and exhibit the characteristics of the same period, such sculpted jades which perfectly combines man, tiger and bird of prey are very rarely seen.

◀ Food Vessel (*gui*) with Animal Face Design

Overall height 10.8 cm. Diameter 16.8 cm. Wall thickness 0.6 cm. Color white with streaks of yellow.
Late Shang jade vessel
Henan province, Anyang city, Tomb of Fu Hao
National Museum of China

In the shape of a bronze vessel, the whole body decorated. There is a triangular pattern beneath the rim and a separate design of three *taotie* masks formed from two coiled dragons on the belly. The *taotie* masks have flaring nostrils and eyes in the form of the character 臣 with a string pattern above and below. The lower belly of the vessel is decorated with a four sided rhomboid pattern. The circular foot is decorated with a hook and cloud pattern and eye pattern. Finely carved, the whole is elegantly shaped. When excavated, two fine bone spoons and a bronze spoon were found inside the bowl of the vessel, probably a set. This *gui* is the first Shang period jade vessel of superior quality to have been discovered. Possibly a ritual object.

◀ Jade Pendant Decorated with a Pattern of a Human Figure and Dragons

Length 5.9 cm. Width 1.9 cm. Thickness 0.25 cm.
Color blue-green, some areas of grey-white and yellow-white caused by water discoloration, semi-translucent.
Late Western Zhou ornamental jade
Henan province, Sanmenxia city, Guoguo tomb No. 2011
Henan Institute of Cultural Relics and Archaeology

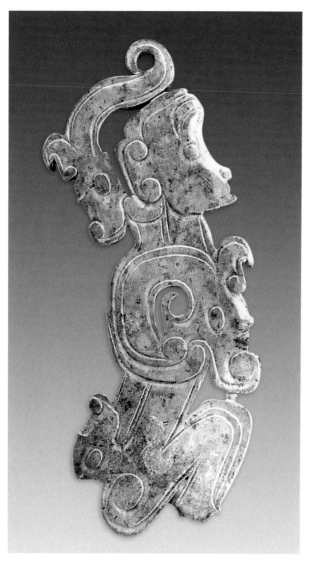

Western Zhou ornamental jades with a pattern of human figures and dragons and phoenixes are frequently found. They consist of human/dragon, dragon/phoenix and dragon/phoenix/human forms. In particular, these jades have curled supernatural animals such as dragons and phoenixes at the upper and lower limbs and head of the human figure. The carving of this unusual combination of man and animal on jade ornaments is peculiar to Western Zhou jades.

The whole of this pendant is occupied by a crouching human figure in profile. The head resembles that of a monkey. A dragon encircles it with its tail curled above the head. There is another dragon carved beneath the neck and a dragon's head on the buttocks. A hole has been bored within the circle of the tail of the dragon at the head. Its head is strongly carved and its body ornamented with a geometrical pattern of lines. The head and limbs of the human figure are ornamented with a pattern of curled supernatural dragons, tigers and horses.

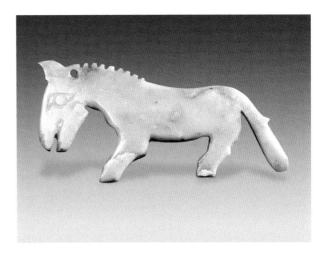

▶ Jade Pendant in the Form of a Horse

Length 6.3 cm. Width 2.9 cm. Thickness 0.2 cm. Color blue-green/white with patches of brown.
Late Shang dynasty ornamental jade
Henan province, Anyang city, Tomb of Fu Hao
Chinese Academy of Social Sciences Institute of Archaeological Research

The horse is walking with its head lowered, mouth open and ears upright. It has eyes in the shape of the character 臣, the neck has a thick mane, the legs are short and thick and the tail droops. There is a protuberance half-way down the tail the end of which has been ground to a slanted edge. There is a hole behind the ears. This kind of jade horse is extremely rare in the Shang dynasty, it is also the earliest representation of a horse in jade.

▶ Jade Pendant in the Form of a Dog

Length 5.7 cm. Width 3.5 cm. Thickness 0.5 cm. Color dark green.
Late Shang dynasty ornamental jade
Henan province, Anyang city, Tomb of Fu Hao
Chinese Academy of Social Sciences Institute of Archaeological Research

In the shape of a recumbent dog or wolf looking back over its shoulder. Round eyes and ears turned back, raised flanks. The forelegs are bent beneath the neck and the back legs are bent forward, the tail droops. The neck is decorated with a double link pattern and the body with a pattern of stylised cirrus clouds. Both sides of the piece are the same. The forepaws and back paws are worn smooth and the tip of the tail has been ground to a slanted edge. There are small holes above the upper lip and the forepaws. The hole above the lips is positioned at the point of equilibrium so that when a cord is strung through it the piece remains level. The piece may be worn as a pendant or used as an engraving tool.

▶ Jade Pendant in the Form of a Dragon

Length 8.9 cm. Thickness 0.2 cm. Color blue-green/white.
Early Western Zhou period ornamental jade
Shandong province, Tengzhou city, Zhuangli Xicun
Tengzhou City Museum

The dragon is flat with an undulating body and serrated extensions on each edge. It appears to be swimming. Both sides are decorated with a curved double incised pattern of two *kuilong* dragons with their tails intertwined. There are holes in the raised spines at either end of the piece. The incised lines throughout the piece are fluently executed and the workmanship is meticulous. This piece is the first example of its kind seen amongst excavated Western Zhou pieces.

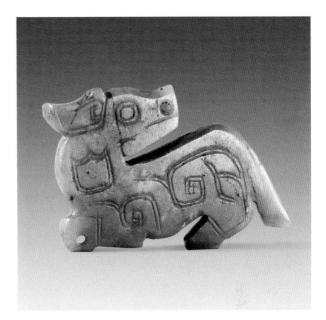

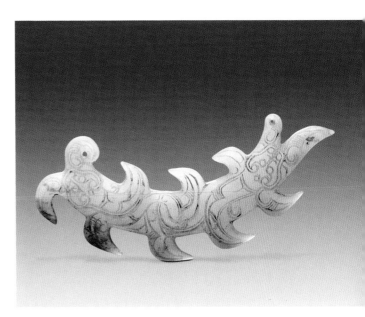

Decorative Motifs of Xia, Shang, and Western Zhou Periods

Illustration	Name	Characteristics
	Rhombus	Common during the Shang period. Formed by the double incision of squares connected at the corner; the squares arranged continuously or equidistantly. Mainly found on jade dragons and other animals or on jade vessels.
	Cloud and thunder	The continuous circular design is known as cloud and the square as thunder. The pattern is formed by bending a line back upon itself. Frequently used for the decoration of jade vessels and human and animal figures.
	Triangular	A Shang period jade decoration. The small form of this decoration is used on jade dragons and arc-shaped pendants (*huang*). The large, formed of layers of straight lines, is used on jade vessels.
	Joined curve	A longitudinal jade decoration of the Shang and Zhou periods. Formed by the incision of two joined concave curves, the point of the joint resembling the character 人. Frequently used on the trunks of animals or on jade vessels.
	Double link	Common during the Shang period. Formed by a double incised belt of near ovoid links. The link has from one to three layers of broken lines, the longest line curved back on itself to form a frame, the middle with divergent lines which themselves diverge. One side of the layer has two sharp corners. Made with a small rotary tool (*tuo*), this pattern is frequently found on dragons and other animals.

Illustration	Name	Characteristics
	Fish scale	In the form of fish scales. Often carved in overlapping upper and lower layers. Common from the Late Shang to the Spring and Autumn periods. Frequently used to represent fish scales or feathers on jade fish and the necks of jade birds.
	Phoenix	A bird form with a peacock's tail, head crest and hooked beak. In the Late Shang the pattern was a simple, neat outline. During the Western Zhou mainly curved lines were used to form the figure of the phoenix with a double pattern of thinner inner lines and thicker outer lines.
	Eyes in the form of the character 臣	Those inset carved with double lines, the round eyeballs often carved in protrusion, the eye sockets carved in a double hook pattern are typical of human and animal eyes of the Shang period. Western Zhou eyes in the 臣 (oracle bone script 𦣻) pattern are elongated and curved at the corners.
	Inclined blade (single slant)	A Western Zhou pattern. Formed from a double line pattern with a thin inner line and thick outer. The outer was carved with an inclined blade to produce a slant. Frequently found as a decoration on animals and all types of pendants.

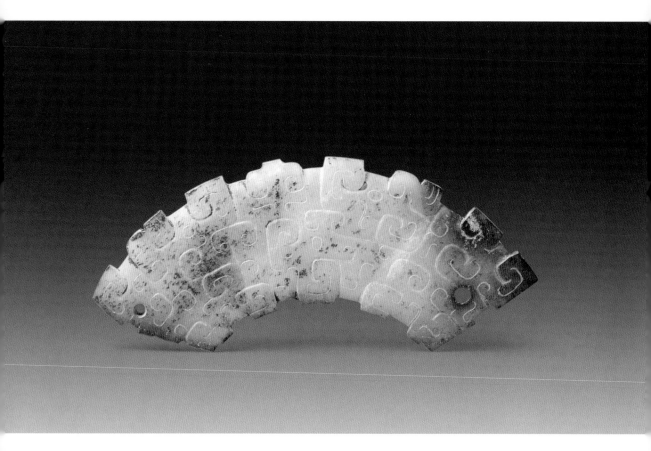

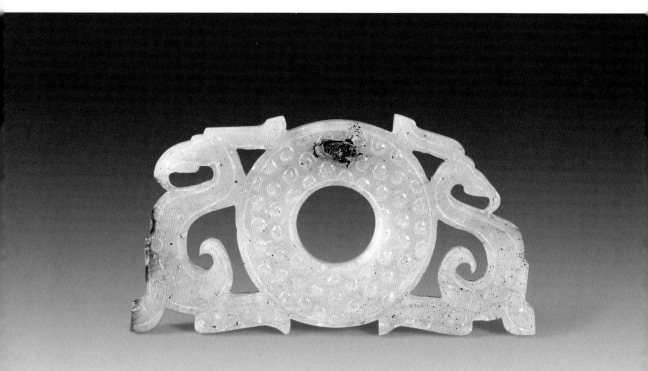

3. Spring and Autumn Annals and the Warring States Periods

The Chinese historical period of the Spring and Autumn Annals extended from the 8th century BC to the beginning of the 5th century BC. The Zhou system of patriarchal rule was beginning to break down and society was in a tumult of change to the point of institutional collapse. This social background was reflected in the use of jade. On one hand there was a systemization and idealization of its various uses with the ritualization of jade reaching its peak. On the other, the upper classes lost their monopoly of its use, particularly during the Warring States period when the use of jade to accompany burials became relatively common.

Jade of the period of the Spring and Autumn Annals and Warring States can be divided according to use into ritual objects, tools, ornaments and artistic pieces. The finest and most common jades of the period are ornamental. Pendants of this period are also frequent both in type and number, consisting of neck ornaments, bracelets, earrings, jade strings or pendant sets. Artistic pieces of the period were made mainly for visual appreciation and though few in number, are fine in quality and rich in variety of pattern.

◄ **Arc-Shaped Jade Pendant (*huang*) with Snake Pattern**

Length 9.3 cm. Width 2.9 cm. Thickness 0.4 cm. Color white. Some black and brown staining with cinnabar and earth stains.
Late Spring and Autumn Annals period ornamental jade
Henan province, Hui county, Liuligejia tomb
Taipei Museum of History

Fan shaped with protrusions on the four edges. Two dragons' heads with interlinked bodies, the surface is completely covered by a snake pattern with an incised feather pattern within the cloud pattern. Patterns on both surfaces are the same. The design is executed with a criss-cross pattern of thick and thin incisions. There is a hole bored at either extremity.

◄ **Phoenix Pattern Jade Disc (*bi*)**

Length 7.6 cm. Width 4.0 cm. Color white, semi-translucent, highly polished with streaks of bronze-green staining and black spotting.
Warring States period ornamental jade
Hebei province, Pingshan county, Nanqijicun, Zhongshanguo tomb No. I
Hebei Cultural Relics Research Institute

Both surfaces of this piece have been ground to produce a grain pattern in slight relief. Two phoenixes are carved back to back on the edges of the disc, their bodies in the shape of the letter S, tails curled and one foot outstretched.

▼ **Tiger-Shaped Jade Pendant with a Pattern of Cirrus Clouds**

Length 12.7 cm. Width 6.2 cm. Thickness 0.3 cm. Color blue-green/gray with patches of black, smooth and semi-translucent.
Early Warring States period ornamental jade
Henan province, Guangshan county, Baoxiang Temple, Tomb of Huang Junmeng and consort

Flat body carved into the shape of a dragon with its head lowered, mouth open and ears pricked forward. The body is arched and tail curled. Holes have been drilled at the mouth and tail. A cirrus cloud decoration has been carved on the body and tail to symbolise the patterning of a dragon's skin. The two feet are decorated with a pattern of pendant scales and there is a pattern of fine incisions on the ears. The outer edge is outlined by an incised double line.

◄ Grain Pattern Jade Ring (*huan*)

Diameter 10 cm. Diameter of hole 5.7 cm. Thickness 0.5 cm. Color pale green, semi-translucent, glossy with partial brown staining.
Warring States period ornamental jade
Hebei province, Pingshan county, Nanqijicun, Zhongshanguo tomb No. 1
Hebei Cultural Relics Research Institute

Inner and outer edges have a raised outline, both surfaces carved with a grain pattern. The shape of the piece is regular and the pattern dense and even. A standard example of a piece of the period of the Spring and Autumn Annals and Warring States.

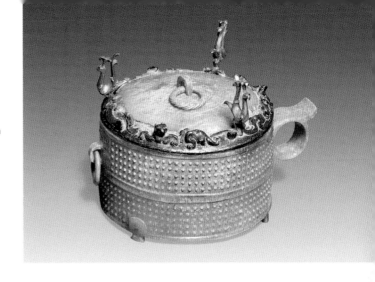

▼ Jade Pendant in the Form of a Phoenix and a Dragon Ornamented with a Grain Pattern

Length 21.4 cm. Width 11.5 cm. Thickness 0.9 cm. Color yellow, semi-translucent, smooth and glossy with some patches of brown staining.
Late Warring States period ornamental jade
Anhui province, Changfeng county, Yanggong tomb No. 2
Anhui Cultural Relics Archaeological Research Institute

A flat body which has been fretwork carved into the shape of a dragon twisting in flight. The dragon's mouth is open and its head is turned to the rear. The body undulates and the tail is transformed into a phoenix. The inner and outer edges of the body are marked with a raised outline. A grain pattern has been ground out on the body as well as raised patterns of recumbent silkworms and incised lines on horns, feet, and wings. A hole has been drilled in the back.

▲ Jade Wine Jar (*zun*) with a Pattern of Phoenix and Dragon and Linked Grains

Overall height 9.5 cm. Diameter 11.0 cm. Color yellow/brown.
Warring States period jade vessel
Henan province, Luoyang city, Jincun, Tomb of the Eastern Zhou King
Freer Gallery of Art, Washington DC.

The vessel is comprised of a body and a lid. The lid is domed with a semi-circular knob surrounded by four incised patterns of persimmon stems at the center. The surface of the lid is carved with a circle of cirrus cloud patterns. The edge of the lid has an inlaid gold decoration and four carved standing phoenixes and three coiled dragons. The body is decorated overall with a linked grain pattern divided into upper and lower portions by a string pattern that circles the body. There is a moveable ring secured to the center of the body by a bridge-shaped knob and a diametrically set handle on the opposite side. The bottom of the vessel has three hoof-shaped feet.

Decorative Motifs of Spring and Autumn Annals and the Warring States Periods

Illustration	Name	Characteristics
	Grain	Made by picking away the surface of the jade to form rows of round convex humps. One of the commonest forms of decoration during the Warring States period.
	Tadpole	A derivation of the grain pattern formed by adding a curved line to the edge of the grain to form the tail of a tadpole. Frequently added to the body of dragons to strengthen the feeling of movement.
	Silkworm	Derived from the grain pattern. Picking away the surface of the jade to raise a curved line at the edge of each grain, the line in proportion with the grain and resembling a recumbent silkworm. This pattern was common during the late Spring and Autumn Annals period but gradually disappeared after the middle of the Warring States period.
	Cloud	Shaped like a cloud. Made by incision or bas-relief, each formed by joining the tails of two opposite grain or whirlpool patterns. A common decoration during the Spring and Autumn Annals and Warring States period.
	Continuous hook	Originated in the thunder and cloud patterns. Incised and formed by joining individual thunder or cloud patterns. The earliest jades bearing this pattern appear in the middle and late Spring and Autumn Annals period with sinuous curved double hook lines. During the Warring States period this pattern becomes less exuberant.

Illustration	Name	Characteristics
	Continuous cloud	Formed by symmetrically joining several individual cloud patterns to make a chain. By the late Warring States and Early Western Han periods, a number of jade vessels were densely and profusely decorated with this attractive pattern.
	Coiled snake	Formed by the incision of a fluent double hook pattern to form a series of dragons' heads in profile; the dragons' eyes formed by a single incised circular line. Common during the Spring and Autumn Annals period and found as a decoration on jade discs and rings.
	Coiled dragon	Common during the Warring States to Han periods. Often appears in high relief or open-work relief in a coiled, crawling or climbing pose. Appears on jade discs, swords and seals.
	Whirlpool	An incised decoration resembling a whirlpool, in shape like the tadpole pattern. The earliest occurrence of this pattern, though rare, is during the Western Zhou period. During the Spring and Autumn Annals period the tail of the whirlpool was elongated into the form of a bent hook. During the Warring States period this pattern became the rule, and was plainly carved and widely used.
	Animal face	Also known as *taotie* mask pattern. Made by incision or light relief to carve out the head of a fierce beast and frequently found as one of the decorations on small jades, discs, swords and jade door furniture. Its earliest appearance was during the Spring and Autumn Annals period. It was very popular from the Warring States period to the Han dynasty.

4. Qin, Han, Wei, Jin, and Northern and Southern Dynasties

The economic prosperity and political stability of the Han period created a social environment favorable for the manufacture of jade which then entered a period of overall development. More jades have been discovered from the Eastern and Western Han periods than any other, the finest pieces being concentrated in the tombs of feudatory princes and vassals (*zhuhouwang*) in Anhui province. These can be divided into ritual objects, funerary pieces, ornaments, display pieces and jade vessels. The most magnificent of the jades of these two periods are the ornaments. The display jades are mostly animals. There is also a variety of human figures carved in sculpted form which embody the artistic spirit of Han jades. The large number of jade dishes discovered not only demonstrates the progress in the art of manufacturing jade during the Han dynasty and the availability of sources of jade but also foreshadows the gradual movement away from spiritual life towards daily life, and the laying of the foundations for the popularization of jade that took place from the Tang and Song periods onwards. The Han period also saw the emergence of many new forms. The jades of the two Han periods are the richest in decoration and in artistry of form, many of which were copied by later generations.

Because of frequent dynastic change and the deceleration of economic development during the Wei, Jin and Southern and Northern dynasties, the manufacture of jade declined from the peak that it had attained during the two Han periods, reaching a low ebb in variety of types, numbers, and skill. During this period varieties became fewer, sacrificial jades are hardly seen at all and there was a reduction in funerary jades because of a court prohibition of lavish funerals. Fewer display items and jade vessels for daily use are seen and there was a trend toward simplification. Patterns of this period are obviously sketchy and the jades flat, plain and coarsely polished.

▶ Phoenix Pattern Jade Sword Guard

Length across 6.2 cm. Center width 4.1 cm. Side width 3.7 cm. Center thickness 2.4 cm. Side thickness 0.4 cm. Color originally blue-green stained to a chicken-bone white with some cinnabar.
Western Han ornamental jade
Guangdong province, Guangzhou city, Xianggang, Tomb of the Nanyue King
Museum of the Mausoleum of the Nanyue King

The jades used in antiquity to decorate bronze and iron swords were known as jade sword furniture and a set usually consisted of pommel, guard, blade and scabbard chape. Complete sets of jade sword furniture started in the Western Han period. The sword guard is a decorative fitting on the body of the sword. Because of its shape and size and its lack of tactile quality not many have been handed down. The form and decoration of jade sword furniture of the Western Han period is relatively developed and fixed, the style of its forms and decoration continuing into the Eastern Han period though not many examples have been excavated. Although jade sword furniture from the Six Dynasties has been discovered it had already deteriorated.

This sword guard has a raised central ridge, the face of an animal below with the ridge forming the symmetrical bridge of the nose. Two symmetrical open-work sculpting phoenixes stand at either side. The phoenix of ancient legend flew in search of peace and prosperity thus, making it an auspicious bird. In addition, it symbolized imperial power in ancient China.

The exquisite workmanship of this piece demonstrates the technical and artistic summit of Han period jade manufacture.

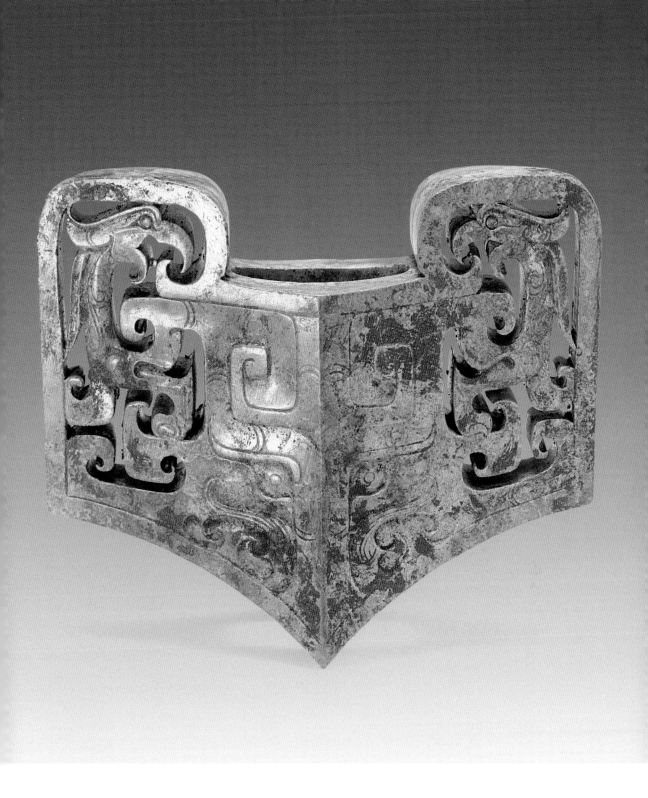

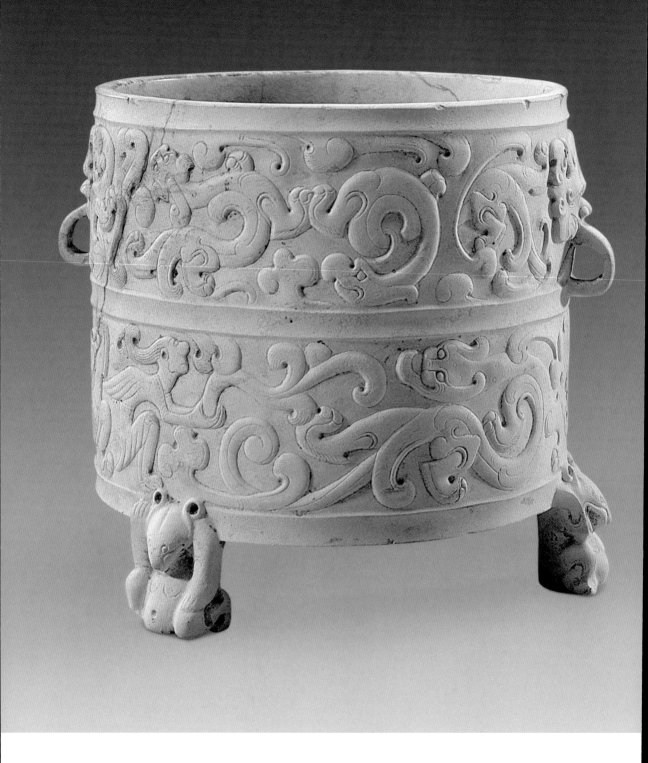

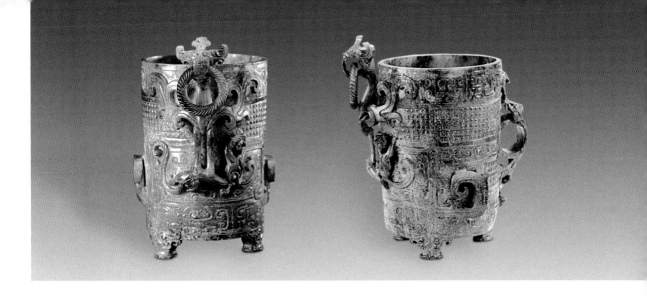

▲ Jade Goblet (*zhi*) with a Decoration of the Vermilion Bird with a Ring in Its Beak Trampling a Tiger

Overall height 13.1 cm. Rim of goblet height 9.8 cm. Lip diameter 7.91 cm. Base diameter 7.4 cm. Wall thickness 0.3 cm. Height of feet 1.2 cm. Color white with some yellow and black/brown staining.
Western Han jade vessel
Anhui province, Chaohu city, Beishantou, Western Han tomb
Chaohu City Museum

The goblet (*zhi*) was a widely used drinking vessel during the Zhou, Qin, Han and Jin periods. Most goblets of value are made of jade and the principal characteristics are the straight wall and round cup. The belly is comparatively deep, generally with ring-shaped ears and three feet at the most, with or without lid and a capacity less than that of bronze or lacquer goblets. Han period goblets are comparatively common, delicately decorated and of complicated handiwork and unique form. Jade goblets of the Six Dynasties follow those of the Han period with only limited changes in the style of minor decoration.

One side of this goblet is decorated with a high relief carving of the vermilion bird with a ring in its beak trampling a tiger. The head of the bird extends away from the lip of the goblet, its beak holding a moveable ring decorated with a twisted thread pattern. Its feathered wings are stretched back and its claws grasp a tiger. The other side of the goblet has an ear-shaped handle decorated with a bear pattern. The other two sides are decorated with a modified feather pattern. The whole surface of the goblet is decorated with hooked grain and cloud patterns. The base has three feet and is decorated with rhomboid geometrical patterns and a reverse hook cirrus cloud pattern as well as a lattice decoration.

◀ Jade Wine Jar (*zun*) with a Pattern of Immortals Dragons and Animals

Overall height 10.5 cm. Diameter at mouth 10.5 cm. Height of feet 2.0 cm. The piece has been turned a chicken bone color by serious water seepage. There is one crack.
Western Jin jade vessel
Hunan province, Anxiang county, Huangshantou, Tomb of Liu Hong
Anxiang Cultural Relics Management Bureau

Shaped as a cylinder with a straight mouth and three feet in the form of bears. The sides of the vessel are decorated with two panels, the upper consisting of immortals, hornless dragons, tigers, clouds and dragons, and the lower of immortals, dragons, tigers and bears. The design is complicated and rich in variety.

▼ Twisted Thread Pattern Jade Ring

Diameter 5.1 cm. Diameter of hole 2.6 cm. Thickness 0.2 cm. Color white, with some staining.
Western Han ornamental jade
Jiangsu province, Yizheng city, Zhangji, Miaoshancun, Zhaozhuang Western Han tomb
Yizheng City Museum

Both surfaces of the ring are closely carved with a slanting twisted cord pattern; both the pattern and ground are polished, the edge slightly thin. This type of jade is frequently found in the Warring States and Western Han periods.

Illustration	Name	Characteristics
	Rush	A decoration on jade ornaments from the Warring States to the Han periods, in the style of the rush matting used in antiquity. Three parallel crossed lines separate the pattern into a series of small hexagonal panels causing the center to form a naturally raised flat hexagon that does not protrude beyond the surface of the piece. There is a triangular pattern between each hexagon. Usually found on jade discs (*bi*) and rings (*huan*).
	Rush square whirlpool	The incision with a rotary tool of an additional whirlpool pattern panels within the hexagonal rush pattern. The surface remaining level. Found on jade discs (*bi*) and arc-shaped pendants (*huang*).
	Hornless dragon (*chi*)	During the Han period, this pattern generally took two forms: one in which the dragon's head resembled that of a tiger, and thus known as hornless dragon and tiger (*chihu*) pattern, with a nearly square or trapezoid face, flat mouth, round or near round eyes, straight or pug nose and the eye brows formed by incised single or double lines. Frequently found on jade sword furniture, extended-edge discs (*chukuobi*) and all types of pendant. A further form of this pattern has a sharp mouth and ears, round eyes and a sinuous body. Found mostly on Han and Six Dynasties jade utensils and pendants.
	Cirrus cloud	Apart from the geometrical hooked cloud pattern, there are a number of cirrus cloud patterns in the form of a curled whirlpool, some resembling billowing clouds, some raised, some flat. Found on sword pommels, decorated belts on utensils and pendant ornaments.

Illustration	Name	Characteristics
	Nipple	Evenly arranged nipple shaped decoration, no incised outline or whirlpool. Commonly found on jade discs.
	Phoenix	In this pattern the phoenix has a relatively long body, hooked beak, tall crest either raised or feathered back. Eyes either round or almond shaped. Generally either with the head turned or raised to the front. Common in ornaments and the decoration of vessels.
	Dragon	In this period the dragon pattern can be broadly divided into two: one type with the dragon's head in profile, with slightly protuberant almond eyes and some lightly incised circular lines around the eyeball, and a double-bladed upper eyelid found in the Early Western Han period. The tail is decorated with a twisted thread pattern or divided into multiple tails and becoming more graphic. This type of pattern is commonly found on all types of jade pendants.

The other type of pattern is a frontal view form of a double-bodied dragon with a single head. The face resembles that of a fierce animal with slightly rounded eyes, two claws pressed into the ground, the bodies curled to left and right and mostly found on jade discs decorated with a pattern of one or two one-legged dragons (*kuilong*). |

5. Sui, Tang, Song, Liao, Jin and Yuan Dynasties

Beginning with the Sui and Tang periods, the types and artistic styles of jade gradually abandoned the mysterious and developed towards the secular. Moreover, the custom of using jade as burial items was no longer prevalent. Jades of this period that are seen nowadays are, for the most part, pendants, belt ornaments and utensils. Their principal characteristic is one of realism. In addition, the number of Sui and Tang jades that have been handed down is comparatively large. From examples that have been handed down or excavated it can be seen that the standard of jade manufacture during the Sui and Tang period was very high and that the technical skills of incision, relief, open-work carving, sculpting and polishing were highly developed. The images they produced were vivid, natural and fluent in line. The jade selected for carving was usually flawless pure white mutton fat jade which lent a rich splendor to each piece.

During the Song dynasty the habit of the use of jade was not confined to the ruling classes, but was acquired by all classes of society and gradually became commercialized. There is an increase in exquisitely carved and strongly realistic openwork pieces that have birds, animals, flowers and grasses as their subject. Excavated Song pieces include recumbent deer, discs, boxes, bracelets, hairpins, coins, seals and rings. Transmitted pieces include in the main, statues of the Buddha, incense burners patterned with designs of animal ears and clouds, deer-patterned octagonal cups, pendants decorated with birds, flowers and grasses, and other human figurines of which vividly shaped, carved jade figures of children

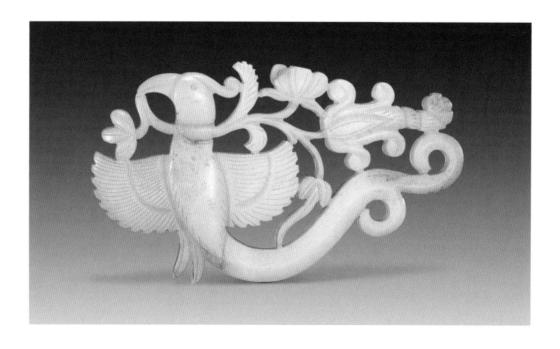

are predominant.

In the history of the development of jade manufacture in China the Yuan period formed an important bridge between past and future and marked the establishment of a special organization to manage the manufacture of jade. Excavated Yuan jades include ear-handled lidded vases, belts, belt hooks, hairpins and brush washers. Transmitted jades include raised-character seals (*longniujia*), jade paperweights in the shape of a herdsman and his horse (*mumazhen*), dragon-patterned beakers with moveable rings and others.

The jades of the Liao and Jin dynasties display the animals and plants of the natural world, infused with the spirit of the wild. Liao jades include utensil-shaped pendants, and pendants in the form of dragons, phoenix and fish pierced for a gold chain. There are also ink-stones and water holders (*shuiyu*) as well as Khitan ceremonial belt plaques. Jin dynasty jades include

flower petals, flower petal garlands, bamboo sprays, cranes with grass in their beaks, and peacock-shaped ornaments, all carefully symmetrically designed.

▲ Jade Brush Washer Decorated with a Pattern of Deer

Height 6.4 cm. Diameter 10.7 – 14.5 cm. Color white, with a dark brown older color, partial black/brown staining caused by fire.
Song dynasty jade vessel
Palace Museum, Beijing

Oval shaped, inner base carved in relief with a pattern of 11 billowing clouds. The outer rim carved with a landscape pattern, the bowl carved in bas-relief with deer of different shapes with *lingzhi* fungus in their mouths, moving amongst clouds.

◀ Jade Pendant Decorated with a Bird Holding a Flower in Its Beak

Length 7.6 cm. Width 3.8 cm. Thickness 0.8 cm. Color blue-green, with some brown staining.
Tang dynasty ornamental jade
Palace Museum, Beijing

Flat carved jade showing an Asian paradise-flycatcher with a flower in its beak, with the detail finely carved. The bird in flying posture with wings outstretched. The edges of the wings are serrated with feathers carved between each serration.

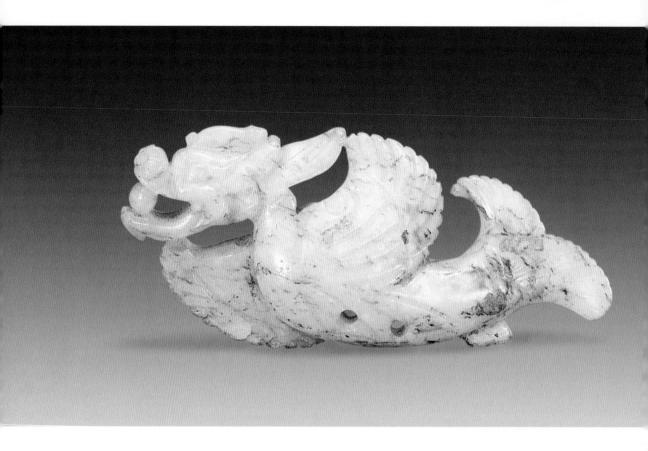

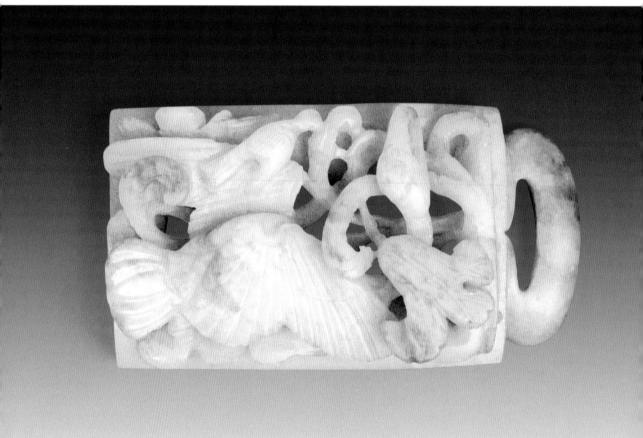

◀ Jade Pendant in the Shape of a Sea Serpent

Length 6.9 cm. Width 3 cm. Color white with some partial yellow staining.
Liao dynasty ornamental jade
Palace Museum, Beijing

Oblong shaped, this pendant is carved with a fish with a dragon's head and the tail of a flying fish and called a "sea serpent" (*yulong*). It has a jewel in its mouth and wings on either side of the body stretched in flight. The caudal fin is split and raised. Wings and fin decorated with a carved pattern. The sea serpent shape was common during the Liao and Jin dynasties.

▶ Jade Bowl with Lotus Pattern

Height 6.5 cm. Diameter at mouth 7.9 cm. Diameter at foot 4.45 cm. Color white with horizontal cracks and patches of brown staining.
Tang dynasty jade vessel
Palace Museum, Beijing

Round mouth with an incised string of pearl decoration at the edges. The body has a hidden pattern of double tiered lotus leaves. The foot splays outwards but is slightly concave at the center.

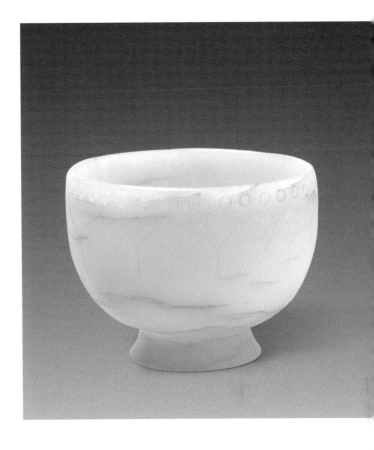

◀ "Spring Water" Jade Belt Item

Length 8.3 cm. Width 7.5 cm. Thickness 2.4 cm. Color white, with partial traces of red/brown.
Jin dynasty ceremonial jade
Palace Museum, Beijing

Oblong shaped, the surface is carved with a representation of a falcon catching a goose, known as "spring water." The plump goose keeps to the water, its necked curved beneath a lotus bloom while the falcon swoops towards its head. The underneath has a ring from which pendants may be hung. The side has a horizontal slot through which a belt may be threaded.

▼ The Dushan Sea of Jade

Height 62 cm. Diameter 150 cm. Circumference 493 cm. Color black with white blemishes.
Yuan dynasty jade vessel
Beijing, Beihai Park Management Office

3,500 kg in weight, this huge jade wine vessel, known as a *yuweng* is oval in shape and decorated in relief with serpents and other sea monsters disporting themselves amongst waves and cliffs. The inner wall is ground smooth. Because the jade was quarried in Dushan it is known as the Dushan sea of jade.

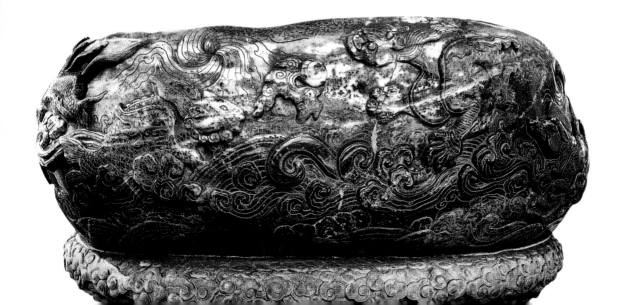

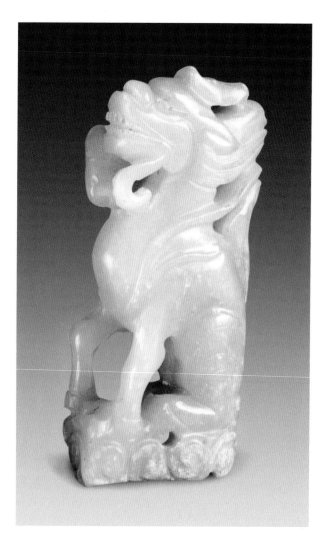

◀ Jade Pendant in the Form of a Beast with a Single Horn

Height 7.0 cm. Width 3.0 cm. Color blue-green with some white staining.
Song dynasty ornamental jade
Shanghai, Songjiang district, Xilinta underground palace
Shanghai Cultural Relics Management Committee

The single-horned beast squats with head raised and chest thrust out. Its round eyes bulge slightly beneath coarse eyebrows. The nose is high and the mouth, which holds a *lingzhi* fungus, is open displaying the teeth. The thick hair floats backwards, there are wings at the shoulders and the tail is curled upwards. The left foreleg stands straight while the right is slightly bent. The back legs are as if sitting and the whole body is covered with an incised pattern of cirrus clouds. A "heaven to earth hole" (*tiandikong*) is pierced from the head through to the base of the piece and there is a horizontal hole through the legs. The style of the fine line carving of the body hair and mane of the beast is characteristic of the Song dynasty.

▼ Jade Bowl with a Pattern of Clouds

Height 5.7 cm. Width 19.9 cm. Color blue-green/white, some yellow/brown staining.
Tang dynasty jade vessel
Palace Museum, Beijing

The body of the bowl is covered with a pattern of cirrus clouds in bas-relief. The mouth of the bowl is oval and the base is flat. The interior is plain and undecorated. The handle is carved with an open-work cloud. In Chinese, "cloud" is a homophone of "luck." Thus clouds represents a desirable destiny that symbolises a yearning for luck and fortune.

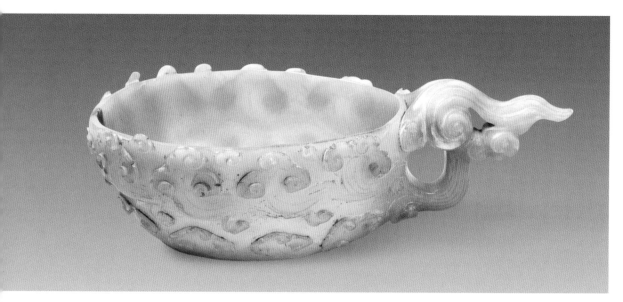

Decorative Motifs of Sui, Tang, Song, Liao, Jin and Yuan Dynasties

Illustration	Name	Characteristics
	Barbarian entertainer	A Tang dynasty decoration on jade. The representations divide into two groups. The first consists of barbarians (*huren*) sitting cross legged, either playing instruments or singing; the second of barbarians dancing on a round carpet. Frequently found on jade belts.
	Cloud	A Tang and Song decoration. There are two kinds of cloud pattern in the Tang dynasty, the first where the cloud-head looks like the character 凸 with a wispy tail; the second where the shape is like the character 品 with the same kind of tail. 　The Song dynasty cloud pattern takes three forms, the first with its tail like the letter S and either with a serrated cloud-head or curled to either side; the second with *lingzhi* fungus shaped clouds sometimes with serrated edges; the third without a tail and with vertically drooping billows. Frequently found on belt decorations.
	Dragon	A decoration from the Tang to the Yuan dynasties. The dragon has a long thin head, a thin, pointed upper jaw, with lips slightly drawn back, long eyes, streaming hair and body covered in a lattice of scales. The dragon is usually surrounded by a ground pattern of clouds, and flowers and grasses. Frequently seen on pendants and jade vessels.

Illustration	Name	Characteristics
	Bird	A Tang and Song decoration. Tang birds have three-cornered eyes, short wings, the wing tips either raised forward or along the back, and the wings decorated with a fine incised pattern and the tail arranged like flower leaves. Song dynasty bird patterns frequently show an Asian paradise-flycatcher with a flower in its beak, wild geese or peacocks. The paradise-flycatcher's eyes are either incised, three-cornered, or round. Wings are most frequently found with one extended and one folded. The wild geese have slender necks, raised heads and extended wings slightly curved rearwards with incised lines at the back and front edges to represent feathers. The peacocks have incised eyes and just a few tail feathers, the eyes on the feathers being represented by semi-circular cavities edged with fine incised lines. Incised lines on the wings represent feathers. Frequently seen on pendants and jade vessels.
	Phoenix	A decoration from the Tang to the Yuan dynasties. Short, blunt beak and crested head. Wings outstretched. Graceful tail feathers, with the tip divided into three. Two claws close to the body. The phoenix is usually surrounded by a ground pattern of clouds, and flowers and grasses. Frequently seen on pendants and jade vessels.
	Lion	A decoration from the Tang to the Yuan dynasties. Carved by incision and picked bas-relief with designs of lions in various poses. Often seen on jade belts.
	Hornless dragon	A Song and Yuan dynasty ornament. In the Song dynasty the head of the dragon was either narrow or broad with the eyes, nose, and mouth in the middle of the head, the mouth thrust forward and the cylindrical ears sometimes bent forward, often with an incised spiral pattern on the ear. The neck is long and narrow and there is a tangle of hair at the back of the head that may be horns. There is an incised spiral pattern on the elbows or buttocks. The Yuan dynasty dragon has a long thin neck, shoulders in the shape of the character 人 and ribs on either side in the shape of the character 二. Ears are sometimes round and sometimes shaped like a disc with a depression at its center. Frequently seen on pendants and jade vessels.

Illustration	Name	Characteristics
	Blossom and petal	A decoration from the Tang to the Yuan dynasties. Tang petal patterns include crab-apple, pomegranate, peony, honeysuckle, scroll patterns, lotus and wild chrysanthemum. Some blossoms are circular with concave centers and the edges decorated with short incisions, the stamen peach shaped. Some are oval and decorated with a mesh pattern, others triangular with a pattern of fine incisions. Petals are mainly pointed and presented as an overlapping pattern of the character 人. There is usually a conical stalk at the center edged with short fine incisions. Song and Yuan dynasty flower and grass patterns include lotus, peony, flower spray patterns, trumpet vine, *tuanhua* shrub (Chinese group flower), *lingzhi* fungus, bamboo, creepers, lily, pomegranate and cherry. The patterns can be divided into large and small styles. The large style is relatively thick and with little alteration in hierarchy. Small flowers are delicately carved with overlapping leaves in a hierarchy. Eight-petalled flower sprays and the five-petalled flowers of the *tuanhua* shrub present a concave spherical shape while the larger lily petals are usually raised. Lotus leaves are large, ribbed and veined. Frequently seen on pendants and jade vessels.
	"Spring water" design	Liao, Jin and Yuan dynasty decoration. Subjects are usually geese, falcons and herons against a background of lotus and lotus blossoms, water weed and arrowhead. The design usually shows a goose amidst waterweed with a falcon pecking at its breast. Found on pendants, belts and incense burner lids.
	"Autumn hill" design	Liao, Jin and Yuan dynasty decoration. Design usually includes tigers and deer against a background of rocks and oak trees. Frequently found on pendants, belts and incense burner lids.
	Barbarian lion trainer	Yuan dynasty decoration. The design usually depicts barbarians with deep eyes and high noses wearing tall caps, short-sleeved jackets and long boots, taming a lion. The lions are in different poses on a ground pattern of plants or clouds. Frequently found on jade belt plaques.

6. Ming and Qing Dynasties

The Ming and Qing dynasties were the greatest period in the development of Chinese jade. There was a rich abundance of jade forms during the Ming dynasty and the scope of its use broadened to include items for the court and for the scholar's studio, household utensils, decorations on clothing and hair ornaments, jades for appreciation and archaistic pieces. Motifs on Ming dynasty jades were mostly selected from particularly auspicious examples of flowers and grass, animals, lucky designs and depictions of sages. In particular, there are frequent examples of designs of auspicious animals such as dragons, phoenix, deer, and unicorns (*qilin*) as well as lotus flowers, peonies, *lingzhi* fungus, pine trees and prunus.

Jade was widely used during the Qing dynasty. Its use extended from the emperor and the imperial concubines, through the nobility and officials to the common people. The scope of examples extended from the symbols of imperial power such as the imperial seal and the sacrificial vessels used in the worship of gods and ancestors to ordinary utensils and clothing decorations and women's hairpins. There were also jades with more than one use. The commonest Qing jades are court jades, jades used in daily life, items for the scholar's studio, display pieces and pendants. The choice of decoration is also wide-ranging and covers four main areas:

realistic designs of auspicious plants, people and animals; abstract designs of auspicious plants and animals and geometric patterns; pictorial designs of landscapes, buildings and fairy tales; and jade pieces bearing a poem or inscription in the hand of Emperor Qianlong.

▶ Jade Bowl with Gold Lid and Tray

Height 7 cm. Diameter at mouth 15.2 cm. Diameter at foot 5.9 cm. Color white.
Late Ming utensil
Beijing, Changping district, Ming Dynasty Tombs (*Ming Shisanling*), Dingling tomb
Dingling Tomb Museum, Beijing

Round, wide-mouthed bowl with a gently curved belly and circular foot. The surface is undecorated. It has a gold, dragon pattern openwork lid and a gold tray with a pattern of two dragons playing with a pearl. "A dragon frolicking with a pearl" is a traditional pattern, demonstrating cheerfulness. The jade matches the gold and exudes the imposing style of the imperial house.

▶ Chrysanthemum Petal Bowl

Height 6.3 cm. Diameter at mouth 22.5 cm. Diameter at foot 13.9 cm. Color dark green.
Mid-Qing utensil
Palace Museum, Beijing

Jade bowls from the Ming and Qing periods are comparatively common. Of fine quality design and patterning they are mainly for court use. This bowl is round and the walls carved vertically to represent chrysanthemum petals. Scholars in China have often used particular plants to subtly express their aspirations. Traditionally, chrysanthemums symbolize aloofness and pride.

The bottom of the bowl is ornamented with a triple chrysanthemum petal pattern with the stamen at the center. The foot is decorated with a chrysanthemum pattern. The wall of the bowl is extremely thin and carved with chrysanthemum petals in delicate convex/concave relief, demonstrating a high level of skill. The bowl represents the art of jade manufacture during the Qing dynasty.

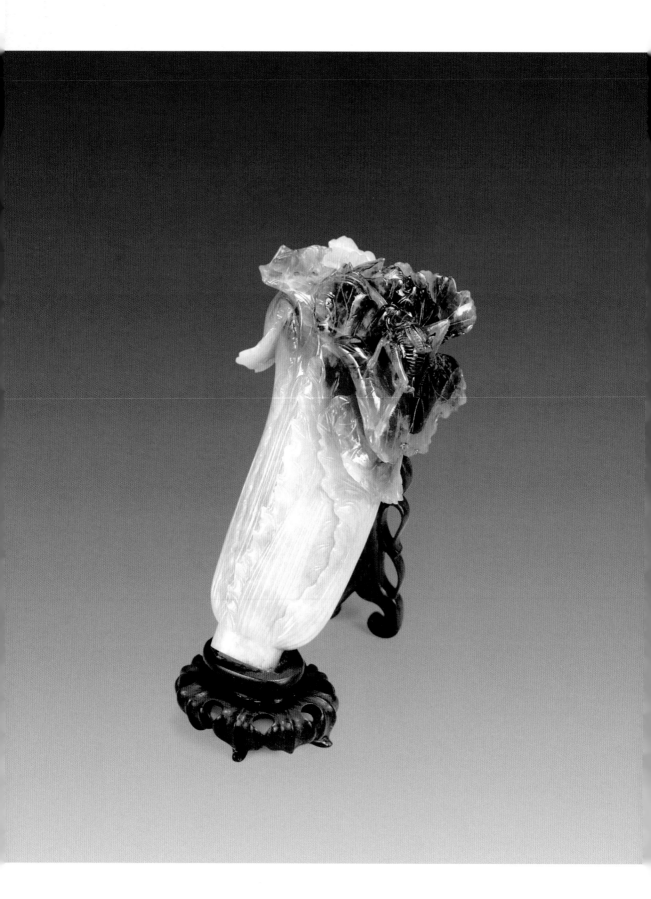

▶ Jade Snuff Bottle in the Shape of a Gourd

Overall height 6.4 cm. Diameter at mouth 0.8 cm.
Color white, a jade pebble with an area of yellow/brown skin.
Qing dynasty item for daily use
Palace Museum, Beijing

Snuff was introduced to China from the West during the Ming dynasty. Bottles made specially for containing snuff were first produced during the reign of Emperor Kangxi of the Qing dynasty. Under the inspiration of the emperor, the various workshops controlled by the Qing palace office of works and supply (*zaobanchu*), the kilns controlled by the court at Jingdezhen, and the jade workshops in Suzhou and Yangzhou produced snuff bottles of all kinds. Snuff bottle production reached its peak during the reign of Qianlong and declined after the reign of Jiaqing but snuff bottles, of which those of jade were an important component, were still in production as an art form up until the Republic.

Following the contours of the jade pebble, this bottle is carved into the shape of a gourd with ten segments. The wall of the bottle is decorated with leaves and stems, two of the leaves being carved from the yellow/brown skin and there is a trace of the skin color on the bottom of the bottle. The stopper is ingeniously designed and carved to the shape of a small gourd with an ivory spoon attached. Large gourds were once called *gua* (gourd) and the small *die* (melon) and the phrase "*gua die mian mian*"—"a succession of gourds and melons" implied flourishing sons and grandsons.

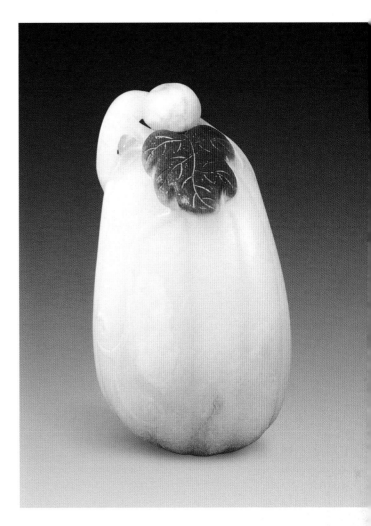

◀ Jadeite (*feicui*) Jade Cabbage

Height 18.7 cm. Jadeite, white, green and red occurring naturally.
Mid-Qing dynasty display jade for a study
Palace Museum, Taipei

The carver has exploited alterations in the color and luster of the material to produce the very embodiment of a cabbage. The white forms the body of the cabbage with delicate leafstalks showing clear veining. The emerald green forms the naturally curled fresh cabbage leaves. A splash of red on the side of the cabbage is used to carve a grasshopper at rest. Originally displayed in the Yonghe Palace of the Forbidden City it was part of the dowry of the Empress Longyu, consort of the Emperor Guangxu. It is one of the finest jadeite examples of the use of color (*qiaose*) of the Qing dynasty.

▶ Jade Brush Washer in the Form of a Peach

Height 6.1 cm. Diameter at mouth 9.5 – 10.3 cm.
Color blue-green/gray, some yellow/brown staining.
Ming dynasty desk furniture for the scholar's studio
Palace Museum, Beijing

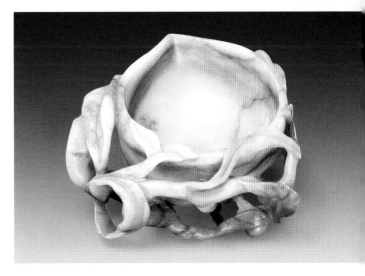

The piece appears as half an opened peach which symbolizes longevity and good fortune. The outer wall is carved into an open-work twist of stems and leaves that form the handle and foot of the piece.

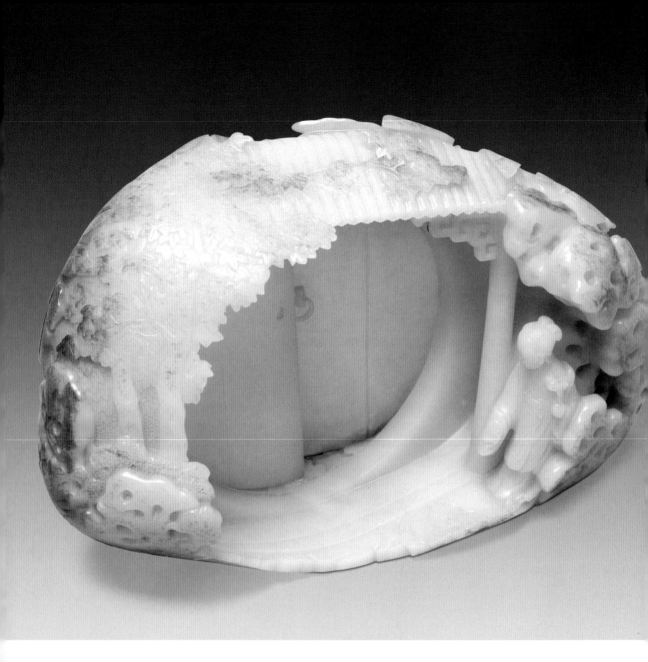

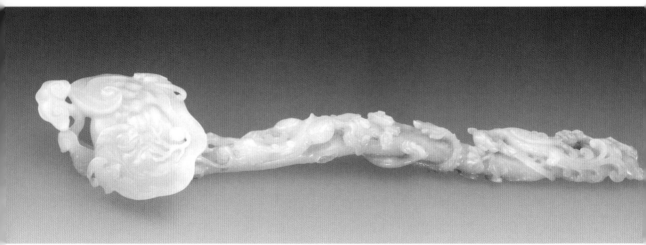

◀▶ Jade Landscape "A Beauty in the Shade of a Tung Tree"

Height 15.5 cm. Length 25 cm. Width 10.8 cm. Color white, carved from the outer skin of a pebble of white jade. The surface displays a large area of orange/yellow skin.
Mid-Qing dynasty display jade
Palace Museum, Beijing

The jade landscape was a fashionable display piece during the Qing dynasty. It generally took paintings as a model from which to carve landscapes and figures and achieved some fame as a type of three dimensional painting.
The subject of this scene in jade is a circular doorway with a door pillar and tiled eaves in the shade of a tung tree. One leaf of the door is closed and the other slightly ajar. There are two girls peeping at each other through the doorway, one girl holding a flower, and the other with an offering held in both hands. On either side of the doorway, tung trees, pond stones and banana trees have been carved to take advantage of the jade skin color to represent the elegant courtyard scenery of southern China.

◀ Jade *Ruyi* in the Form of a *Lingzhi* Fungus

Length 38.8 cm. Color blue-green.
Mid-Qing dynasty display jade
Palace Museum, Beijing

During the Ming and Qing period the *ruyi* became a display piece that symbolized good fortune. At the Qing court, the nobility and ministers were all expected to present these *ruyi*s as offerings on the birthday of the emperor or empress or at major ceremonies. *Ruyi* carries the allegorical connotation, "As one would wish." Nine (*jiu*) boxes of nine *ruyi*s were sometimes presented, symbolizing the homophonic 久久 (*jiujiu*, everlasting) and *ruyi*—"As one would wish forever."

This *ruyi* is in the shape of a *lingzhi* fungus which can prolong life, its head carved in relief with two bats and a flaming pearl, and a small open-work sculpting *lingzhi* fungus on the outside. The stem of the *ruyi* is carved in high relief and partial open-work relief with a pattern of clouds and dragons playing with pearls, cinnabar phoenix and *lingzhi* fungus and flowers. Cloud dragons also curl realistically around the top and bottom of the stem.

Decorative Motifs of Ming and Qing Dynasties

Illustration	Name	Characteristics
	Fortune, wealth and longevity	Auspicious symbolic Ming dynasty decoration. The center of the design has three venerable old men symbolizing Fortune, Wealth and Longevity. Beneath are two children and the auspicious animals, deer and red-crowned crane, as well as gourds and auspicious cloud patterns. Used on vessels, display pieces and ornaments.
	Two dragons playing with a pearl	Mid-Ming dynasty decoration. A dragon on either side playing with a flaming pearl in the center and surrounded by a circle of auspicious clouds. One dragon in the ascendant the other beneath. Mainly used on ornamental jade tablets, also seen on vessels and ornaments.
	Double phoenixes	Qing dynasty decoration. Two phoenixes opposite each other each holding a *lingzhi* fungus in their beak with drooping wings and tail, the tail feathers curled with a foot placed on the tail. Frequently seen on jade pendants and jade vessels.
	Double bats and gourd	Qing dynasty decoration. A flat narrow-waisted gourd (*hulu*) with the top carved with open-work relief vine tendrils which droop down over the gourd and spread over four smaller gourds. There are also two bats carved in relief on the surface of the gourd. 葫芦 (*hulu*, gourd) is a near homophone of 福禄 (*fulu*, fortune and wealth). The spreading vine tendrils also symbolize prosperous generations of sons and grandsons.\n This pattern is extremely common and frequently seen carved in bas-relief on jade vessels, display pieces and pendants.
	Pine and crane	Qing dynasty decoration. The red-crowned crane symbolizes longevity. Pine and crane in partnership express the theme of "pine and crane together lengthen the years." A cylindrical shaped piece of jade may be carved along its contours to represent a pine trunk and the center hollowed out to form a brush pot with the walls decorated with a pattern of pine and crane in high relief.\n This pattern is frequently carved on jade vessels used in the study or on screens.

Illustration	Name	Characteristics
	Eight jewels	Qing dynasty decoration. A decorative design that uses the eight Buddhist jewels: the conch shell, the wheel of the law, the sacred umbrella, the white canopy, the lotus blossom, the sacred vase, the goldfish and the endless knot. Commonly known as the eight signs of good luck. Usually incised or carved in bas-relief on pendants and jade vessels.
	Rosette	Qing dynasty decoration. A circular platform is carved from the jade by reducing the ground and each rosette is carved in bas-relief with an auspicious design of butterflies on a gourd, gourds, grapes, Buddha's finger (Citrus medica), lotus blossom, auspicious peach (*futao*) and pomegranates interspersed with bats holding chimes (*qing*) or patterns of "卍" in their mouths together with the characters 寿 (*shou*, longevity) and 喜 (*xi*, joy). Used on pendants and jade vessels made for display.
	Belladonna and reed	Mid-Qing decoration on Mughal jades. A continuous line of belladonna in profile. In the center of each belladonna there is an open blossom and two unopened buds, on either side there is a blossom inclined to the center. The neighboring plants are bound together and the space between carved with smaller belladonna. The combination of bas-relief with the technique of hollowing out is a particular characteristic of the decoration of Mughal jades. A decoration usually found on the outside of round jades.
	Gold inlaid stones, flowers and grasses	Mid-Qing decoration on Mughal jades. The center is inlaid with a pattern of grasses in gold leaf surrounded by a pattern of flowers. The flower blossoms are formed from an inlay of 180 red gemstones.

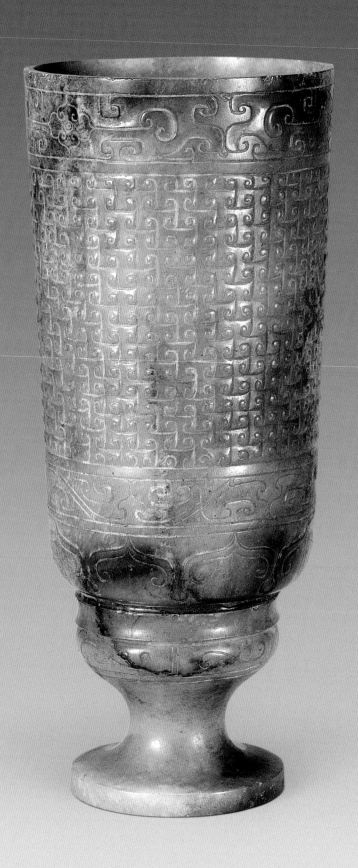

CHAPTER FOUR
THE PRINCIPAL FORMS, USES AND SUBJECTS OF JADE

China, as a country pre-eminent in the production and manufacture of jade, also has one of the most extensive histories of jade use. The ancient jade with various principal forms were used as ornaments, tools, utensils, vessels, sacrifice and display objects, etc.

On the basis of historical records and archaeological material the uses of jade can probably be divided into:

Ceremonial: as symbols of authority and rank; mainly tablets (*gui*) and discs (*bi*).

Sacrificial: used in sacrifices to heaven and earth and the four directions, ancestors, sun, moon and stars, hills and rivers; e.g. discs and squared tubes (*cong*).

◄ Hook and Whirlpool Pattern Jade Cup

Height 14.5 cm. Diameter at mouth 6.4 cm. Diameter at foot 4.5 cm. Ccolor blue-green with partial brown staining.
Qin dynasty jade vessel.
Shaanxi province, Xi'an western suburbs, Dongzhangcun, E'pang palace site of Qin dynasty
Xi'an Institute of Archaeology and Cultural Relics Preservation

Shaped as an upright cylinder with a deep slightly tapering body. Carved in three levels with persimmon stems and geometrical joined hook patterns at the top, in the middle with a regular pattern of hooked whirlpools and a pattern of shallow relief *ruyi* clouds at the bottom. The foot is in the form of a narrow waisted drum carved in incised outline at the top with a circle of five panels of S pattern. The base is plain. The patterning of the whole piece is of meticulous beauty.

Funerary: used at funerals and in burials.

Pendant: as a pendant on the body; e.g. discs, rings (*huan*), arc-shaped pendants (*huang*).

Military: as authority for the deployment of troops and dispatch of commanders and symbol of power; e.g. toothed ritual blade (*yazhang*) and tiger emblem (*hufu*).

Protocol: used in diplomatic ceremonies; e.g. tablets (*gui*).

Inlay: as a jade inlay to other objects.

Musical: played as a percussion instrument; e.g. jade chimes (*qing*) and hatchet shaped jade or notched disc (*qi*).

Over the course of the several thousand years, Chinese ancient jades also fall into various subjects, displaying the Chinese love of jade. Among them, this chapter presents you jades in the shape of animals, the human form, the ancient bronze style and Mughal style.

1. Jade Disc (*bi*)

The disc is a flat circular object with a hole in the middle. Jade discs are the earliest ceremonial objects to appear and have the longest usage.

During the Neolithic period jade discs were mostly used to accompany

burials or in sacrifices and reflect a primitive religious consciousness. These discs lack decoration and there is no common form either in size or in the number that accompany burials.

During the period from the Shang to the Western Zhou dynasty jade discs, as ritual items, became the preserve of the nobility. Shang discs are mostly plain and undecorated, though some individual discs have a number of incised concentric patterns on the surface. Early Western Zhou jades are generally plain with some irregularities to the edge. The discs are thick at the center and thin at the edge; late period discs display incised patterns of curled dragons, phoenix, and clouds, with the frequent use of thick and thin lines in a combination of raised and incised decoration. The Western Zhou first set the fashion for the use of decorated jades as ornaments.

Jade discs were most extensively used during the period of the Spring and Autumn Annals and Warring States. Jades not only played an important role in rites and ceremonies but were much

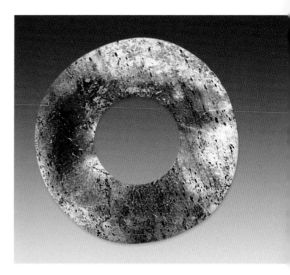

▲ Jade Disc

Diameter 16.6 cm. Diameter of hole 6.7 cm. Thickness 0.5 cm. Color blue-green with some partial white staining.
Miaodigou 2nd period culture ritual jade
Shanxi province, Ruicheng county, Qingliang temple, Tomb No. 30
Shanxi Provincial Institute of Archaeology

The Miaodigou 2nd period culture of 5,000 – 4,400 years ago is part of the Neolithic archaeology of the central China region and is centered on southern Shanxi province. The surface of this jade is flat and smooth, with the hole drilled from both sides, traces of the drill clearly visible. The edge has straight and curved irregularities.

Irregular edges are a characteristic of the prehistoric jade discs of the southern Shanxi area.

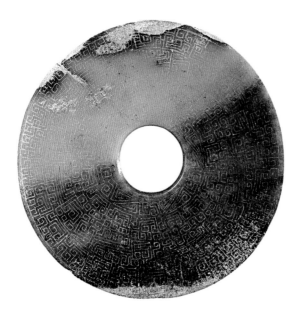

◀ Dragon Pattern Jade Disc

Diameter 29.7 cm. Diameter of hole 5.9 cm. Color black/green, some grey/white staining.
Late Spring and Autumn period ritual jade
Shaanxi province, Fengxiang county, Majiazhuang No. 1 building complex site
Baoji City Museum of Bronzes

This is the largest and most elaborately decorated Spring and Autumn jade disc so far discovered. The disc is not of a uniform thickness, both sides are carved with a slanting triangular coiled decoration of dragons with body and tail formed from a hooked cloud pattern, two dragons to a section, head and tail overlapping with a rope pattern either side of each curled dragon. From outside to center, the first and second coils each consist of nine sections totaling 18 dragon patterns, the third with five sections totaling 10 patterns, the fourth with three sections totaling six patterns. Each side of the disc contains 52 dragon patterns, a total of 104 in all.

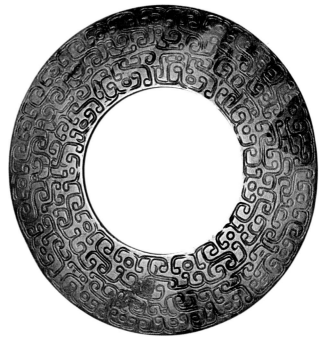

used as ornaments, with an increase in the variety of forms. Generally, ritual jades are comparatively large and regular in shape; jade discs used as pendants were smaller and often used together with other jade ornaments. Apart from circular discs there are also magnificent oval and round-cornered examples.

From the period of the late Warring States onwards jade discs became a funerary item and part of the accoutrements of the deceased, being placed on the chest or at the back of the corpse. Jade discs of this sort were mainly decorated with designs of animal heads, a fierce animal probably being intended to ward off demons and ill luck.

The development of jade discs into the Han dynasty reached its historical peak in form, decoration and handicraft skills. A relatively large number of Han ornamental discs have been excavated displaying a multiplicity of changes in shape and decoration. These, generally relatively small discs were used as pendants, and apart from the normal grain, whirlpool, and rush patterns also included open-work carved discs. There is also a series of large discs used as funerary objects and ornamented with a one-legged dragon (*kuilong*) pattern. There is a small number of comparatively large discs of fine workmanship which having been used in life were buried with the occupant of a tomb. In addition, a large number of extended-edge discs (*chukuobi*) have been discovered. They fall into three types: internally extended, externally extended, and both internally and externally extended. The decorations of the extension are more often patterns of dragons, hornless dragon and tiger (*chihu*) and phoenix. During the Eastern Han dynasty, discs with auspicious inscriptions such as "a wealth of sons and grandsons" (*yizisun,* 宜子孙) , "profit and long life" (*yishou,* 益寿) and "joy forever" (*changle,* 长乐) were popular.

There was a gradual decline in the use of jade discs after the Han dynasty and apart from their use in the sacrifices and ceremonies of dynastic royal houses they were rarely seen. During the Ming and Qing dynasties the form of jade discs imitated the ancient, those which imitated the grain and hornless dragon patterns being in the majority.

▲ Coiled Snake Pattern Jade Disc

Diameter 11.6 cm. Diameter of hole 6 cm. Thickness 0.2 – 0.3 cm. Color yellow/brown with some black staining.
Early Spring and Autumn period ornamental jade
Henan province, Guangshan county, Baoxiang Temple, Tomb of Huang Junmeng and consort
Henan Museum

One side of the disc is incised with an elaborate coiled snake pattern; the other is plain.

▶ Dragon Pattern Jade Disc

Diameter 24.5 cm. Diameter of hole 4.0 cm. Thickness 0.7 cm. Color blue-green.
Western Han funerary jade
Anhui province, Tianchang city, Anle Beigang tomb complex
Tianchang City Museum

Each side of this disc bears the same decoration. A central rope divides the pattern into two with a rush pattern in the inner area and a decoration of four panels of single-headed, double-bodied *kuilong* dragons on the outer circumference. The dragons' temples are marked with an oval grid pattern. The dragons are delineated with fine incised lines and there are also regular deeper incisions with a polished trough, a common characteristic of this type of jade.

◀ Grain Pattern Jade Disc

Overall length 29.9 cm. Disc diameter 13.4 cm. Diameter of hole 4.2 cm. Thickness 0.6 cm. Color blue-green some surface water staining.
Mid-Western Han period ornamental jade
Hebei province, Mancheng county, Lingshan No. 1 tomb
Hebei Province Cultural Relics Preservation Center

A grain pattern completely covers the body of this disc and there is a raised inner and outer edge. The extension from the outer edge is in the form of a symmetrical pair of dragon and cloud patterns with the dragon's mane twisted upwards and a pattern of flowing clouds above the dragon's head. There is a small hole at the tip of the extension.

▶ Hornless Dragon (*chi*) and Grain Pattern Disc

Diameter 20.4 cm. Diameter of hole 5.8 cm. Thickness 2.0 cm. Color blue-green with signs of ageing, some staining.
Ming court jade
Palace Museum, Beijing

The center hole is decorated with a carved dragon and the surface and outer edge of the disc are decorated with eight hornless dragons in high relief. The other surface is decorated with an incised grain pattern, all with the meaning of "the hope of success for a child" (*jiaozi chenglong*). A grain pattern on one side with hornless dragons in relief on the other is a characteristic of Ming and Qing jade discs. Probably a ceremonial jade.

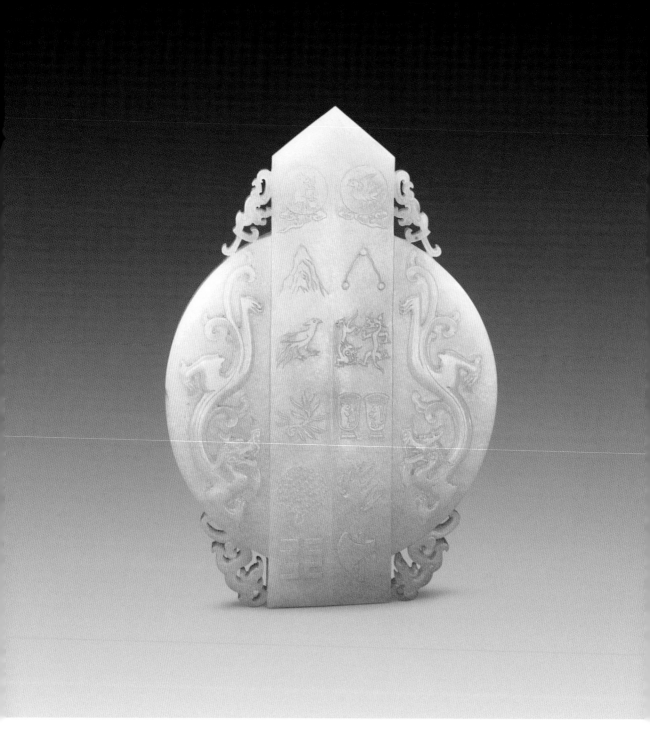

▲ Jade Tablet-Disc with Pattern of the 12 Symbolic Badges

Length 17.8 cm. Width 12.3 cm. Color white.
Qing court jade
Palace Museum, Beijing

One side of this disc has the tablet (*gui*) on top with the 12 symbolic badges carved in bas-relief (earth, moon, stars, hills, dragon, pheasant, wine vessel, water plant, fire, rice, and two embroidered flower patterns). Both aspects of the disc, either side of the tablet are each decorated with an earth-bound dragon pattern in bas-relief. The top and bottom of the tablet beyond the circumference of the disc are both ornamented with a pair of open-work relief carved hornless dragons. The other surface of the disc has no central hole and is carved in relief with a dragon within a central circular embrasure. This surface is also carved with a pattern of grain and grain ears. An arrangement of three stars is incised on the tablet above the disc and a pattern of waves below.

2. Jade Squared Tube (*cong*)

The *cong* is cylindrical on the inside and square on the outside and used as a ritual object in early sacrifices to the earth god. Some scholars believe that the square and cylindrical aspects of the *cong* represent heaven and earth and that the central tube represents a conduit between the two. Consequently the *cong* effectively symbolizes the ancient Chinese world view and its universal behavior.

During the mid and late Neolithic period, the jade *cong* appears in large numbers in the Liangzhu culture of the Zhejiang area, the Shixia culture of Guangdong, the Taosi culture of Shanxi and the Qijia culture of northwest China. The *cong* of the Liangzhu culture are the most developed. Jade *cong* are evenly decorated with patterns of animal heads centered on a four-cornered line divided into four panels, the decoration following the contours of the jade to produce identically patterned panels. Some *cong*, in addition to the basic animal face pattern, have finely incised figures of deities and cloud and thunder patterns.

There are few examples of *cong* from the Shang and Zhou dynasties. Excavated examples demonstrate that *cong* from this period are universally small in shape and size and mostly plain and undecorated. They are regularly cut with a comparatively large central tube and somewhat thinner than Neolithic examples.

Very few *cong* from the Spring and Autumn and Warring States period have been discovered. There are examples of plain-surfaced, animal face-patterned and half-*cong*. The plain examples, small in size and simple in design, are frequently found in the Spring and Autumn and Warring States period. Animal face-patterned and half-*cong* from the Warring States period have been found in the tomb of the Marquess Yi of Zeng in Hubei province. *Cong* of this period are basically identical to those of the Shang and Western Zhou periods except for a few changes in decoration.

Han dynasty *cong* rarely appear. Generally, they are squat cylinders that are square externally and undecorated. Imitation jade *cong* in early styles appear from the Song dynasty on. From the final years of the Ming dynasty through the Qing there were many imitations of the small plain Shang and Zhou *cong* as well as of those of the Liangzhu culture.

▼ **Jade Squared Tube**

Height 3.5 cm. Width at corners 7.3 cm. Diameter 7.1 cm. Diameter of hole 6.6 cm. Color brown/yellow with some black/green visible.
Longshan culture ritual jade
Shandong province, Wulian county, Dantucun
Wulian County Museum

This Longshan culture jade *cong* is a squat cylinder, circular inside and square outside with a comparatively large central hole. The four flat outer surfaces are each divided into two by a comparatively thick vertical groove and further sub-divided into four equal sections by three very narrow horizontal grooves. The three line double- incised pattern and the animal face pattern formed by large circular eyes on the external surface resemble excavated jade *cong* from the Liangzhu culture.

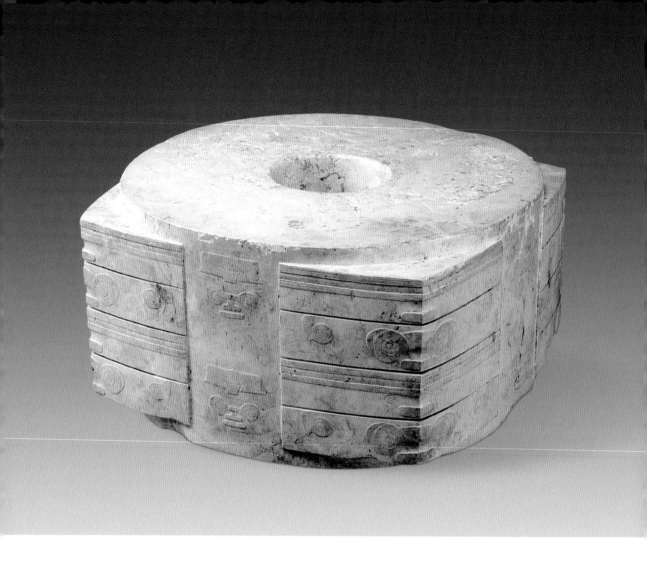

▲ Jade Squared Tube Decorated with Animal and Deity Heads

Height 8.8 cm. Diameter of hole 4.9 cm. Diameter of collars 17.1 – 17.6 cm. Color yellow/white with some irregular patches of red/purple.
Liangzhu culture ritual jade
Zhejiang province, Yuhang county, Fanshan tomb No. 12
Zhejiang Institute of Archaeology and Cultural Relics

Large quantities of jade of many types have been found in every tomb and at every site of the Liangzhu culture of 5,300 – 4,000 years ago. Decorations on Liangzhu jades have mainly been patterns of deities and animal faces, dragon's heads, birds, and straight lines. Types can be divided into utensils, ornaments and ritual objects.

This Liangzhu jade is in the form of a squat tube, looking from above rather like a jade disc. The corners display four sections with eight panels containing simplified designs of the faces of deities and animals, each with a carved bird pattern on either side, the proportions of the head, wings and body exaggerated. The central trough on the four flat surfaces of the tube contains carved designs of a combined god and animal

face, one above the other. This design is probably the "mystic emblem" (*shenhui*) worshipped by the Liangzhu people and is a classic Liangzhu decoration. This sacred ritual jade is 4.5 kilos in weight and is known as "king of the *cong*." At the time of excavation it was lying upright at the lower left of the skull of the tomb's occupant.

▶ Jade Squared Tube with a Pattern of Animal Faces

Height 5.4 cm. Width 6.0 cm. Diameter at center 6.6 cm. Diameter of hole 5.5 cm.
Color blue-green/white, smooth with some brown staining and cracks.
Warring States ritual jade
Hubei province, Suizhou city, Leigudun, Tomb of Marquess Yi of Zeng
Hubei Provincial Museum

Squat body, round inside and square outside, the center slightly larger than the two ends, the central section damaged. The hole drilled from both ends and the collar quite tall. Each of the four sides is carved with a pattern resembling a ferocious animal's head. The collar is incised with a horizontal S pattern

and net pattern. This piece resembles jade *cong* of the Liangzhu culture but with particular characteristics of patterning and arrangement.

▶ Jade Squared Tube

Height 2.8 cm. Overall diameter 7.2 cm. Diameter of collar 6.7 cm. Thickness 0.5 cm. Color black/green, semi-translucent.
Late Shang dynasty ritual jade
Henan province, Anyang city, Tomb of Fu Hao
Chinese Academy of Social Sciences Institute of Archaeology

Jade *cong* of the Shang dynasty are usually plain or just decorated with a few lines or external projections which are ornamented with cicada or thread patterns. They have already lost the feeling of mystery that attached to Neolithic jades of the Liangzhu culture. This piece is a squat cylinder with the outer surrounding surface so ground as to produce four arc-shaped projections, each projection incised with two parallel horizontal lines dividing the decoration into upper and lower sections. Either side of the center line of the projection there are two raised circular dots resembling the eyes of an animal. Either side of the projections there are two sets of upright incisions. The aperture is nearly straight, the surface decoration finely executed and the piece polished internally and externally.

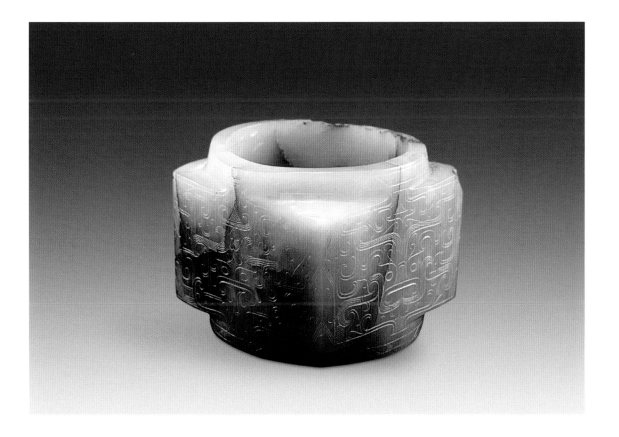

3. Jade Arc-Shaped Pendant (*huang*)

Arc-shaped pendants are the most numerous and have the greatest variety of types and the longest history of circulation of all ritual jades. They first appeared during the Hemudu culture of 7,000 years ago.

The arc-shaped pendant is a ritual jade used in sacrifices to the North, and a ritual jade for sacrifices to heaven. Some people believe that early people made them in the shape of the rainbow that appears as the sky clears after rain.

Many Neolithic and Shang dynasty arc-shaped pendants are broadly shaped like a fan and generally undecorated. Some finely worked pendants from the late Shang dynasty in the shape of fish or dragons have rhomboid or triangular patterns.

During the Western Zhou period the arc-shaped pendant became the most important component of pendant sets, usually decorated with a pattern of stylized animal heads. From the Neolithic period to the Western Zhou, the pendants had a hole at both ends so that the back (the longer curve) faced downwards.

A large number of pendants of the Spring and Autumn period have been excavated, mainly in the traditional shapes and undecorated but also some with carved patterns of animal faces, birds, clouds and thunder, continuous hooked clouds and curled clouds.

During this period also, a hole appeared on the back of the pendant indicating a change in the manner of use so that the back now faced upwards.

The peak in the use of arc-shaped pendants occurred from the Warring States to the Han dynasties when the number of shapes and decorations increased, with a single hole in the back of the pendant and carved dragon's heads at either end.

During the Wei and Jin period there are holes at either end but not on the back of the pendant which was mounted vertically as part of a set. After the Wei and Jin there are fewer pendants in the arc shape and the decoration tends to be simpler. After the Tang dynasty the arc-shaped pendant basically leaves the historical stage.

▶ Arc-Shaped Jade Pendant Decorated with a Tiger's Head

Length 11.9 cm. Width 1.9 cm. Thickness 0.5 cm.
Color grey/white with some yellow staining.
Neolithic Lingjiatan culture ornamental jade
Anhui province, Hanshan county, Lingjiatan site, Tomb No. 8
Anhui Institute of Cultural Relics and Archaeology

This piece is the earliest known arc-shaped pendant. Flat and arc-shaped, both ends are decorated with tiger heads in relief with eyes, nose and ears as well as the wrinkled head and forward facing claws incised or drilled out. Incisions on the pendant represent the tiger's stripes. The pendant is unique in form. Four other tiger head arc-shaped pendants have been excavated at Lingjiatan and demonstrate the reverence in which tigers were held.

▶ Dragon and Phoenix Patterned Arc-Shaped Jade Pendant

Height 13.9 cm. Width 4.2 cm. Thickness 0.6 cm.
Color deep green, slight staining with spots of bronze rust, semi-translucent.
Late Shang dynasty ornamental jade
Henan province, Luyi county, Taiqinggong Changzikou tomb
Henan Institute of Cultural Relics and Archaeology

This piece is carved with a dragon and phoenix design in both open-work and incision with the dragon above and the phoenix beneath. The design is the same on both sides and carved with a double hook incised pattern, joined double curves, and single incised lines to delineate the detail of the dragon and the phoenix. Its form and patterns bear all the hallmarks of Shang dynasty jade carving.

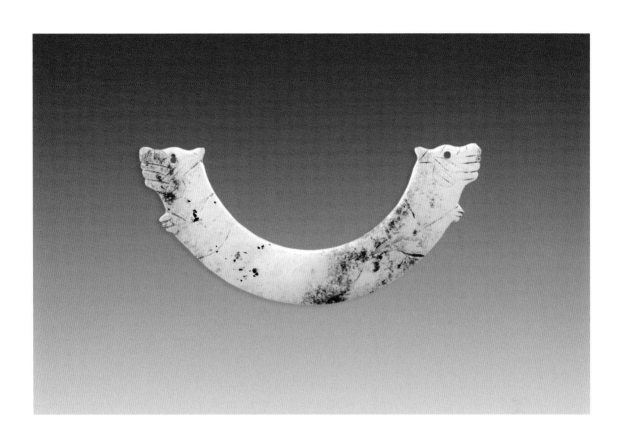

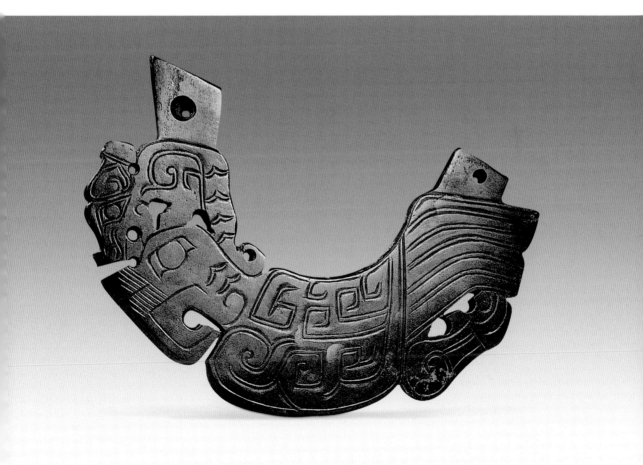

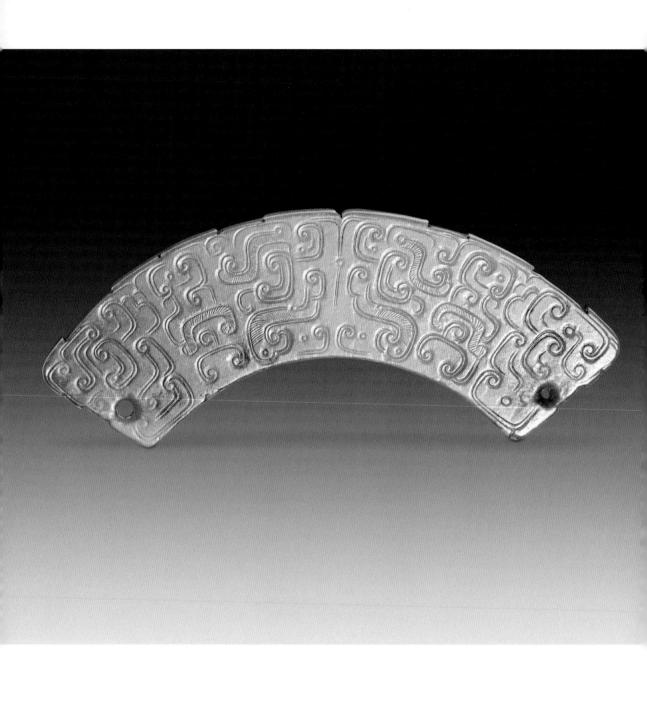

▶ Arc-Shaped Jade Pendant with a Pattern of a Human Figure and a Dragon

Height 9.5 cm. Width 2.9 cm. Thickness 0.3 cm. Color blue-green, with several patches of red/brown.
Later Western Zhou ornamental jade
Henan province, Sanmenxia city, Guoguo tomb No. 2001
Henan Museum

The front of this piece is decorated with two symmetrical designs of a human figure and a dragon. The reverse is plain. The human figure lacks limbs, the body is bent but nose, eyes, ears and hair are all present. The dragon's body is coiled, the eyes are oval, its head has horns, the nose is twisted upwards and the mouth shows fangs. The edges of the piece are decorated with rectangular protrusions (*feileng*). There are round holes at each end. The decoration has been executed with fluently incised double lines, the outer line carved with a slanting blade. There is an open-work aperture between the dragon/human patterns. The form and patterns are both characteristic of Western Zhou arc-shaped pendant jades.

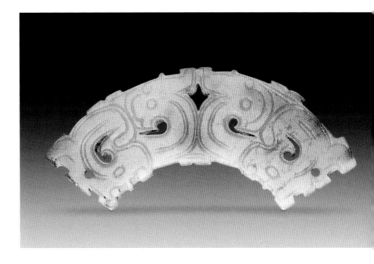

▶ Dragon Shaped Arc-Shaped Jade

Length 13.6 cm. Width 3.7 cm. Thickness 0.3 cm.
Color pure smooth textured yellow; the bulk already stained brown.
Late Warring States ornamental jade
Anhui province, Changfeng county, Yanggong tomb No. 2
Palace Museum, Beijing

This piece is basically formed from four dragons with considerable open-work carving. The dragons' bodies are coiled and twisted into a variety of shapes. One side of the jade has been ground with patterns of clouds, fish scales and lines; the other is plain.

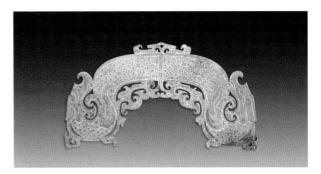

◀ Coiled Snake Pattern Arc-Shaped Jade Pendant

Length 11.0 cm. Width 2.5 cm. Thickness 0.2 cm.
Color blue-green, semi-translucent and smooth.
Early Spring and Autumn period ornamental jade
Henan province, Guangshan county, Baoxiang Temple, Tomb of Huang Junmeng and consort
Henan Museum

The edge of this piece is decorated with symmetrical pairs of rectangular protrusions. One surface is carved on left and right with a symmetrical design of a stylized snake in double hook incisions. There is a round hole at each end. The traditional form, beauty of design, fluency and regularity of line and fine carving all point to a standard piece of the early Spring and Autumn period.

▼ Arc-Shaped Jade Pendant Decorated with a Dragon's Head

Length 10.8 cm. Color blue-white/white, partial staining and split.
Western Han ornamental jade
Hebei province, Ding county (now Dingzhou city) tomb No. 40
Hebei Provincial Cultural Relics Institute

Open-work carving is used in this piece to combine two dragons into one body. The dragon pattern is incised and the extended edge (*chukuo*) at the center of the piece has a pattern of long, twisted clouds. The corners of the dragon's eyes are marked by upward hooked bristles, a form of dragon's eye frequently seen during the Western Han dynasty. The dragon's body is ornamented with a geometrical pattern of continuous hooked clouds.

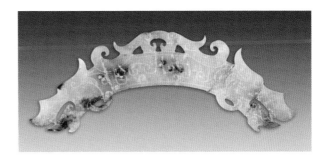

4. Jade Tablet (*gui*)

The functions of tablets can be divided into four: the tablet held by the Son of Heaven (emperor) alone; the emblem indicating status held by the nobility when in the presence of the Son of Heaven; the tablet used by the Son of Heaven when sacrificing to the earth god and former kings; and the tablet used in oath taking, establishing ties of friendship, expelling evil and in betrothals.

Tablets of the pre-Qin period were of many different trapezoid forms, some narrow at the top and wide at the bottom and some wide at the top and narrow at the bottom. During the Xia dynasty tablets were long and flat, without a point and pierced with holes at the blunt end. Those with one hole were usually undecorated and those with two were decorated with horizontal rows of characters carved in relief next to the hole or incised with continuous rhomboid patterns of clouds and thunder.

Jade tablets of the Shang dynasty were of two sorts: one still followed the forms of the Xia dynasty, without a point and with holes, with some examples decorated with incised longitudinal double lines or a pattern of carved extruded raised lines; the other with a pointed tip and a flat base rather resembling later tablets.

In general, Western Zhou tablets were long, pointed and undecorated but finely made.

During the Spring and Autumn and Warring States period, the use of jade tablets began to spread, though there was no strict regulation of their use and they are found in the graves of commoners as well as the tombs of the nobility, the difference being in numbers and the quality of the jade. During this period jade tablets were also used in oaths of alliance and as simple books.

Tablets of the Han dynasty followed the form of the Spring and Autumn Annals and Warring States period. They are pointed, with sloping shoulders and a level base and undecorated. However, there was a great reduction in their use. They are no longer found in the graves of commoners but only in the tombs of the nobility and at the sacrificial ceremonies performed by the emperor, demonstrating the emergence of a strict system of regulation.

After the Han dynasty the system of regulation tended to collapse, and although tablets were still used at imperial rites and important

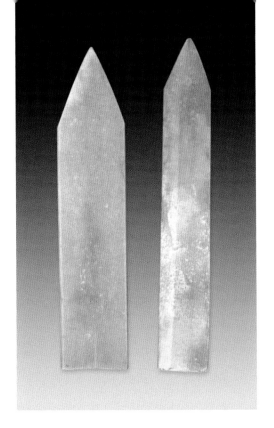

ceremonies during the Ming and Qing dynasties, their shape generally followed the ancient pointed form. Of the excavated and transmitted jades of the Ming dynasty, the majority are either undecorated or decorated with the grain pattern. The form of Qing tablets is basically the same as the Ming and some follow the form of those handed down from the Ming and previous dynasties.

◀ Groove-Patterned Jade Tablet

Length 22.7 cm. Width 3.8 – 4 cm. Thickness 0.9 cm. Color deep green with some light brown staining at the top.
Late Shang dynasty ceremonial jade
Henan province, Anyang city, Tomb of Fu Hao
Chinese Academy of Social Sciences Institute of Archaeology

This piece takes the form of a flat bar, wide at the blade and narrow at the base end. There is a round hole at the center of the base end. The blade is thick with rounded corners. Both sides of the tablet are carved with eight incised grooves with the six inner grooves close together. The base end is carved with four closely aligned parallel lines.

◀ Jade Tablet

Two damaged and incomplete items. Left: Length 5.5 cm. Width 1.1 cm. Thickness 0.1 cm; Right: length 5.8 cm. Width 0.8 cm. Thickness 0.15 cm. Color fine blue-green with some white staining at the top.
Mid-Western Zhou period ceremonial jade
Shaanxi province, Fufeng county, Huangduicun tomb No. 25
Zhouyuan Museum

▶ Jade Tablet

Length 18.8 cm. Width 5.8 cm. Color grey/white, some black patches.
Mid-Warring States period ceremonial jade
Henan province, Hui county, Guweicun tomb No. 1, Sacrificial pit
National Museum of China

▶ Jade Tablet

Length 18.6 cm. Width 7 cm. Thickness 1.35 cm. Diameter of hole 0.35 cm. Color blue-green, with some black spots, some grey/white staining on the surface.
Mid-Western Han period ceremonial jade
Hebei province, Mancheng county, Lingshan tomb No. 1
Hebei Province Cultural Objects Conservation Center

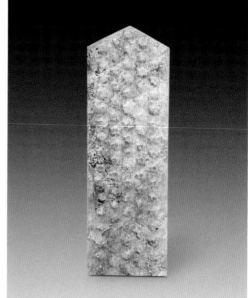

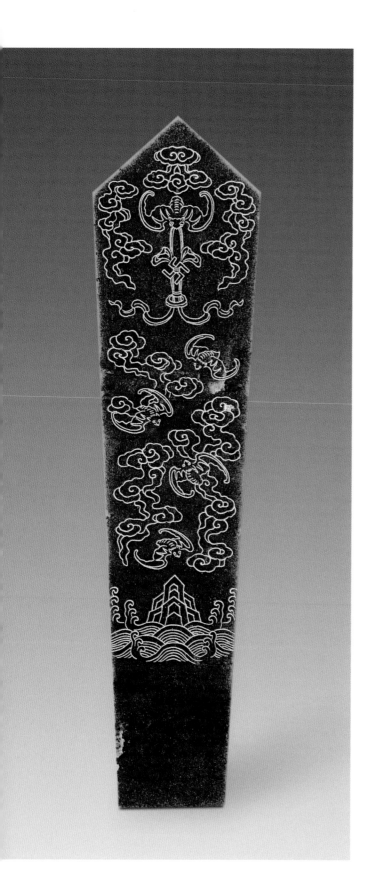

▲ Grain Patterned Jade Tablet

Length 15.2 cm. Width 5.1 cm. Thickness 0.8 cm.
Color blue-green/grey, signs of erosion. This type
of jade stone is relatively common during the Ming
dynasty.
Ming court ceremonial jade
Jiangxi province, Nancheng county, Hongmenxiang,
Zhubing tomb
Jiangxi Provincial Museum

This piece has five vertical rows of lightly and rather
crudely carved grain pattern resembling the rush
pattern of the Han dynasty in that it uses parallel
incisions from three directions to carve out a raised
hexagon, a simplified method for carving a grain
pattern. A further Ming dynasty method for carving
a grain pattern was to mark the position of each
round grain with a tube drill and then grind away
the surrounding surface. The simplicity of form and
crudeness of execution of this piece is a characteristic
of Ming jade carving.

◄ Inscribed Jade Tablet

Length 41.2 cm. Width 10.6 cm. Thickness 1.1 cm.
Color jasper green.
Qing dynasty court ceremonial jade
Palace Museum, Beijing

This piece is inscribed with characters and patterns
in gold inlay. The side bearing the text is decorated at
the top with a triple pattern of equidistant stars and
at the base with a pattern of sea and rocks. Between
them there is a 466 character regular script (*kaishu*)
inscription about the imperial jades in the hand of the
Qing dynasty calligrapher and statesman Zhu Guijing.
The other side is decorated at the top with bats
holding streamers bearing the swastika symbol denoting good
fortune in their mouths and at the bottom with an
incised pattern of sea and rocks. Between them there
is an incised pattern of bats in flight amongst clouds.
This is a Qing dynasty ceremonial piece designed on
the basis of ancient texts.

5. Jade Ritual Blade (*zhang*)

According to ancient texts a jade ritual blade (*zhang*) was, in shape, "half a *gui*," and was used in sacrifices to the god of the South and to hills and rivers, accompanied the Son of Heaven on tours of inspection, and was also used by the nobility in betrothals.

Ritual blades of the Xia dynasty are relatively long, with a forked convex blade at the top and asymmetrical points at either end of the blade.

Shang dynasty blades are long, flat and thin, sometimes with irregularly sized gaps in the curved blade at the top giving the appearance of two pointed horns.

Blades from the Western Zhou are relatively rare, their shape much as those of the Shang dynasty, small in dimension but long and narrow, slightly concave at the center and the triangular blade with one long and one short point and a rectangular handle.

Numerous blades, with the text of the oath on them, have been excavated at the sites of Spring and Autumn and Warring States oaths of loyalty. However, these are not of standard shape and look rather like the traditional edge-bladed long sword.

A few undecorated ritual blades of the Qin, Han, Wei, Jin, Southern and Northern dynasties have been discovered.

▲ Jade Ritual Blade
Damaged length 34.5 cm. Width at damaged tip 7.8 cm. Thickness at handle 0.3 cm. Color black, patches of water damage.

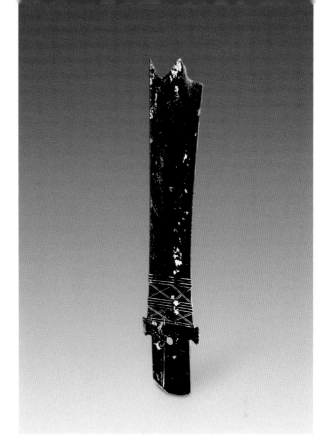

Longshan culture ritual blade
Shaanxi province, Shenmu county, Shimao site
Shaanxi Museum of History

Flat and shaped like a narrow shovel blade with a pattern of incised parallel and intersected lines. Rounded blade edge (i.e. blunt) and never sharpened, suggesting that this piece was not for actual use but had some symbolic significance. This piece is also known as a sword-shaped, tip-bladed jade.

▶ Jade Ritual Blade
Length 42.25 cm. Width 4.32 – 9.18 cm. Thickness 0.36 – 0.55 cm. Color black, jade of pure quality but with patches of blackish yellow on either surface.
Late Shang to Early Western Zhou dynasty ceremonial jade
Sichuan province, Chengdu city, Jinsha site
Chengdu Cultural Relics and Archaeology Institute

Long, narrow, thin, asymmetrical body, the longer side a little thicker than the short side. The blade is an inward curved arc with one side ground to an edge.

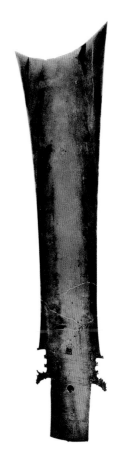

6. Jade Halberd-Shaped Blade (*ge*)

The halberd-shaped blade was a common weapon during the Shang period and specimens of jade are first seen in the Erlitou culture. Thereafter, they became common during the Shang and Zhou dynasties. Because of the brittle quality of jade they were of no use in actual combat and the large number of excavated halberd blades show no sign of use, thus demonstrating that they were ceremonial objects used to reflect the dignity of the nobility.

There are two stages to the changes of shape of the *ge*. The first stage covers the Erlitou culture and the Early Shang Erligang period. In this period the blades are universally large and usually about 30 cm. in length. Apart from a few with a simple pattern of curves, they are undecorated. In the second stage, the Yinxu period and the Late Shang, the dimensions shrink and the early Yinxu period blades have a length of 15 – 20 cm. Blades of the later Yinxu period are within a length of 15 cm. with the smallest having a length of only 4 – 5 cm. These *ge* are of two types: curved and straight, the upper beak decorated with parallel crude sun patterns or both beak and blade decorated with incised patterns of animal heads and stylized clouds.

The shape and characteristics of *ge* of the Western Zhou are similar to those of the Late Shang, though very small and finely worked pendant type blades also appear. In addition, patterns of phoenix, sacred animals (and humans) appear on halberd-shaped blades of this period.

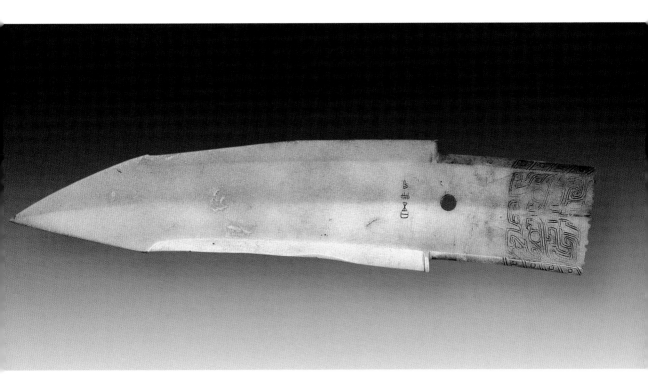

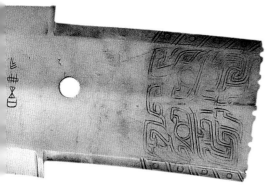

◄▲ Halberd-Shaped Jade Blade Decorated with an Animal Face and Inscription

Overall length 38.6 cm. At thickest 0.6 cm. Color white, with some brown staining, semi-translucent.
Late Shang dynasty ceremonial jade
Gansu province, Qingyang county, Yelinxiang
Qingyang City Museum

The obverse and reverse of this piece are both decorated with a design in double hook pattern of an animal face with eyes like the character 臣. The upper and lower edges of the beak are decorated with four panels of slanting short double lines and circles. There is a single hole drilled just behind the rear edge of the blade. Just forward of the rear edge of the blade the three characters "*zuo ce wu*" (the function and name of an official) are inscribed vertically in seal script. This *ge* is of fine quality jade and patterning and, unusually, bears an inscription, a treasure amongst Shang dynasty jade *ge*.

The sporadically occurring blades of the Spring and Autumn and Warring States retain the characteristics of the Zhou dynasty.

During the Han dynasty there is a change in jade *ge*, to one type where the blade becomes a heavily decorated pointed rectangle with a symmetrical pattern of coiled double dragons at the front, grain pattern in the center and geometrical and dragon and phoenix patterns at the back. The back of the *ge* is plain, the beak narrow and rectangular with two holes. In the other type, the blade is curved, the point like the tip of an olive with edges to both sides and decorated with a hooked cloud pattern. The beak is rectangular and also decorated with a continuous cloud pattern. The *hu* (the place, forward of the beak, where the horizontal blade of the *ge* curves downwards) and the beak are separately carved with three and one small rectangular holes respectively.

After the Han dynasty the jade halberd-shaped blade disappears.

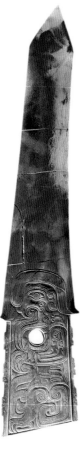

◀▼ Halberd-Shaped Jade Blade with a Human-Headed Mythical Animal Pattern

Length overall 36.2 cm. Color yellow/brown.
Western Zhou ceremonial jade
Shanxi province, Quwo county, Jinhou tomb group, Tomb No. 63
Shanxi Province Institute of Archaeology

Both sides of the beak of this piece are ornamented with a similar decoration, a design of a human headed mythical animal, crouching with its tail on the ground. It has eyes in the shape of the character 臣, large ears and in-turned fangs beneath a round nose. The lower jaw has whiskers that reach the feet. One shoulder is hunched and the hand grips the beard. Apart from the human thumb the remaining fingers and toes are the talons of a wild animal. The decoration is mainly double incised with a slanted blade and accompanied by extremely finely incised lines at a density of 56 lines to the millimeter. This blade is superbly made, its subject, the mythical animal very unusual, the design deeply and finely carved. Altogether it is a rare item of great quality.

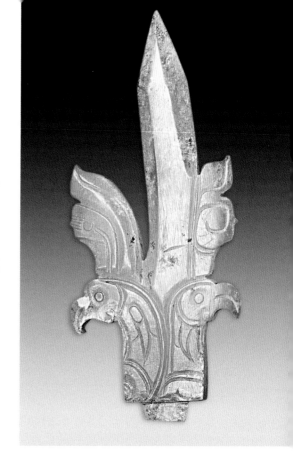

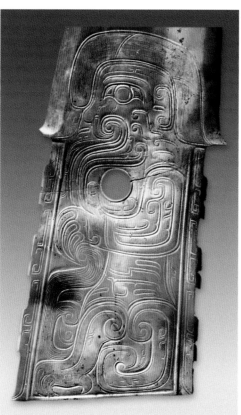

▲ Halberd-Shaped Jade Blade with a Bird's Head Pattern

Length overall 7.5 cm. Thickness 0.35 cm. Color white, semi-translucent.
Western Zhou ceremonial jade
Shaanxi province, Fufeng county, Qiangjia tomb No. 1
Zhouyuan Museum

This piece is decorated with phoenix heads at the upper and lower portions of the rear of the blade. Both phoenix have round eyes and pointed curved beaks and wings spread above their heads. Both designs are exactly the same.

▶ Halberd-Shaped Jade Blade

Length 23.2 cm. Thickness 0.12 cm. Color blue-green/white, smooth and bright, with some staining.
Late Spring and Autumn period ceremonial jade
Shanxi province, Houma city, Qincun oath of loyalty site, Pit No. 284
Shanxi Province Institute of Archaeology

The upper and lower edges of the blade of this piece are sharp. The lower edge is slightly curved up towards the tip whilst the upper edge is relatively straight. There is a single drilled hole where the beak joins the blade. This piece is finely carved and is probably a ceremonial jade buried as an important pledge after an oath of loyalty and the death of the owner.

▶ Halberd-Shaped Jade Blade with Dragon Pattern

Length 17.2 cm. Width 11.2 cm. Thickness 0.7 cm.
Color blue-green/white with some yellow earth staining and white water stains.
Western Han ceremonial jade
Jiangsu province, Xuzhou city, Lion Mountain, Tomb of King of Chu
Xuzhou Museum

Between the blade and the lower portion (*hu*) of this jade there is an open-work extension carved with the figure of a dragon in flight. Both the blade and the lower portion are ornamented with hooked continuous clouds. One side of the beak is decorated with a design of a coiled hornless dragon (*chi*) and the other with a phoenix with a hooked beak and its wings outstretched. According to legend, the *chi* is one of the nine sons of the dragon. In Buddhist scripture, the *chi* serves the God of Rain. Given the power to extinguish fire, the *chi* serves to protect against disasters and fires. This is a finely worked Han jade of original design which combines both ceremonial and ornamental use.

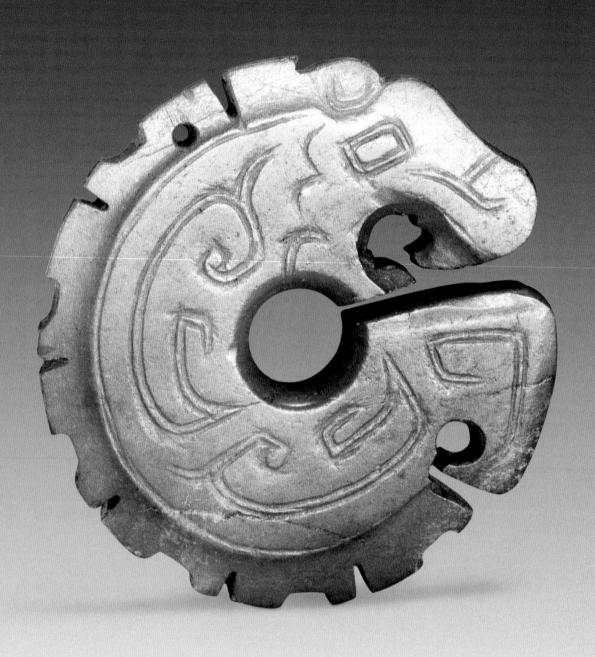

7. Jade Slit Ring (*jue*)

Jade slit rings are similar in shape to rings (*huan*) and discs (*bi*) but are slit.

Slit rings were a relatively common ornament during the Shang and Western Zhou dynasty. Shang slit rings are flat and are plain-surfaced or in the form of a dragon. Western Zhou rings remain flat but the body is wider than those of the Shang dynasty and usually plain and undecorated though a few specimens are decorated with incised patterns of phoenix and dragons in thick and thin curved lines.

Not many slit rings of the Spring and Autumn Annals and Warring States period have been excavated. Those seen are of two types: a traditional existing Neolithic type, flat and usually undecorated, though some are carved with cloud, hooked cloud and dragon patterns or with two dragons' heads at the slit; the other is round bodied and peculiar to the Spring and Autumn and Warring States period, either plain or with a milled string or animal face patterns. Since most excavated examples have been found at either side of the skulls of the occupants of tombs, it is reasonable to assume that these slit rings are probably earrings.

▲ Jade Slit Ring

Two items. Diameter 2.8 – 2.9 cm. Diameter of hole 1.3 – 1.4 cm. Thickness 0.4 – 0.6 cm. Color yellow/green.
Neolithic Xinglongwa culture ornamental jade
Inner Mongolia Autonomous Region, Aohan Banner, Xinglongwa settlement site
Chinese Academy of Social Sciences Institute of Archaeology

Jade artifacts from the Xinglongwa culture are predominately small and types relatively few. To a great extent they exhibit the primitive characteristics of early jade. The great majority of excavated jade slit rings are classic Xinglongwa jades.

These two items are polished overall, the outer edge quite thick, and were found by the left and right ears of the skull of the occupant of a tomb. One of them was found on the lower left of the skull with the slit facing up.

◄ Jade Slit Ring in the Form of a Dragon

Diameter 5.5 cm. Diameter of hole 1.2 cm. Thickness 0.5 cm. Color pale green, with slight staining.
Late Shang dynasty ornamental jade
Henan province, Anyang city, Tomb of Fu Hao
Chinese Academy of Social Sciences Institute of Archaeology

This slit ring is in the form of the letter C. The dragon has a pointed tail curled outwards. There is a hole at its neck, with curled cloud pattern on the body and tail. This form is very common and is a classic example of a Late Shang dynasty jade.

◀ Jade Slit Ring with a Pattern of a Coiled Snake

Height 3.0 cm. Overall diameter 2 cm. Diameter of hole 0.9 cm. Color light brown, semi-translucent and glossy.
Late Spring and Autumn period ornamental jade
Henan province, Xichuan county, Xiasi tomb No. 3
Henan Provincial Institute of Cultural Relics and Archaeology

This piece is in the form of a circular tube with a slit in one side. The body is carved with a coiled dragon pattern and the top with a pattern of double circles.

▼ Jade Slit Rings with a Pattern of a Fish-Tailed Dragon

Two items. Both: Diameter 4.15 cm. Diameter of hole 1.5 cm. Thickness 0.3 cm.
Color blue-green, with traces of yellow.
Late Western Zhou dynasty ornamental jade
Henan province, Sanmenxia city, Guoguo tomb No. 2012
Henan Provincial Institute of Cultural Relics and Archaeology

One side of these two slit rings is decorated with a pattern of a fish-tailed dragon. Both pieces are similar in quality of jade, color, size and workmanship. The dragons however, are opposite ways round.

▲ Jade Slit Ring with a Pattern of Curled Clouds and Dragons' Heads

Diameter 3.9 cm. Color yellow/brown, semi-translucent and smooth.
Mid-Warring States period
Hebei province, Pingshan county, Qijicun, Zhongshanguo tomb No. 1
Hebei Province Cultural Relics Institute

This piece is flat and circular with a gap in the circle, the two sides of the gap being decorated with a dragon's head pattern. The inner and outer rims are decorated with a silhouette pattern and the surface has a milled pattern of curled clouds. There is a hole opposite the gap.

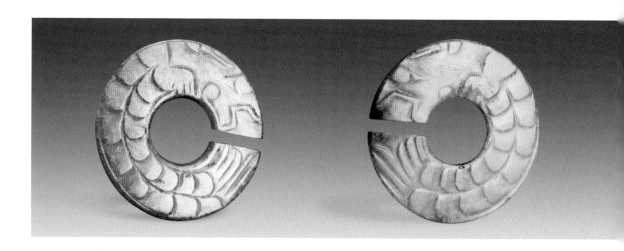

8. Jade Pendant Sets

Large jade pendant sets originated during the Western Zhou dynasty and were formed from a number of pieces of jade strung together to make a pendant ornament to be hung on the body. During the period of the Spring and Autumn Annals and Warring States these pendant sets became more elaborate; from the Warring States to the Han dynasty there was a tendency towards simplification.

The major components of these sets were jade discs (*bi*), arc-shaped pendants (*huang*), rings (*huan*) and jade dangles (*chongya*) strung on silk cords ornamented with pearls and tubular sleeves of jade. Large pendant sets comprising numerous arc-shaped pendants are only found in the tombs of rulers and their consorts. They are not found in the tombs of crown princes or other high ranking members of the nobility, demonstrating that a strict system regulated their use. At the same time pendant sets with numerous *huang* also symbolized the distinction between high and low, junior and senior. Jade pendant ornaments excavated from tombs of the Spring and Autumn Annals and Warring States period suggest that the higher the social status of the noble the more elaborate the pendant set and the better the quality of the stone and of the workmanship. Conversely, the lower the social status of the noble the fewer the ornaments.

▶ **Jade Pendant Set**
Diameter of disc 5.2 cm. Length of dragon shaped jade 10.7 cm. Color blue-green/white, with some brown/black staining, semi-translucent and polished.

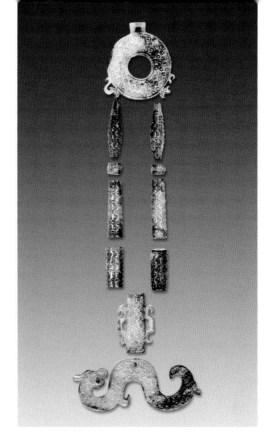

Mid-Warring States period ornamental jade
Shandong province, Qufu city, Ancient capital of Luguo site complex B, Tomb No. 58
Qufu Cultural Artifacts Management Committee

This pendant site comprises of one jade disc (*bi*), nine jade tubular sleeves and one jade dragon shaped ornament. The jade disc is at the very top and has a square tooth-like protuberance for suspending from a cord. The left and right of its lower edge have two open-work carved phoenix decorations and the surface of the disc is decorated with a grain pattern. Beneath the disc there are eight jade tubular sleeves decorated with grain pattern in two symmetrical rows. Beneath this there is a larger tubular sleeve of jade decorated with a grain pattern and with a dragon on each side. At the bottom there is a dragon covered in a grain pattern and with a hole in its back.

On page 110
Jade Pendant Set

Length approx. 50 cm. Width approx. 30 cm.
Mid-Western Zhou period ornamental jade
Shaanxi province, Fufeng county, Qiangjia tomb No. 1
Zhouyuan Museum

This pendant set consists of a total of 396 pieces of light yellow, light green and white jade arc-shaped pendants, tubular sleeves, animal faces and pieces of red and yellow agate. There are 28 various jade pendant ornaments, 328 agate beads and 40 beads and tubes of other material. This set is complete and hangs from the neck over the chest.

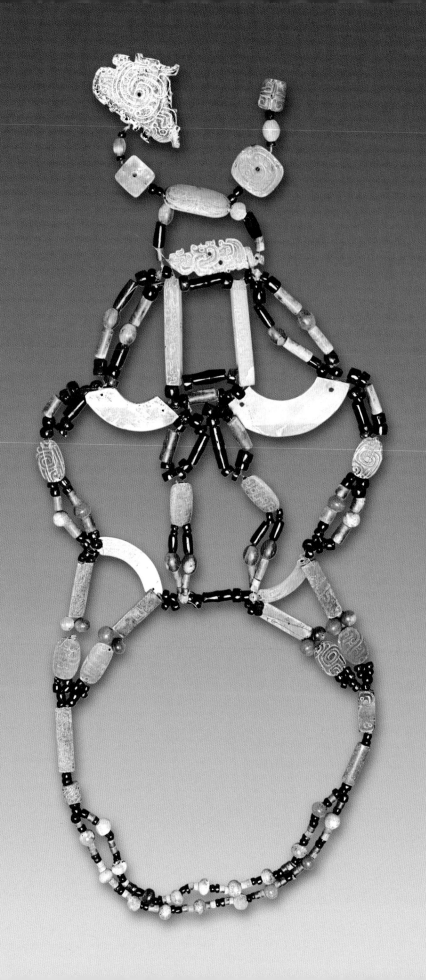

9. Desk Furniture for the Scholar's Studio

Items of desk furniture for the scholar's studio are the product of the Chinese tradition of writing to which the use of writing implements of jade lends an air of richness and elegance. The principal kinds are seals and non-paper stationery items.

Seals represent prestige and trust. Before the Qin dynasty seals (*yinzhang*) were known as *xi,* a term which, from the time of the emperor Qin Shi, was specifically attached to the seal used by the emperor. Seals of jade have been used historically.

The implements of the scholar's studio were the particular province of the literati. The earliest are found in the Song and Liao dynasties and comprise jade brush rests in the form of the character 山 (*shan,* hill), jade slabs for grinding ink, jade paperweights and jade brush washers, all of comparatively simple design and not of particularly fine workmanship. Some are partially carved in open-work relief or high relief.

By the time of the Ming and Qing dynasties the appeal that the scholar's studio held for scholar-bureaucrats promoted a vogue for writing implements of jade. The most frequently encountered were

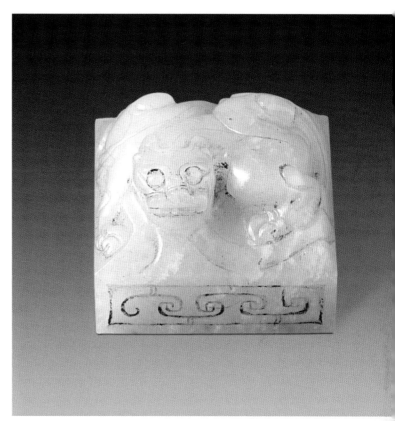

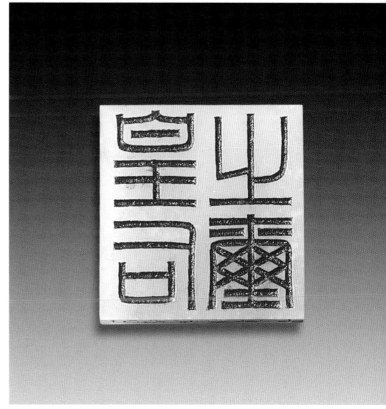

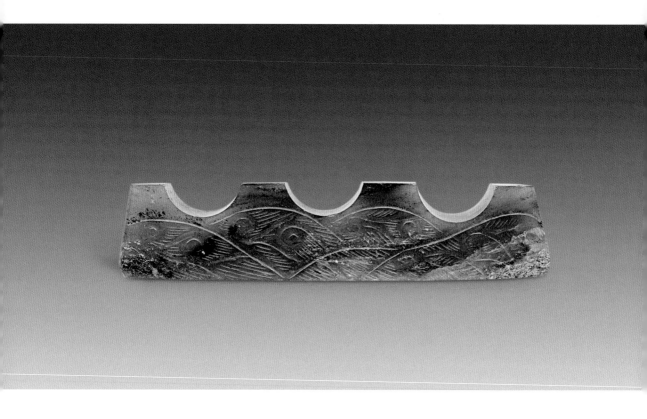

brush stands, brush washers, boxes for seal ink, ink slabs, paperweights, brush rests and water droppers. Jade writing implements of the Ming and Qing showed considerable originality in design and decoration and took the form of animals and plants such as deer, horses, ducks, melons and gourds. Pattern design was similar or combined two forms such as cloud and dragon or dragon and phoenix. The carving was either of a simple vigor or refined delicacy and of many styles.

On page 111

Imperial Seal (*xi*) in Jade

Height overall 2.0 cm. Width 2.8 cm. Color white.
Western Han jade
Shaanxi province, Xianyang city, Hanjiawan Langjiagou
Shaanxi Historical Museum

The seal is square with a handle in the form of a hornless dragon and a tiger on top. The sides of the base are incised with a hooked cloud pattern and the four characters of the inscription read "*huang hou*

zhi xi"—seal of the empress, in seal script. Since the seal was excavated in the vicinity of the tomb of the Emperor Gaozu, Liu Bang and his consort Empress Lü, it is generally considered to have been a seal used by the empress. This is the only known excavated example of a Han dynasty imperial seal.

▲ Wave Pattern Jade Brush Rest in the Shape of the Character 山

Height 2.3 cm. Length 10.5 cm. Width 1.1 cm. Color blue-green.
Song dynasty jade desk furniture
Zhejiang province, Quzhou city, Shisheng ancestral tomb
Quzhou City Museum

Brush rests, otherwise called holders, are found in the simple form of the character 山 for hill, in the form of sculpted mountain peaks, and in a form that incorporates a number of carving techniques to produce the shape of a bridge.

This piece is an oblong with three semi-circular gaps of 1.8 cm diameter to hold brushes. Both sides of the piece are ornamented with a pattern of waves. According to a legend, when a flood dragon emerges from the water, surging swells appear in the background. Wave patterns have come to have many allegorical meanings, often representing good fortune and respectability.

▲ Jade Paperweight in the Shape of a Bactrian Camel

Height 6.0 cm. Length 9 cm. Width 3.3 cm. Color blue/green, with some blemishes.
Ming dynasty desk furniture
Palace Museum, Beijing

Paperweights for holding down scrolls of calligraphy can be round or oblong and sculpted in the form of people, animals, and plants. Ming dynasty weights are usually sculpted in animal form and are designed to be appreciated as well as used. In the Qing dynasty, in addition to the sculpted animal and plant forms there are also specially made geometrically shaped long and round weights.

In this weight the camel is recumbent and its head, abdomen, humps, tail and feet are decorated with finely incised lines. The carving is vigorous and the workmanship meticulous.

▼ Jade Paperweight in the Form of a Hornless Dragon (chi)

Length 27.8 cm. Width 3.2 cm. Color light blue-green and pure in texture.
Qing dynasty desk furniture
Palace Museum, Beijing

This weight takes the form of a long rectangular strip of jade upon which is carved a pattern of one dragon and two hornless dragons (chi) in high relief. At the tail end of the weight, two chi are at play, one crouched and the other with its head turned as if looking back at it. At the head, a dragon with the body of a chi turns back its head to gaze at the two chi. This type of long rectangular paperweight, also known as a ruler-weight, is relatively common in the Qing dynasty.

▼ Jade Brush Holder in the Form of a Bridge

Height 7.3 cm. Length 22 cm. Color blue-green/white with some blemishes.
Mid-Qing dynasty desk furniture
Palace Museum, Beijing

Carved to the shape of a level wooden bridge with a slope at either end, there are two rows of supports carved beneath the bridge, whilst on the bridge itself there is a pattern of cross planks. A small boat with two people seated in it moves between the bridge supports. Lifelike donkey riders and pedestrians carrying burdens on poles or on their backs cross the bridge. The natural and lively composition illustrates a country scene in southern China. In its carving of the bridge supports and of the figures and animals to produce a brush holder of such ingenious design, this piece is an outstanding example of mid-Qing desk furniture.

▶ Jade Brush Washer in the Shape of a Sunflower

Height 7.4 cm. Length overall 17 cm. Color blue-green/white, with slight brown staining.
Ming dynasty desk furniture
Palace Museum, Beijing

Jade brush washers are the most frequently seen item of Ming and Qing desk furniture and are designed to hold the water in which brushes are washed whilst at the same time embodying the qualities of display and appreciation. Cleverly designed and in various geometrical shapes such as square, round, oval and overlapping square, they are frequently carved in the shape of plants like the lotus, peach, crab-apple, melon, gourd, and *lingzhi* fungus. At the same time the decorative impact in terms of shape and pattern is strengthened by the addition of carved handles in the shape of dragons, bats, flowers and children.

This piece is in the form of a sunflower with the inner wall carved as four sunflower petals with a raised stamen in the center. The outer wall is surrounded and carved with an intertwined pattern of blossoms, stalks and leaves. The base is formed of open-work carved stems and leaves and in a few places the surrounding leaf pattern extends over the rim of the vessel. The florid exhibitionism of the carving of this piece has all the obvious characteristics of the Ming dynasty.

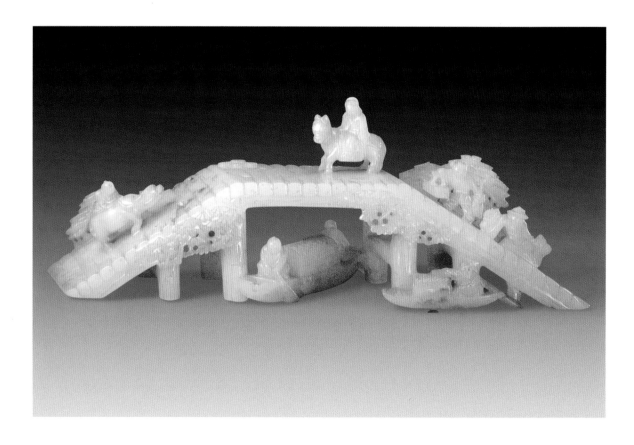

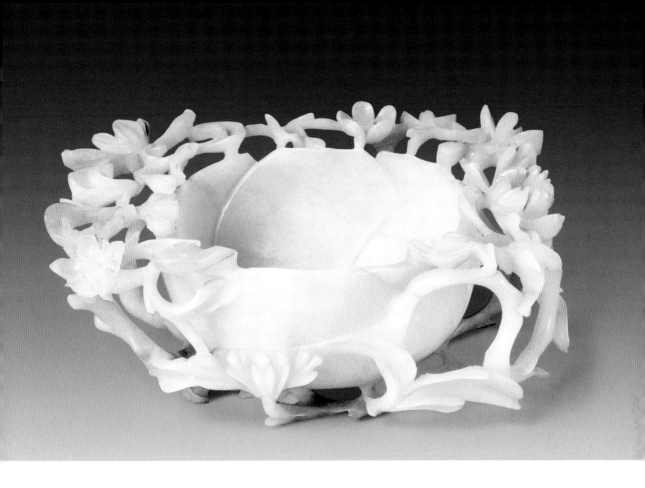

▶ Jade Ink Slab

Height 2.0 cm. Length 13.3 cm. Width 9.5 cm. Color blue-green, acquiring the color of old jade.
Qing dynasty desk furniture
Palace Museum, Beijing

Ink slabs are used for grinding ink. A fine ink slab should hold ink without damaging the brush, store the ink without drying out and grind ink soundlessly. The slab usually has a picture and is as much for appreciation as for practical use. Jade ink slabs have all these characteristics and are a major component of the studio's jades.

This ink slab is in the shape of the character 风 (*feng*, wind). The edges are raised and a depression has been ground away in the center, the space where the ink is ground is nearly elliptical and the well is almost oblong. A cartouche on the bottom is inscribed "*jia qing yu shang*"—"for the imperial appreciation of Emperor Jiaqing" in seal script. This piece is in the style of Tang ink slabs in the shape of the same *feng* character. Artificial ageing has endowed it with grace and dignity.

On page 116
Jade Pendant in the Form of Double Phoenixes

A Qing dynasty ornamental jade. The god-like bird the phoenix, is a frequently encountered traditional

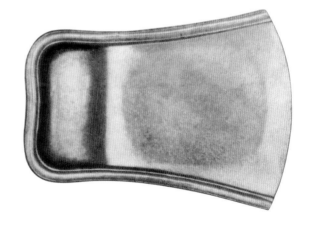

design in Chinese historical *objets d'art*. In this frequently occurring double phoenixes design, the phoenixes stand opposite each other with a *lingzhi* fungus in their beaks. Their necks are carved with incised long feathers and the bodies decorated with a scale pattern, the wings and long tails droop and the tail feathers are curled, while the feet stand on the tail. This beautiful piece is finely carved in a combination of the techniques of open-work and incision. The design is often used on jade pendants or on the surface of jade vessels.

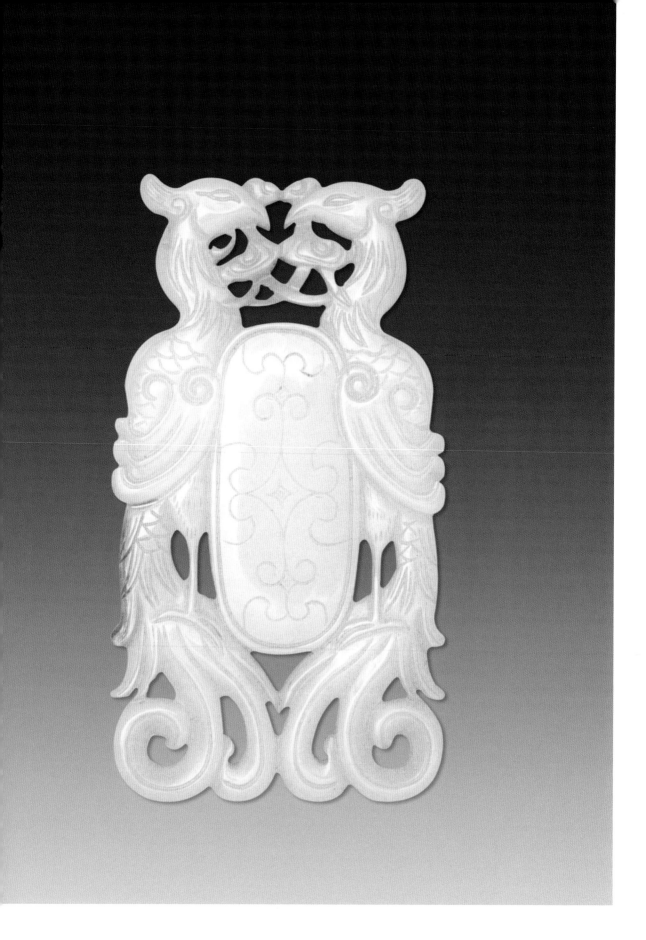

10. Jades in the Shape of Animals

From the Neolithic to the Qing dynasty, animals are almost a permanent subject for jade carving. The techniques of representation, from reflecting the characteristics and habits of animals to pictorial carvings of complete animals and their endowment as symbols of good luck, proceeded vividly from the simple to the elaborate and from the shallow to the profound.

There were already numerous jades in animal form during the Neolithic period. By the Shang and Zhou dynasties the variety of jades in animal form had greatly increased and there were dragons, tigers, bears, deer, horses, elephants, oxen, goats, rabbits and parrots. Most were carved from squared cylindrical jade with an emphasis on realism and variety of posture. Artistically, there was an emphasis on the characteristics of the habitual physical postures which the various kinds of animals adopted; there was no carving of hair or fur but the carving, instead, of a symbolic decorative pattern with double incised lines.

The Spring and Autumn and the Warring States period saw the introduction of technical innovations in jade carving developed from the basis established during the Western Zhou period. Very thin strips of jade were carved into pairs of dragon and tiger shapes, whilst at the same time fine straight lines were used to incise double hooked coiled snake or cloud patterns. Occasionally, circles were carved here and there to ensure that the design was evenly distributed throughout the jade.

Many animal jades carved in the round survive from the two Han dynasties, for example winged human figures mounted on a horse, which adequately display the superb three-dimensional carving skills of the Han dynasty.

The outstanding characteristic of Tang and Song pendants is the strength of their realism as it is expressed in their subject matter and the consequent production of large numbers of jade carvings of human figures, plants and animals.

During the Liao and Jin dynasties the nomadic peoples of the North produced carved jades with designs of a hawk catching a swan and of mountain tigers and deer, known respectively as "Spring water" jade and "Autumn hill" jade. These were subjects peculiar to the North.

During the Ming and Qing dynasties the jade carving industry flourished and there was a marked increase in the variety of carved jade animals. Their size also increased compared with previous dynasties. In point of characteristics, Ming animal jades are rather rugged in appearance, the carving uncomplicated and with little attention to fine detail. Generally the heads are rather small with numerous ridges on both head and face.

In the Qing dynasty, the animal bodies are more naturally proportioned, the carving exquisite and the subjects those with auspicious connotations.

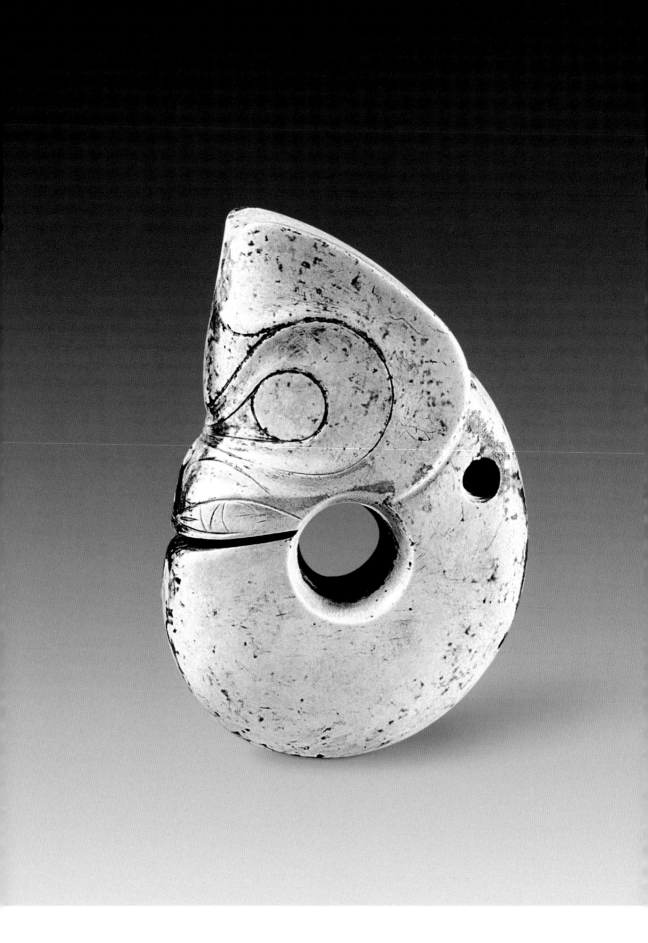

▶ Jade Dragon

Length 26 cm. Overall width 21 cm. Diameter of
section 2.3 – 2.9 cm. Diameter of hole 0.95 cm. Color
black/green.
Hongshan culture ornamental jade
Inner Mongolia Autonomous Region, Ogniud Banner,
Sanxingtala
National Museum of China

The earliest jades in the shape of dragons appear in
the Hongshan culture of 6,500 – 5,000 years ago. This
dragon jade is in the form of a reversed letter C, the
upper lip protrudes slightly and the mouth is tightly
closed but thrust forward. The nose is flat with a
sharp ridge along its length. There are two small
nostrils and ridged eyes. The eyebrows stand out like
the teeth of a comb. The forehead and the jaw are
both finely carved with a rhomboid lattice pattern.

There is a long mane on the back of the neck
which flows in a curve towards the rear, the two edges
form a blunt blade and there is a concave groove
on either side. The dragon's narrow body is curved
inwards and the tail is curled. There is a small hole on
the back of the dragon as if for threading a cord for
suspending the jade so that the head and tail are at the
same level.

This piece is carved in the round from a complete
piece of jade and is the earliest known jade dragon
and is known as "China's first dragon." Some people
believe that it was a clan emblem or totem.

◀ Jade Pig-Dragon

Length 15 cm. At widest 10.2 cm. Thickness at break
3.8 cm. Color blue-green, the surface stained to an
ivory white.
Hongshan culture ornamental jade
Liaoning province, Jianping county
Liaoning Province Archaeology and Cultural Relics
Institute

In the Hongshan culture dragons that lack feet, claws,
horns, scales or dorsal crest are representative of the
early period form. This piece is amongst the largest
and most regularly shaped of Hongshan culture pig-
dragons. It has an extremely large head, short fat ears,
large round eyes, wide mouth with lips thrust forward
and fangs and there are a number of incised wrinkle
lines on the nose. Because of its resemblance to a pig's
head this type of piece is known as a "pig-dragon."
The dragon body is thick and heavy with head/tail
curved into a ring, a smooth hole at its center. There is
an incomplete slit where head and tail meet and a hole
behind the ear drilled from both sides to take a thread.

▶ Jade Pendant in the Form of a Dragon

Color blue-green, completely clear.
Late Shang dynasty
Henan province, Anyang city, Yinxu
Chinese Academy of Social Sciences Institute of
Archaeological Research

▲ Jade Dragon-Shaped Pendant

Overall length 3.6 cm. Color milk white, semi-translucent, overall smooth and gleaming with some flaws.
Mid-Western Zhou period ornamental jade
Shaanxi province, Fufeng county, Qijia tomb No. 41
Zhouyuan Museum

The dragon has a curved body with wings and tail spread for flight, round eyes, curled upper lip, prominent nose, lower lip drawn back, a hole drilled from both sides in the mouth and blunt horns. The body is covered with a cloud pattern double incised with a slanting blade.

▼ Jade Dragon Pendant with Whirlpool Pattern

Length 9.9 cm. Thickness 0.4 cm. Color blue-green, some brown staining.
Late Spring and Autumn period ornamental jade
Shanxi province, Taiyuan city, Jinshengcun, Zhaoqing tomb
Shanxi Province Institute of Archaeology

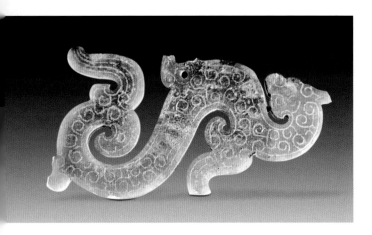

The majority of dragon forms dating from the Spring and Autumn Annals and Warring States period are in the shape of a single or double S. There are also examples where the body is crouched or cylindrical. Most dragon bodies have head or tail at either end, though there are examples which have carved double heads either face-to-face or back-to-back. The feet are clawed or winged. Some dragon bodies are clawless and serpentine. Apart from plainly decorated examples the most frequently encountered patterns include whirlpool, grain, curled cloud and joined hook cloud.

This piece has a curled tail, feet and horns. The whole body is finely incised in outline with a whirlpool pattern within the outline. The tail is decorated with a pattern of lines.

▶ Jade Dragon Phoenix Pendant Decorated with a Pattern of Hooked Clouds

Length 15.4 cm. Width 6.8 cm. Thickness 0.3 cm.
Color yellow/brown, semi-translucent and smooth.
The greater part of this jade has turned brown.
Late Warring States ornamental jade
Anhui province, Changfeng county, Yanggong tomb No. 2
Palace Museum, Beijing

During the Late Warring States period there were a number of complicated dragon shapes including coiled double dragons and five-looped dragons. The outer edges of the bodies of some dragons were exquisitely ornamented with phoenix patterns.

This piece is flat, open-work carved and in overall shape resembles an arc-shaped pendant (*huang*). The ends are carved with a pair of symmetrical dragons; the head of one is missing. A pair of phoenix is carved back to back beneath the body of the dragon. A heart-shaped pattern in between joins the two phoenixes. There is a hole in the upper portion of the pendant and a hole beneath the belly of each dragon from which further pendants could be suspended to form a set.

▶ Feather-Patterned Dragon and Phoenix Pendant

Length 6.8 cm. Width 5.9 cm. Color blue-green/yellow.
Warring States period ornamental jade
Henan province, Luoyang city, Jincun, Tomb of the
Eastern Zhou King
Nelson-Atkins Museum of Art, Kansas City

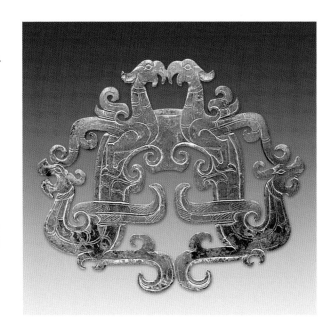

Flat with an intertwined open-work pattern of two
dragons and two phoenixes, the two dragons' heads
face away from each other, each open-mouthed
with the mane flowing back in a hook pattern, their
bodies joined and claws in the form of long hooks.
The upper part of each dragon's body is incised with
the form of a phoenix, its head facing away from the
other, beak slightly open, one foot on the body of the
dragon the other spread in flight and its tail drooping
down towards the dragon's head. Both the dragons
and the phoenix are ornamented with a milled
pattern of feathers and double hooks.

In Chinese culture, the combination of dragon
and phoenix represent the desire for a happy
marriage and a fulfilling life.

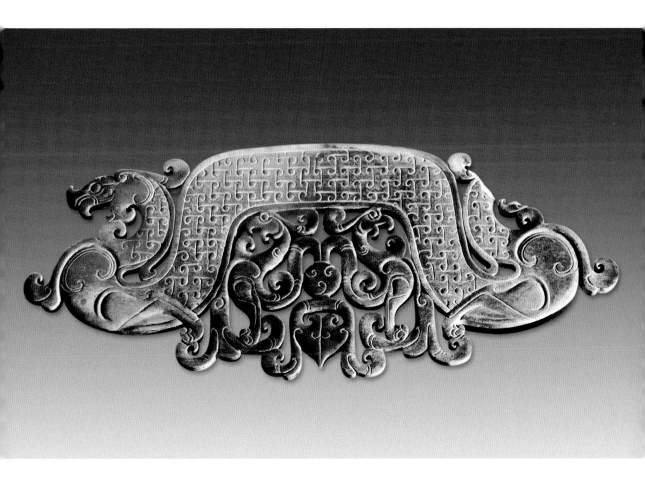

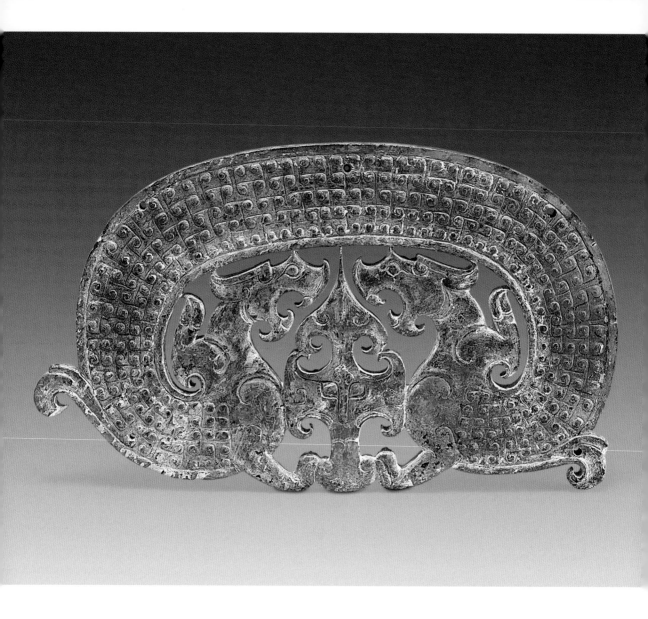

▲ Hook and Whirlpool Pattern Dragon Pendant

Length 10.2 cm. Width 6.0 cm. Thickness 0.4 cm.
Color blue-green, with heavy yellow/white staining.
Western Han ornamental jade
Guangdong province, Guangzhou city, Xianggang,
Tomb of the Nanyue King
Museum of the Mausoleum of the Nanyue King

After the Qin and Han dynasties the dragon became
the emblem of the feudal rulers and their families.
During the Han dynasty jade dragons developed into
a more coiled form. This piece is open-work carved
into the form of two dragons facing each other, their
bodies curled upwards into a conjoined arc, with a
wing outstretched to the lower left and right. There
is an animal face between the dragons with horns in
the form of pointed clouds and a long protruding
tongue which joins the dragon's fore-claw. All the
curved portions are sharply delineated, a classic
characteristic of finely worked Han jades.

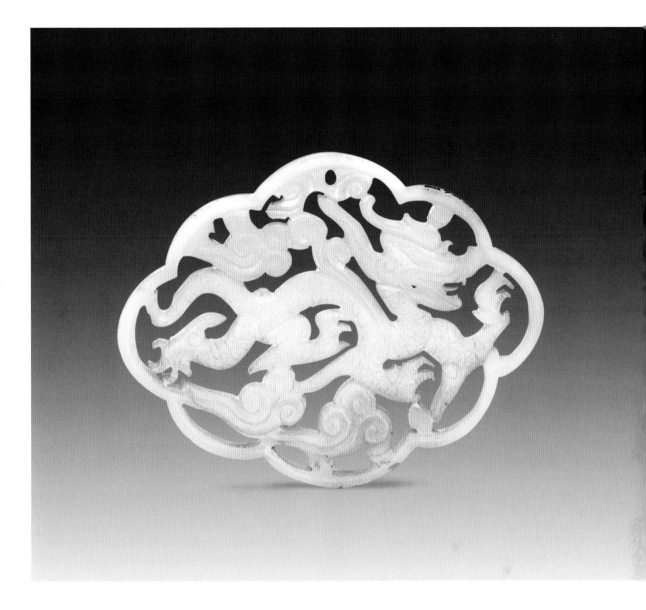

◀ Jade Cicada

Length 2.5 cm. Width 2.0 cm. Thickness 0.9 cm. Color
yellow/green with powdery white in places.
Shijiahe culture ornamental jade
Hubei province, Tianmen city, Shijiahe, Xiaojia Wuji
site, Funerary urn No. 6
Jingzhou Museum

The Shijiahe culture is a late Neolithic culture of
approximately 4,600 – 4,000 years ago in the middle
reaches of the Yangtze (*Changjiang*). The cicada is the
most numerous type of jade form, its importance
lying in the fact that it is the precursor of the jade
cicada forms of the Shang and Zhou dynasties.

▲ Dragon-Patterned Jade Pendant

Length 9.4 cm. Width 7.1 cm. Thickness 0.4 cm. Color
white.
Song dynasty ornamental jade
Palace Museum, Beijing

A characteristic of Tang and Song jade dragons was
an emphasis on using the background to enhance the
dragon as the principal subject by causing the dragon
to appear vividly in a particular environment, as, for
example, dragon and phoenix amongst flowers and
grass or playing with a pearl amongst ripples of water.

The Chinese dragon, as a divine animal, is
associated with good fortune, harmony and prosperity.
The meandering patterns of dragons and flowers
represent dignity and nobility.

This jade pendant takes the form of a plaque in
the shape of a crab-apple carved in open-work with a
similar pattern of clouds and dragons on both sides.
This is a typical Song jade of dragon form.

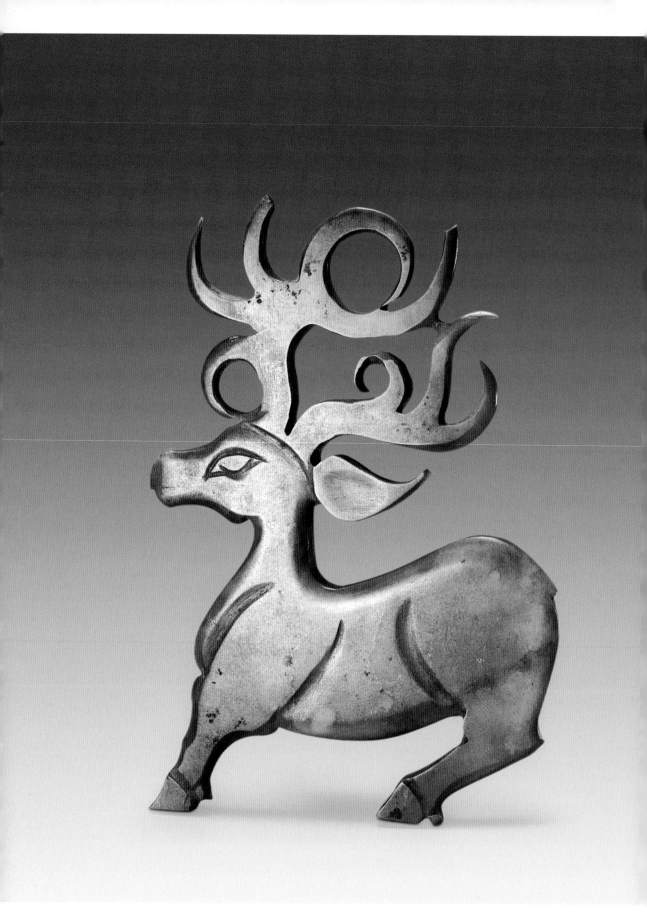

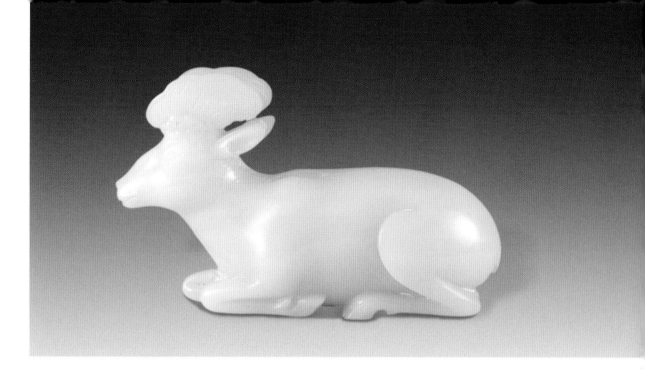

▲ Deer-Shaped Jade Pendant

Height 6.5 cm. Length 10.6 cm. Thickness
approximately 2.2 cm. Color blue-green, smooth and
flawless.
Song dynasty ornamental jade
Beijing, Haidian district, Beijing Normal University,
Qing dynasty tomb of Heisheli
Capital Museum

The design of a recumbent deer was one of the major
subjects of Song dynasty jade carving. Jade deer were
carved in two styles during the Song dynasty. The
characteristics of the first were a narrow head, antlers
either long or mushroom shaped, short tail, with
some deer holding *lingzhi* fungus or creepers in their
mouths. The second had well-fleshed deer usually
with bulging upper legs, chest, loin and rump. This
second style is also frequently seen in Song dynasty
jade camels and wild animals generally.

◄ Deer-Shaped Jade Pendant

Length 8.3 cm. Width 5.9 cm. Color yellowish brown.
Western Zhou ornamental jade
Shanxi province, Quwo county, Jinhou tomb group,
Tomb No. 63
Shanxi Province Institute of Archaeology

Because the characters 鹿 (*lu,* deer) and 禄 (*lu,* luck)
are homophones, deer have been symbols of good
fortune for several thousand years. Western Zhou
jade deer are the most characteristic of carved animal
jades with types that include deer that look to the
rear or forward, are recumbent or standing. Antlers
that rise from the head like a multi-forked young tree
are usually asymmetrical in form.

▼ Jade Pendant in the Form of Two Cranes Holding a *Lingzhi* Fungus in Their Beaks

Length 8.9 cm. Width 4.6 cm. Thickness 0.7 cm. Color
blue-green/white with some slight brown staining.
Song dynasty ornamental jade
Palace Museum, Beijing

Two open-work symmetrically carved cranes stand
opposite each other in a cluster of flowers, their
wings outstretched in an attitude of flight, grasping a
circular link between them in their beaks. Their wing
feathers are carved with finely incised lines. There is an
intertwined pattern of cirrus clouds round the lower
part of their legs. The link held between their beaks was
probably intended to take a cord for use as a pendant.

A rare bird in China, the crane flies high with its
call piercing the sky. In many Taoist stories, people that
become immortals eventually change into cranes. The
crane is thus regarded by Daoists as a divine bird and as
a symbol of longevity in China.

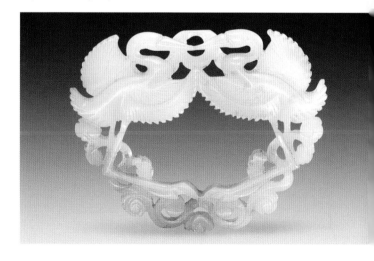

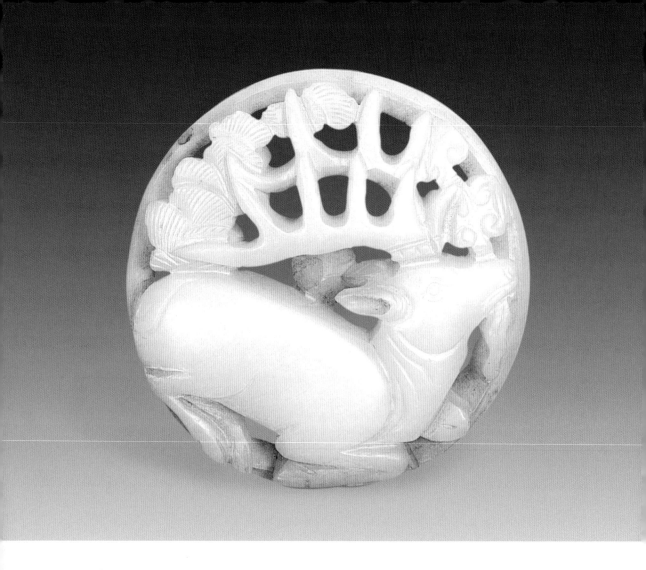

▲ Jade Pendant with Deer and Pine Trees

Diameter 6.8 cm. Color white.
Song dynasty ornamental jade
Palace Museum, Beijing

The surface is carved with a design of a deer and pine trees in open-work with the deer occupying the complete foreground in front of the pines, giving the appearance of both flatness and convexity. In the eyes of the Chinese people, the pine enjoys the title of "the immortal tree," representing longevity, because of its viality, strength and permanent greenness. The design has all the stylistic characteristics of Song dynasty paintings.

◀ Jade Fish Pendant

Length 4.7 cm. Thickness 0.3 cm. Color light green, semi-translucent.
Late Shang dynasty ornamental jade
Henan province, Hui county, Liulige tomb No. 150
National Museum of China

A considerable number of jade fish have been excavated from Western Zhou burials. Homophonous with "surplus," fish stands for affluence and abundance in traditional Chinese culture.

This piece is in the form of a flat arc with round eyes and open mouth. The back and belly have fins carved in fine lines; the tail is forked. The body is slightly curved as if swimming. There is one hole at the head and two on the tail. The decoration is the same on both surfaces of the jade.

▶ Jade Pendant in the Form of a Sacred Bird Carrying a Dragon on Its Back

Length 11.3 cm. Thickness 0.3 –
0.5 cm. Color yellow/brown, the tail
of the dragon tinged with light green.
Late Shang dynasty ornamental jade
Henan province, Anyang city, Tomb of
Fu Hao
Chinese Academy of Social Sciences
Institute of Archaeology

The forms of Shang dynasty jade
bird pendants from the surreal
phoenix to the kind of multi-
functional bird that exists universally
in the natural world can be divided
into two, the realistic and the
exaggerated. The jade birds of the
Western Zhou have flat, rectangular
bodies, mostly with circles as eyes
and just a few simple incised lines to
represent feathered wings and tail.
There is usually a circular hole in
the chest.

This Shang dynasty jade bird
pendant depicts, in carved relief,
the bird with the dragon on its back
stepping on a cloud to ascend the
heavens. The sacred bird stands
erect on a base with an incised
cloud pattern above symbolizing
the clouds. There is a dragon on
the back of the bird with its body
upright. The overall decoration
of this piece is the typically Shang
double hooked incised pattern. The
bird's wings are feather patterned
and the dragon's body and tail
are decorated with rhomboid and
repeated loop patterns, its chest is
carved with the pattern of an eye and
there are delicately curved eyebrows.
The decoration is the same on both
surfaces of the piece which may
have been designed on the basis of
contemporary mythology. It is the
only Shang dynasty example of its
kind.

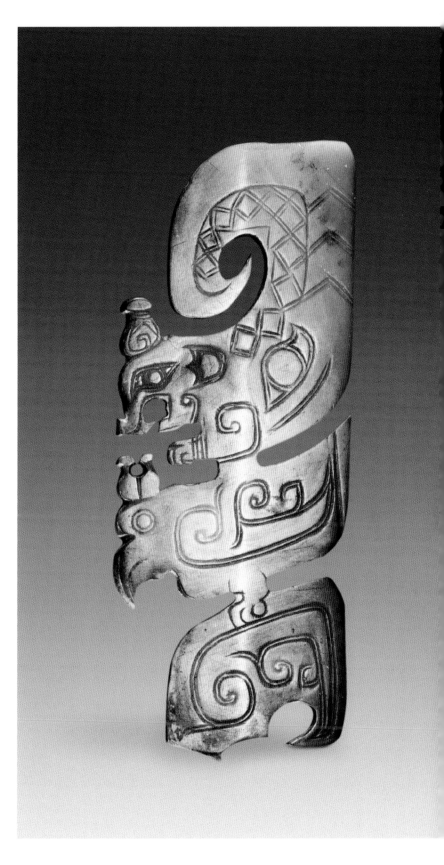

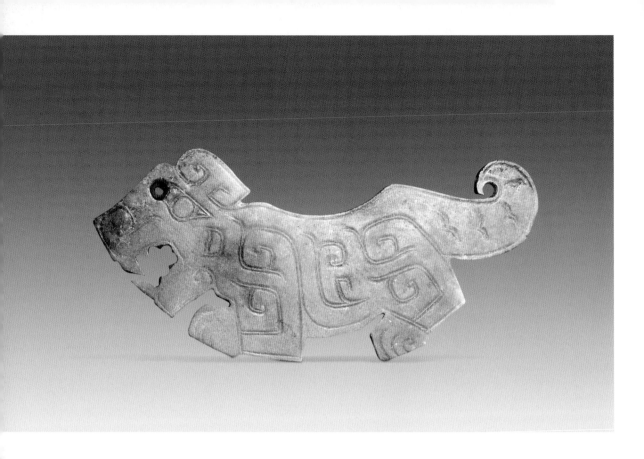

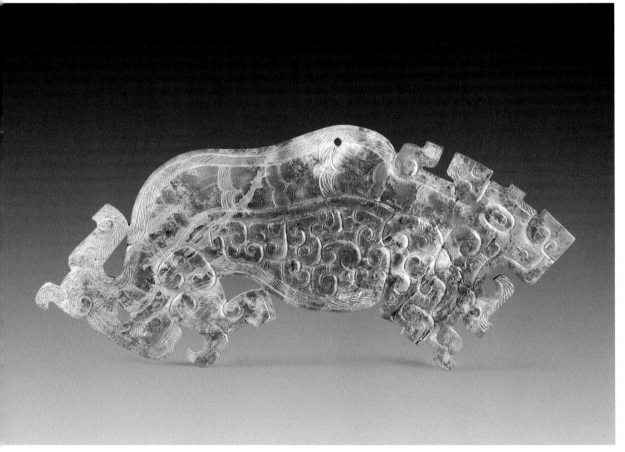

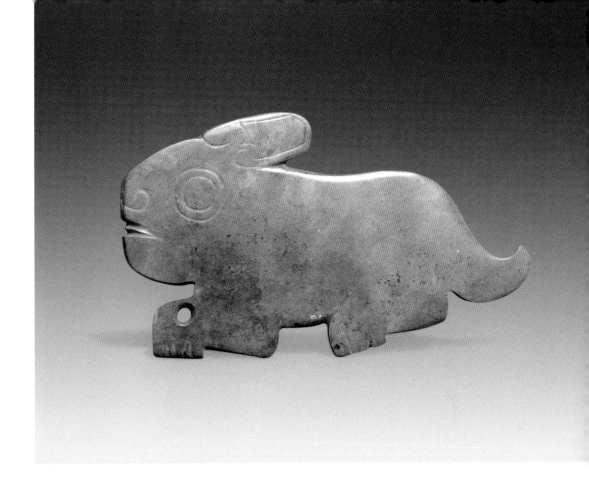

◀ Jade Pendant in the Form of a Tiger

Length 13.3 cm. Thickness 0.5 cm. Color green with grey yellow staining.
Late Shang dynasty ornamental jade
Henan province, Anyang city, Tomb of Fu Hao
Chinese Academy of Social Sciences Institute of Archaeology

Flat, with the tiger represented as walking with head raised, mouth open showing fangs and eyes in the shape of the character 臣. The tiger has cloud-shaped ears, its chest and flanks swelling, the tail slightly curled upwards, legs thrust forward and each foot carved with four claws. The neck is decorated with a double loop pattern changing to a curled cloud pattern on the body. The tail is decorated of double joined curves. This piece has all the characteristics of a typical Late Shang jade.

◀ Jade Pendant in the Form of a Tiger Ornamented with a Curled Cloud Pattern

Length 11.1 cm. Width 4.8 cm. Color glossy yellow/brown, with some patches of black.
Mid-Warring States period ornamental jade
Hebei province, Pingshan county, Nanqijicun, Accompanying grave to Zhongshanguo tomb No. 1
Hebei Province Institute of Cultural Relics

The majority of tiger shaped jades from the Mid-Warring States period are recumbent tigers that resemble the tiger emblem (*hufu*) very closely. All tiger jades of this period are ornamental. As the king of all animals, the tiger has the power to dispel evil. The jade carvers have both accurately grasped the characteristics of the tiger and boldly exaggerated and embellished them. For example, the large head, enormous mouth and teeth, the rectangular body and the use of long lines to represent the tiger's stripes. The spirit of the tiger is often reflected in the portrayal of the feet, on the move powerful and menacing, an unstoppable force, and crouched glowering, instantly ready to spring.

▲ Jade Pendant in the Form of a Rabbit

Length 10 cm. Width 5.8 cm. Thickness 0.5 cm. Color yellow/brown.
Late Shang dynasty ornamental jade
Henan province, Anyang city, Tomb of Fu Hao
Chinese Academy of Social Sciences Institute of Archaeology

Jade rabbits are first seen in the Yin and Shang periods and by the Shang and Zhou periods are quite common. This piece is flat and represents a rabbit running. The head is slightly raised with two round eyes, open mouth and protruding tongue. The nose is carved in outline and the ears are laid back. There is a fat, stumpy tail and the feet are thrust forward with the claws and toenails showing. There is a hole drilled through the foot.

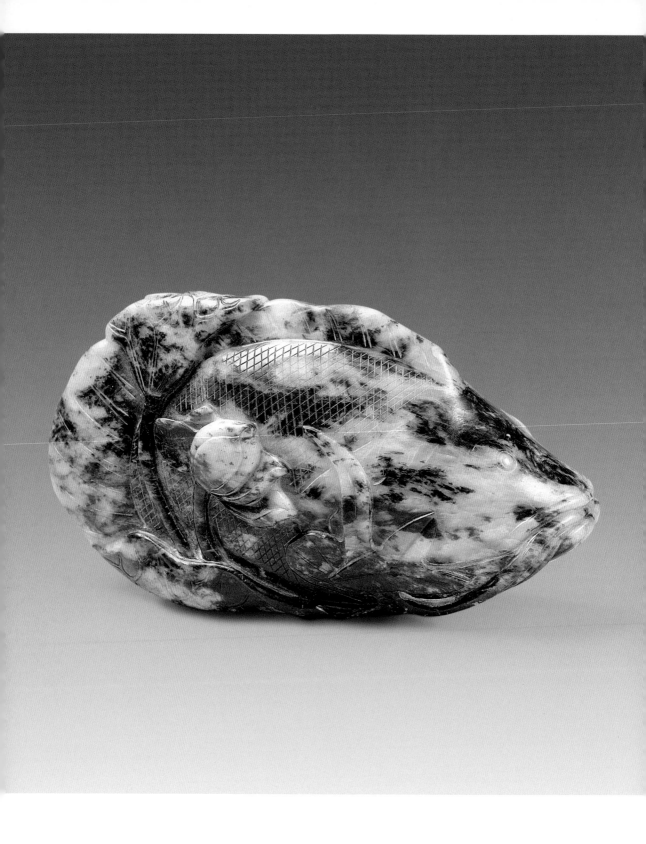

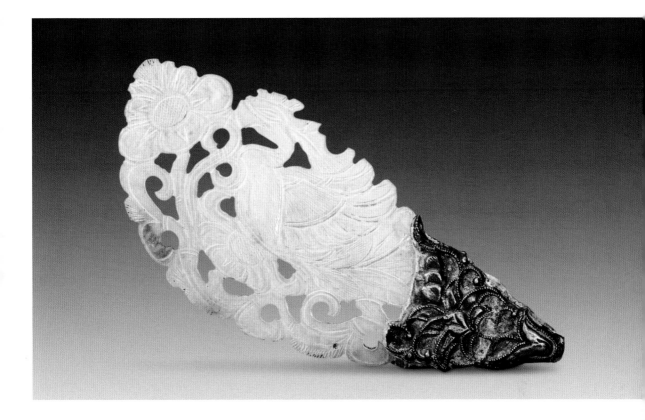

◀ Jade Pendant in the Form of a Mandarin Fish

Length 20.6 cm. Width 11.3 cm. Thickness 6.7 cm.
Color black speckled with yellow and white.
Song dynasty ornamental jade
Palace Museum, Beijing

The jade is flat and oblong. The fish is plump bodied with a broad dorsal fin which joins the tail fin. The fish has a lotus stalk with flowers and leaves in its mouth. The scales and tail fin are represented by fine incised lines.

▶ Jade Pendant in the Form of a Parrot

Height 4.4 cm. Length 7.8 cm. Width 2 cm. Color white.
Tang dynasty ornamental jade
Palace Museum, Beijing

The parrot has round eyes and a short beak with the mouth formed from a horizontal slit. The wings are stubby but the tail long and the lower body ornamented with a long tailed wave pattern. The bottom of the piece has a pair of holes for decorative purposes. Parrots were a popular decoration during the Tang dynasty.

▲ Jade Hair Ornament with a Pattern of Birds and Flowers

Length 11 cm. Width 4.8 cm. Thickness 0.3 cm. Color blue-green/white, with some staining.
Tang dynasty ornamental jade
Palace Museum, Beijing

The ornament is formed of two pieces, a gold hair pin (missing) and a jade hair ornament also known as a jade flower pin. The flower pin is open-work carved with the same incised pattern of a red phoenix facing the sun on each side. The peony flower stems at the base are pierced with two holes. The peony, in all its richness and fullness, symbolizing wealth, rank and good fortune.

Jade flower pins were part of the ornamental jade "dangles" (*yubuyao*) worn in the hair of aristocratic women of the Tang and Five Dynasties.

▲ Jade Pendant in the Form of a Horse

Height 4 cm. Length 6.8 cm. Width 3 cm. Jade
blackened by fire.
Tang dynasty ornamental jade
Palace Museum, Beijing

Mankinds has had a longstanding relationship with
the horse and regard its form as the combination of
power and beauty and its spirit as embodying loyalty
and righteousness.

The piece portrays a recumbent horse with its legs
tucked in and the eyes, mouth, nostrils, ears and mane
represented in bas-relief or incision. There is a hole
bored horizontally at the base of the tail. Jade horses
of the Tang dynasty tend to be rather less fierce and
plumper than those of previous periods.

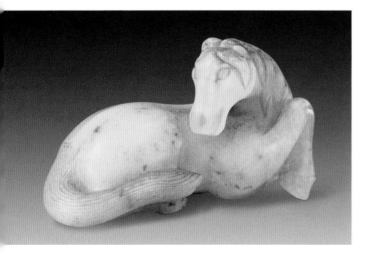

◀ Jade Horse

Height 4.5 cm. Length 8.3 cm. Width 3.3 cm. Color
blue-green with traces of aging.
Ming dynasty display jade for a scholar's study
Palace Museum, Beijing

A recumbent horse with its head turned over its
back, the right forefoot resting on the ground, the
remaining three tucked beneath the body and the
tail curved along the right of the body. The head is
comparatively short with incised rhomboid eyes. The
mane falls over the forehead and neck. The ridge of
the spine is raised.

11. The Human Form in Jade

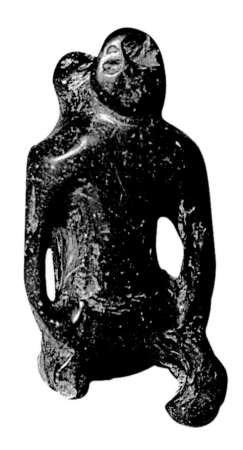

The human figure was a major subject of ancient Chinese jade and in terms of the form of carving employed can be divided into flat and sculpted.

Flat carved human figures were already present in the Neolithic age. The earliest carved jade human figures discovered are those found at the sites of the Daxi culture of 6,500 – 5,300 years ago in Wushan county, Sichuan province. The human figures of this period are mainly outlined in open-work carving with the detail incised. Human figures carved in jade were the photographs of primitive life and reflected the strong religious sense of primitive man.

Human figures in sculpted form start in the Shang dynasty. They were mainly excavated from the Tomb of Fu Hao at Yinxu, Anyang in Henan province where over 10 figures were found. The majority were carved in kneeling or crouching postures or with both hands resting on the knees and with different clothing, head covering and hairstyle according to status, and with strongly delineated facial features.

The human figures represented in carved jade are mainly figures of religious worship, historical heroes, immortals of popular legend and auspicious children or old people. The vast majority are Buddhist figures. This refers not just to the founder of Buddhism, Sakamunyi, but more broadly to all Buddhist images and apart from the Buddha himself, also to Bodhisattvas, to the various upholders of the Law, and to kings, Luohan and disciples of the Buddha. Buddhist figures of carved jade date mostly from the Yuan, Ming and Qing dynasties.

▲ **Jade Pendant in Human Form**
Length 6.8 cm. At the widest 3.5 cm. Thickest 3.0 cm.
Color black.
Daxi culture ornamental jade
Chongqing, Wushan County, People's Hospital site
Wushan County Cultural Objects Management Bureau

The Daxi culture is a Neolithic archaeology of the middle reaches of the Yangtze (*Changjiang*) of 6,500 – 5,300 years ago. This piece is a sculpted figure comprising a large and a small human, one on the back of the other. The hands of the half squatting larger figure rest on its knees with the smaller figure pressed against its back. The eyes of the larger figure are represented by two holes and the smaller figure has three holes and dots representing two eyes and a mouth. The surface of this rudimentary shaped piece has been worn smooth.

◀ Jade Human

Length 8.1 cm. Width at shoulders 2.3 cm.
Thickness 0.5 cm. Color grey white.
Lingjiatan culture ornamental jade
Anhui province, Hanshan county, Lingjiatan site, Tomb
No. 29
Anhui Province Institute of Archaeology

The Lingjiatan culture is a Neolithic culture of
5,500 – 5,300 years ago. This complete figure of a
man is a flat oblong. The face is carved in fine detail.
The two rows of square pattern above the forehead
may relate to the decoration of the head-dress.
The body is symmetrically proportioned and the
modeling superior, displaying both the appearance
and the elegance of primitive early man in the
Jianghuai area.

▶ Jade Pendant in the Form of a Human Head

Height 8.5 cm. Width of face 4.0 cm. Color blue-
green/white, smooth and glossy.
Western Han ornamental jade
Shaanxi province, Xianyang city, Weicheng district,
Zhoulingxiang Xinzhuangcun
Xianyang Museum

The eyebrows, eyes and moustache are portrayed
with finely incised lines. The eyes are long and
slender, the lips thin and the ears large. The bridge
of the nose is comparatively low and there the air of
an inhabitant of the Northwest about the face. There
is a round cap on the head and a natural hole behind
the crown of the cap. There is some damage to the
neck of the piece. Comparatively few Han dynasty
heads of jade have been excavated and this is the
only funerary head to have been excavated from an
archaeological dig so far.

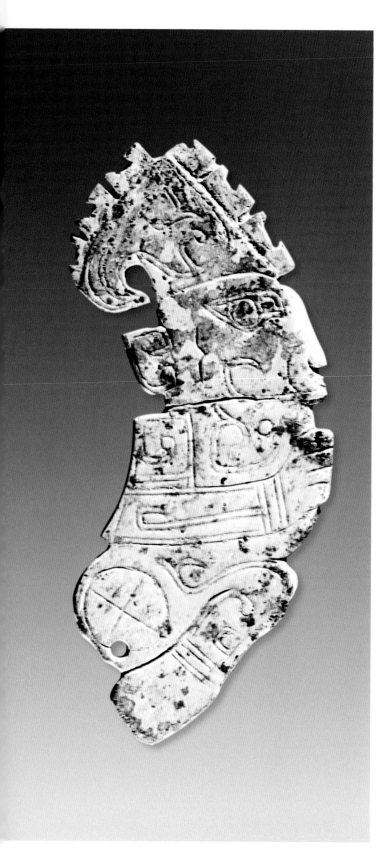

◀ Crested Human Jade Pendant

Length 10.2 cm. Width 3.5 cm. Thickness 0.5 cm.
Color chicken bone white, with some brown
staining, opaque.
Late Shang dynasty ornamental jade
National Museum of China

Shang period flat jades portraying the human
form are either profiles or heads of mythical
figures. Pieces in profile are carved in relief
and are usually of squatting figures with the
head slightly raised, a high nose and protruding
mouth, eyes in the shape of the character 臣 and
ears formed from a cloud pattern.

In this piece the head is surmounted by a
tall crest with serrated segments, the arms are
raised and the hands clasped on the chest. The
legs are bent. Both sides of the jade are carved
with a similar double hook pattern. The bottom
of the piece has a short shallow slot and hole
possibly for mounting. In the Shang dynasty,
representations of mythical figures are portrayed
as a flat oblong with the central portion carved
in bas-relief with the face of a mythical figure
or beast with 臣 eyes, cloud pattern nose, large
mouth slightly agape with hook patterned fangs
at the corners, earrings and a tall cylindrical
feathered head dress. These are possibly gods
worshipped by the ancients.

This pendant is powerfully carved with the
double incised line blade technique typical of
the Shang dynasty. Examples of this type of
portrayal in profile are comparatively numerous
in this dynasty.

▶ Jade Figures

Two items. Right: Length 17.6 cm. Width 2.3 cm.
Thickness 1.0 cm. Left: Length 7.9 cm. Width
1.1 cm. Thickness 0.8 cm. Color pale yellow.
Early Western Han dynasty display jade
Gansu province, Lingtai county, Baicaopo No. 1
and 2 tombs
Gansu Provincial Museum

Jade representations of humans in the Western
Zhou dynasty take the form of flat jade oblongs
of no standard size with the same pattern on
each side and generally portray the subject in
squatting profile. The carving of the head is
complete and the faces, unlike those of the
Shang dynasty, are not depressed downwards
but by the late Western Zhou dynasty are almost
level. The face is quite long; there are cloud
pattern ears; the forehead is raised, the nose and
jaw slightly convex and the representation of
the body somewhat abstract. In particular, the
eyes have developed from the 臣 pattern of the
Shang dynasty into a form where the corners
of the eyes extend beyond the eye socket in a
scrolled pattern, in some examples the eyes on
both sides extend beyond the sockets with a

small incised pattern in the eyebrow.

The body patterning is not as stiff as that of the Shang dynasty and curved lines predominate over straight. The carving is also not as fine and detailed as that of the Shang. Sculpted Western Zhou figures divide into the clothed and the unclothed. The heads of the clothed are comparatively large and adorned with a feathered headdress or crest. The unclothed have both hands folded over the stomach and the head with hair worn in a spiral or adorned with a crest.

These two early Western Zhou figures are very different in appearance. The larger has its hair in snake-like coils ornamented with a tiger head pattern and is unclothed with the hands resting on the stomach and both ears pierced. The smaller has a multi-pointed crest with its body apparently clothed in a gown with four incised twist patterns at the top and bottom intersecting in the middle of the back as if the figure were bound. There is a small hole in the chest.

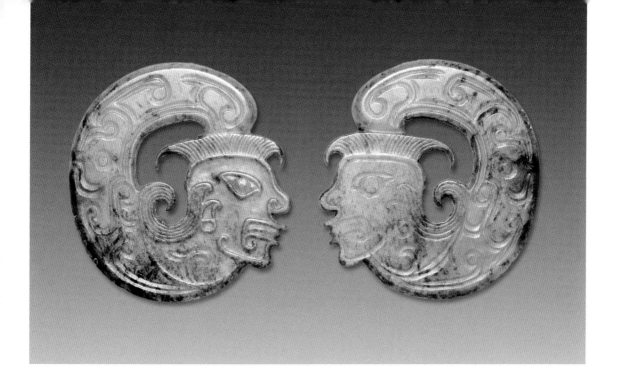

▲ Jade Pendant with Human Head

Two items. Diameter 3.8 cm. Thickness 0.2 cm. Color glossy yellow.
Early Spring and Autumn period ornamental jade
Henan province, Guangshan county, Baoxiang Temple, Tomb of Huang Junmeng and consort
Henan Museum

There are a number of types of human form jades dating from the Spring and Autumn period, with flat carved jades mostly displaying the whole human form, usually with holes at the top or slots at the bottom so that the piece could be hung as a pendant or mounted. Sculpted jades are finely worked and highly polished and designed for display. At the same time, these human form jades are also valuable for research into the appearance, clothing and personal adornment of the people of the time.

These two pieces are similar in thickness and decoration. Both are flat but ovoid in shape. There is a difference in the decoration of the obverse and reverse surfaces of each. The piece on the right has incised hair, eyes, ears, mouth and nose and a snake body on one side. The other side is more or less the same but with eyes of a circular pattern. The piece on the left has incised patterns on one side but a raised decoration on the other. Both pieces are in profile, the ears adorned with circular earrings and probably represent a man and a woman. The carving is exquisite and the representation of a human head on a snake's body unusual. Amongst all jades so far excavated, these pieces are outstanding.

◀▶ Jade Pendant of a Dancing Figure

Length 3.5 cm. Width 3.5 cm. Thickness 1.0 cm. Color blue-green, heavily stained and with some corrosion.
Western Han ornamental jade

Guangdong province, Guangzhou city, Xianggang, Tomb of the Nanyue King
Museum of the Mausoleum of the Nanyue King

This is a sculpted figure of a dancing woman. The dancer has her hair dressed in a spiral to the right of the head and wears a long sleeved gown and skirt with the right sleeve trailing, the sleeve opening and hem decorated with a pattern of rolled clouds and flowers. The dancing girl poses attractively with swinging hips and knees bent as if kneeling, one arm raised and the other drooping. A fine example of a Western Han dancer.

Below is the back view of the dancing figure.

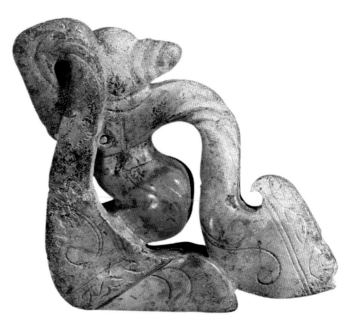

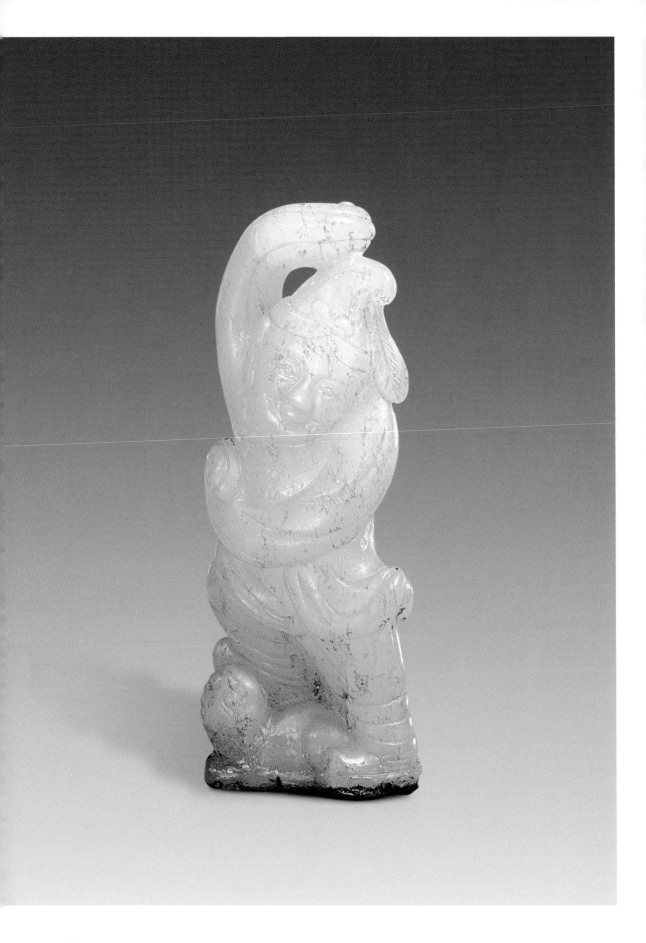

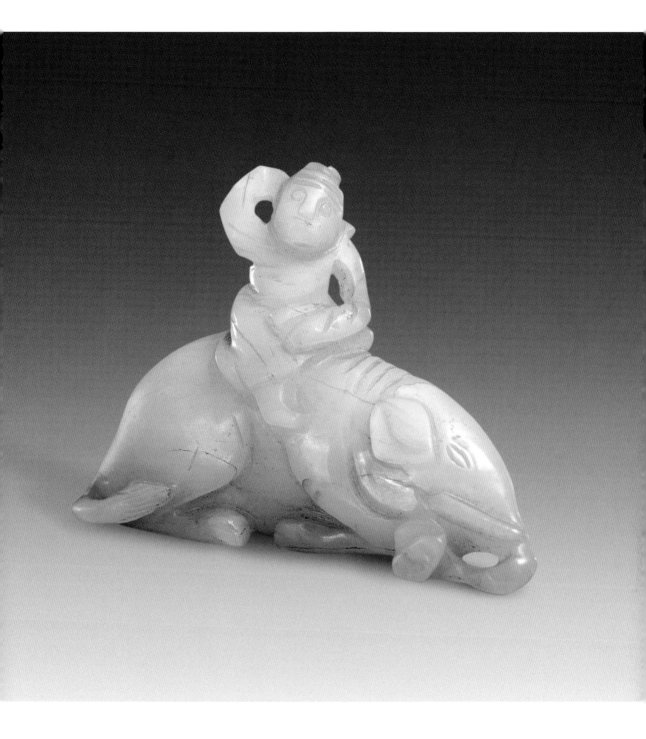

◄ Barbarian Lion Tamer Jade

Height 5.7 cm. Width 2.2 cm. Color blue-green/white.
Tang dynasty display jade
Palace Museum, Beijing

A sculpted figure of a barbarian in a Phrygian cap
with a semi-recumbent lion. The barbarian gestures
with his hands and plays with the lion in a stamping
dance.

▲ Jade Figure of a Man Riding an Elephant

Height 5.5 cm. Length 7.3 cm. Color blue-green/white,
with some yellow staining in parts.
Tang dynasty display jade
Palace Museum, Beijing

A kneeling elephant carved as an oblong with a man
riding on its back. The man is clad in a short-sleeved,
long gown gathered at the waist and wears high
riding boots. He sits cross-legged on the elephant's
back with his left hand resting on his knee and his
right behind his head.

▼ Two Children at Play Pendant Jade

Height 5.8 cm. Width 3.5 cm. Color blue-green with some white earth stains.
Yuan dynasty ornamental jade
Shaanxi province, Xi'an, Beijiao Liucunbao
Xi'an Municipal Institute for the Preservation of Cultural Artifacts

This is a three-sided piece carved to represent two plump-faced children at play. They are dressed in wide-sleeved long gowns with round collars. Their hair, worn over the forehead, and the creases in their clothing are represented by incised lines. One child half kneels on the ground clasping a lotus stem, his head turned to the left whilst the other rides on his back with his left hand resting on the other child's forehead and his right gripping a lotus stalk. There are a number of holes in the lotus leaves.

▶ Jade Buddha

Height 11.5 cm. Length at base 8.1 cm. Width 5.2 cm.
Color blue-green.
Ming dynasty display jade
Palace Museum, Beijing

Wearing a crown the Buddha sits, full faced, with shoulder length ear lobes and eyes half-closed, on the back of a beast. One foot rests on a lotus seat and the other on the shoulder of the beast. The Buddha's right hand rests on his knee and his left on the flank of the beast. He is clothed in a long tunic and long trousers. Jeweled necklaces are carved at his chest and below the waist. The bellowing beast lies on the lotus seat with its head raised to the rear, with bushy eyebrows and protruding eyes, the tangled hair of its mane thrown back and its long tail curled round the Buddha's foot. The lotus seat is decorated with a circlet of lotus leaves. This vigorously carved piece is very much in the Ming style.

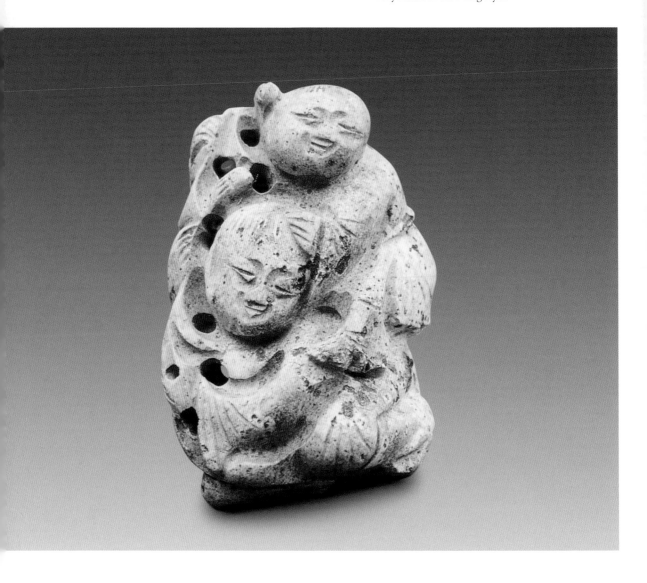

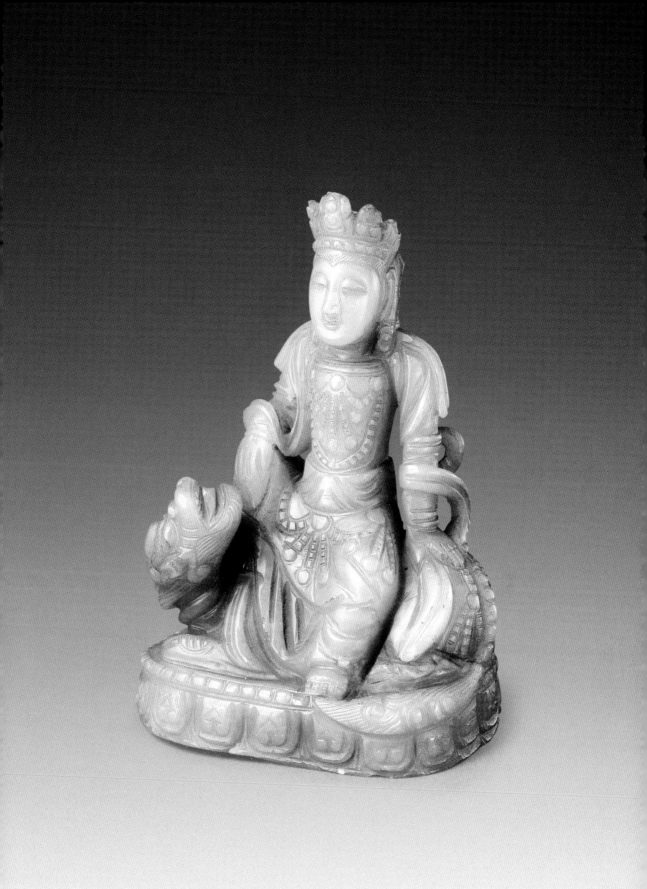

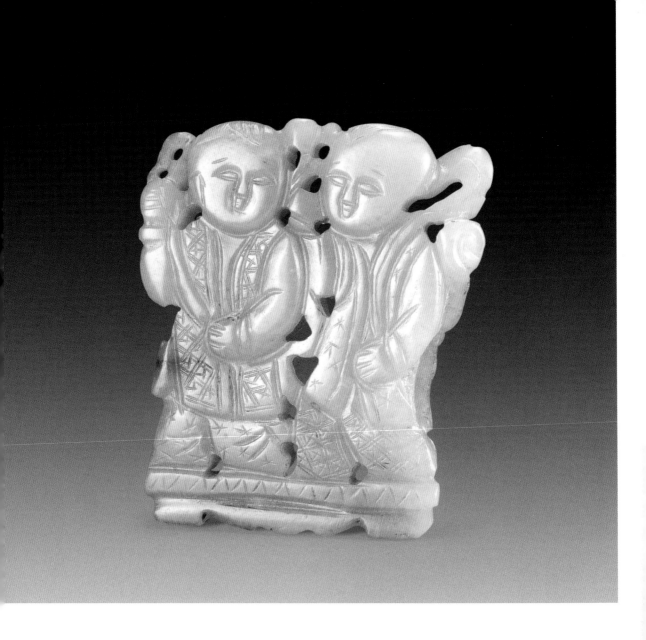

▲ Jade Pendant in the Form of Two Children

Height 6.1 cm. Width 5.5 cm. Color blue-green/white.
Song dynasty ornamental jade
China Cultural Artifacts Information and Enquiry
Center

During the Song dynasty the main form of jade carving was representations of children, the commonest subject being children holding lotus leaves. The picking and bearing of lotus leaves and flowers was a fashionable custom in Song society.

The beauty of lotus leaves has been extolled in classical essays dating back to ancient times. It is an important symbol in traditional Chinese culture as "lotus" is homophonous with "peace" and "harmony." The image of children bearing lotus flowers represented the hope of peace and success for a child.

In this piece one child holds a lotus stalk in its right hand with the arm bent and the stalk drooping to the left and the other child holds a lotus in the left hand with the stalk supported over the rear of the right shoulder. The delicate portrayal of the hair-style and hair is in the classic fashion of Song jades.

12. Jades in Ancient Bronze Style

During the Ming and Qing dynasties, the production of jades in ancient style gradually became one of the main categories of jade manufacture. The models upon which these jades were based were mainly ancient bronzes. During the Ming and Qing dynasties, bronze ritual food vessels (*ding*), food vessels with handles (*gui*), sacrificial food vessels (*dou*), three-legged wine-cups (*jue*), wine vessels (*zun*), and ewers (*yi*) were important forms for stylistic imitation in jade. In general, the jade stone is of superior quality and the carving exquisite.

▼ Jade Food Vessel (*gui*) Ornamented with Animal Ears and Face Pattern

Height 15.2 cm. Diameter at mouth 21.6 cm. Width 31.5 cm. Color blue-green, with some blemishes.
Mid-Qing dynasty jade in ancient style
Palace Museum, Beijing

The *gui* was a ritual bronze vessel for holding food. This piece is in the shape of a bronze *gui* of the Shang dynasty. On either side there is an animal holding the rim of the vessel in its mouth. Beyond the rim there is a thunder pattern and on the neck of the vessel there is a carved pattern of the one-legged dragon and phoenix on a cloud ground. The belly of the vessel has a carved thunder pattern on a brocade ground over stylized animal faces. The base is inscribed in clerical script with the four characters *"qian long fang gu"*—"made in ancient style in the Qianlong reign."

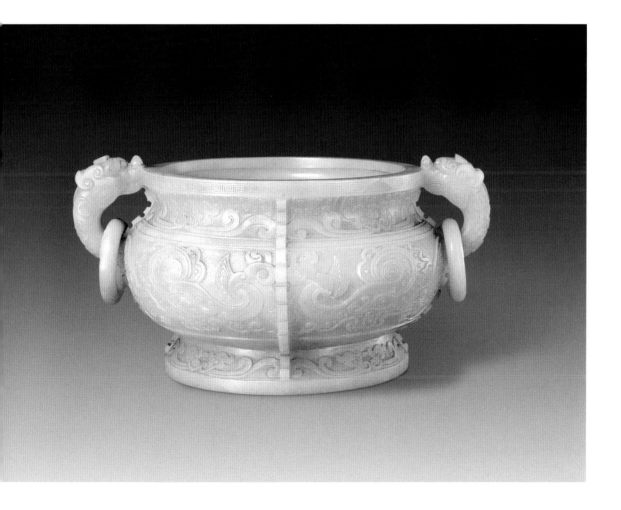

▲ **Jade "***Zhaofu***" Ritual Food Vessel (***ding***)**

Height 25.15 cm. Length 20.9 cm. Width 13.8 cm.
Color deep blue-green.
Mid-Qing dynasty jade in ancient style
Palace Museum, Beijing

In its shape, decoration and inscription this piece
imitates the bronze *zhaofu* ritual vessels. A thunder
pattern circles the mouth of the piece and its belly
is decorated with the face of an animal in relief. The
outer surface of the legs is decorated with a pattern
of stylized cicadas. The inner wall bears an imitation
ancient inscription. On the base there is an incised
inscription in clerical script in three vertical rows "*da
qing qian long fang gu*"—"made in ancient style in the
Qianlong reign of the great Qing."

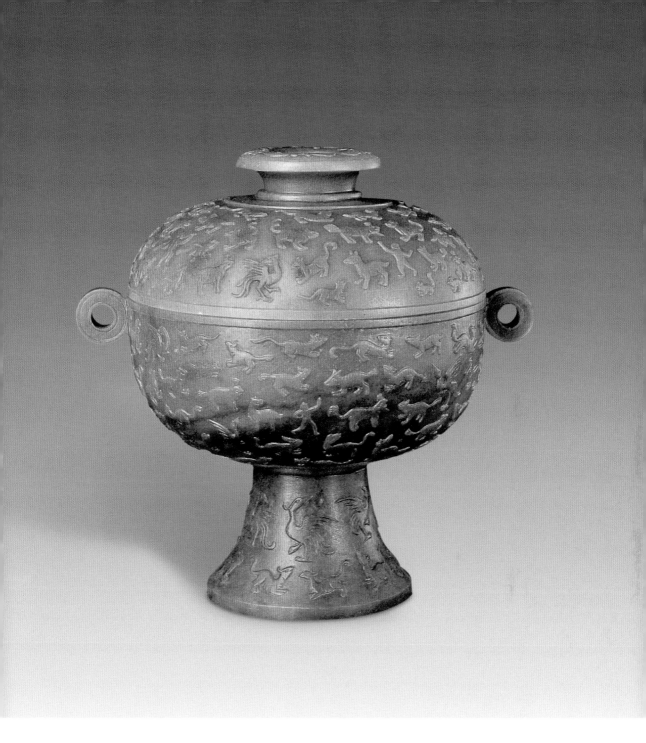

▲ Jade Sacrificial Food Vessel (*dou*) with Hunting Scene Pattern

Height 25.15 cm. Diameter at mouth 15.8 cm. Width
20.9 cm. Color dark green.
Mid-Qing dynasty jade in ancient style
Palace Museum, Beijing

The basic bronze *dou* shape consists of a shallow
dish on top, a handle, and circular feet beneath. Jade
models in ancient style follow this shape and carve
the decoration on the basis of the respective dates of
their bronze originals.

This vessel is in the shape of a high stemmed
bowl. There is a round handle on either side. The lid,
belly and foot are carved in the style of a commonly
seen Warring States bronze hunting scene pattern
of people, galloping animals and birds in flight. The
handle of the lid is carved with four patterns of a one-
legged dragon and phoenix. The interior of the foot
is carved with the six character mark "*da qing qian long
fang gu*"—"made in ancient style in the Qianlong reign
of the great Qing" in clerical script.

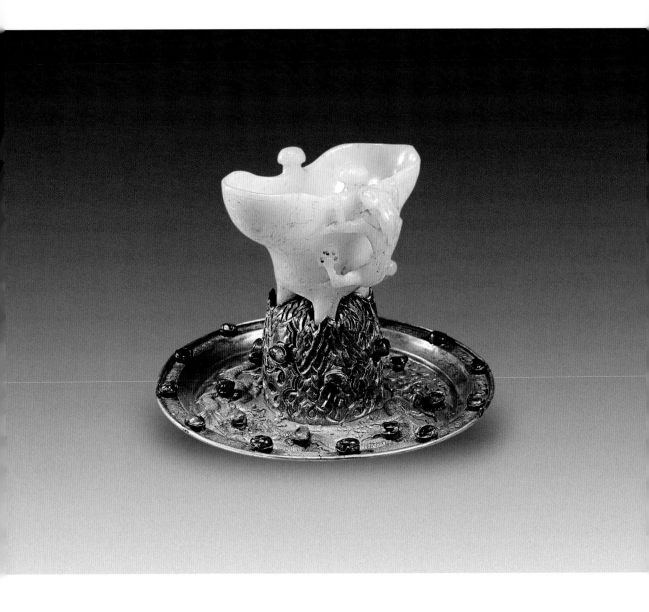

▲ Jade Dragon-Patterned Ritual Wine-Cup (*jue*) on a Gold Stand

Height 11.5 cm. Depth of vessel 5.8 cm. Length 13.2 cm. Width 5.6 cm. Color antiqued white.
Beijing, Changping district, Ming Dynasty Tombs (*Ming Shisanling*), Dingling tomb
Late Ming dynasty jade in antique style
Dingling Tomb Museum, Beijing

The jade *jue* is one of the major types of antique style jades and is manufactured in the form of ancient bronzes. During the Shang and Zhou period the bronze *jue* was a wine vessel. In form it was generally larger at the top than the bottom with a wide curved oval lip with a pourer at one end and tail at the other. Beneath the belly the vessel had three tall, slender feet that slanted outwards. The belly was decorated with a carved pattern of clouds and thunder, one-legged dragon and phoenix with one-legged dragon pattern. Some were ornamented with corner ridges.

This piece is in the shape of an ingot with a dragon handle on one side. The outer surfaces of the pourer and tail are carved with a frontal view of a dragon holding a character in its front claws. The character 万 (*wan*, ten thousand) is on the pourer and 寿 (*shou*, longevity) on the tail. The body is carved with *ruyi* ends pattern. Although the blueprint for the shape of this piece is a bronze, it contains elements of Ming fashion such as the carved hornless dragon handle. Moreover, the gold stand and inlaid jewels are a form of decoration frequently encountered in pieces made for the use of the Ming emperors. This piece displays both elegance and luxury.

▶ Dragon-Patterned Jade Wine Vessel (*zun*)

Height 16.3 cm. Diameter at mouth 9.5 – 16.1 cm. Color blue-green/white.
Qing dynasty jade in ancient style
Palace Museum, Beijing

The *zun* is a wine vessel with a very wide mouth, a slender neck, drum-shaped belly and tall round feet. There are also animal shaped *zun* known as bird-beast *zun*. Both these types can be found amongst jades in ancient style. They generally follow the bronzes in patterning and decoration, though some introduce fashionable Ming and Qing elements in shape and decoration.

This piece is ovoid in shape with four handles sculpted in the open-work form of butterfly and moveable ring sets. The butterflies are extremely realistic and would not be found on an ancient bronze though they are a frequent subject in the realistic decoration of the Ming and Qing. There is a stylized one-legged dragon decoration in bas-relief on the neck. This is a type of stylized decoration in ancient style based on the ancient one-legged dragon pattern. There is a deeply carved-out double dragon and double *chi* dragon pattern on the belly. The foot is decorated with twelve *ruyi* ends cloud patterns, a pattern frequently used during the Qing dynasty, indicating "things go as one wishes."

▶ Twisted Pillar-Handled, Animal-Shaped Jade Ewer (*yi*)

Height 21.5 cm. Width 18.3 cm. Color pure smooth white.
Mid-Qing dynasty jade in ancient style
Tianjin Museum

Ancient bronze ewers were used for pouring water. In the Ming and Qing dynasties they were an important form for jades made in ancient style.

This piece is separated into lid and body with the lower portion of the body in the shape of a round food vessel (*ding*) beneath which are four hoof shaped feet. The *ding* is attached above to an animal shape, the head of which acts as a pourer with a moveable ring beneath the jaw. A double twist pillar forms the handle and the knob on the lid is sculpted into an open-work flower shaped ring set. The lid and body are both carved in a combination of incision and bas-relief with a design of animal faces and one-legged dragons.

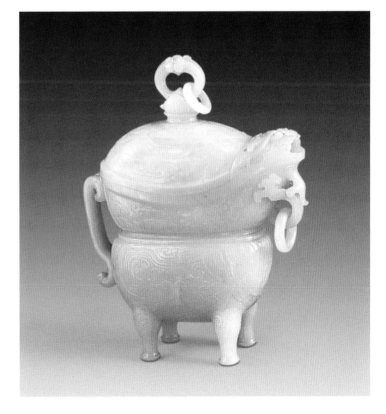

13. Mughal Jade and Jades in Mughal Style

Mughal jade known in short in China as *hen* (for Hindustan) jade was the name by which the Emperor Qianlong knew the jade produced during the 17th and 18th centuries in the area that lies in the north of the present India and Pakistan. After Qianlong pacified the Xinjiang north-south route in the mid 18th century, a large amount of this jade found its way to the court through Xinjiang as tribute. Because of the smooth luster of the jade stone and the quality of its workmanship, Mughal (Hindustan) jade acquired the esteem of Qianlong. However, the amount of Mughal jade that reached the court was limited and insufficient to satisfy the needs of the emperor who ordered the court jade smiths to produce jades in Mughal style.

Jade produced by the smiths in this style bears the characteristics of traditional Chinese culture and workmanship. It is said that the difficulty of carving the undulating texture of the inner and outer surfaces of this sort of thin jade wall is extreme and that the carving was undertaken mainly by the jade smiths of Zhuanzhu Lane in Suzhou and displays their superb craftsmanship.

▲ Jade Powder Horn

Length 10.9 cm. Width 2.8 cm. Color blue-green suffused with grey, black in some places.
Mid-Qing dynasty Mughal jade
Palace Museum, Taipei

The whole piece is carved into the shape of an animal horn. The larger end has a round stopper separated with gold thread which cannot be opened. The smaller end is carved into the shape of a goat's head with eyes of inlaid gold thread and red glass. The stopper is decorated with a flower pattern with a knob of jade forming the stamen surrounded by carved petals. The body of the horn is decorated with a pattern of leaves. There is a metal spring-mounted opener on the top.

Powder horns were for holding gunpowder for pouring down a gun barrel and it is possible that this piece was for play rather than actual use. Powder horns were an important category of Mughal jade. The decorative design and technique of this piece are in the classic Mughal style.

◄ Jade Pumpkin-Shaped Teapot with Goat's Head Spout

Height 15.4 cm. Length 17.8 cm. Width 12.7 cm. Color lustrous white and blemish free.
Mid-Qing dynasty jade in Mughal style
Palace Museum, Taipei

The body of the teapot is carved to the shape of a pumpkin. The spout is a goat's head in relief and the foot is carved in the shape of a twelve-petalled opening flower. The hooped handle is formed from three twisted strands of jade joined at the top by a semi-circular carved lotus seed pod. This piece was originally on display in the Yongshou Palace of the Forbidden City. The teapot is a traditional Chinese form. Animal and plant shapes and patterns are an important characteristic of Mughal jades. This pumpkin-shaped teapot with a goat's head spout is a classic example of a Chinese jade in Mughal style.

APPENDICES

Dates of the Chinese Dynasties

Xia Dynasty （夏） .. 2070 – 1600 BC

Shang Dynasty （商） ... 1600 – 1046 BC

Zhou Dynasty （周） .. 1046 – 256 BC

 Western Zhou Dynasty （西周） 1046 – 771 BC

 Eastern Zhou Dynasty （东周） 770 – 256 BC

 Spring and Autumn Period （春秋） 770 – 476 BC

 Warring States Period （战国） 475 – 221 BC

Qin Dynasty （秦） .. 221 – 206 BC

Han Dynasty （汉） .. 206 BC – 220 AD

 Western Han Dynasty （西汉） 206 BC – 25 AD

 Eastern Han Dynasty （东汉） 25 – 220

Three Kingdoms （三国） ... 220 – 280

 Wei （魏） .. 220 – 265

 Shu Han （蜀） .. 221 – 263

 Wu （吴） ... 222 – 280

Jin Dynasty （晋） ... 265 – 420

 Western Jin Dynasty （西晋） 265 – 316

 Eastern Jin Dynasty （东晋） 317 – 420

Northern and Southern Dynasties （南北朝） 420 – 589

 Southern Dynasties （南朝） 420 – 589

 Northern Dynasties （北朝） 439 – 581

Sui Dynasty （隋） ... 581 – 618

Tang Dynasty （唐） ... 618 – 907

Five Dynasties and Ten Kingdoms （五代十国） 907 – 960

 Five Dynasties （五代） 907 – 960

 Ten Kingdoms （十国） 902 – 979

Song Dynasty （宋） ... 960 – 1279

 Northern Song Dynasty （北宋） 960 – 1127

 Southern Song Dynasty （南宋） 1127 – 1279

Liao Dynasty （辽） .. 916 – 1125

Jin Dynasty （金） ... 1115 – 1234

Xixia Dynasty （西夏） .. 1038 – 1227

Yuan Dynasty （元） ... 1279 – 1368

Ming Dynasty （明） ... 1368 – 1644

Qing Dynasty （清） ... 1644 – 1911

Chinese Jade in Museums in China

Museum	Brief Description of Collection	Location and Website
Capital Museum 首都博物馆	Focusing on utilitarian jade, this exhibition of selected jade art, located in Room K, on the 5th floor of the oval-hall section shows the development and characteristics of the jade art of the Beijing area. It reflects the processes of the development of jade and its manufacture in different periods. The 181 exhibits are divided into three sections. There are a large number of jades excavated from the tombs of the nobility as well as jades inscribed with imperial poems.	16 Fuxingmenwai Street, Xicheng District, Beijing http://www.capitalmuseum. org.cn/
Chaohu City Museum 巢湖市博物馆	The permanent exhibition of the Lingjiatan culture displays some fine precious jades excavated from Lingjiatan sites. They display the brilliant Lingjiatan civilization and its highly developed jade manufacturing and carving techniques.	Fangwanggang, Juchao District, Chaohu, Anhui
Dingling Tomb Museum, Beijing 北京定陵博物馆	The Dingling Tomb is the mausoleum of the Ming Emperor Wanli and his two consorts. More than 3,000 relics have been unearthed from the tomb, mostly utensils used by the emperor and his consort during their lifetime. The jades unearthed are mainly inlaid with gold, and reflect the wealth and luxury of royal court jades.	The eastern foot of the Dayu Mountain, Changping District, Beijing http://www.mingtombs.com/ e_home/
Gansu Provincial Museum 甘肃省博物馆	The collection of jade in the Gansu Provincial Museum dates from the prehistoric period to the Yuan dynasty.	3 West Xijin Road, Lanzhou, Gansu http://www.gansumuseum. com/Default.aspx
Henan Museum 河南博物院	The museum's permanent exhibition gallery, the Henan Ancient Jade Articles Hall, contains items of jade produced over a period of nearly 3,000 years dating from early primitive society to the Qing dynasty. 70 percent of the jade objects are of the Xia, Shang and Zhou dynasties, and demonstrate the rich jade culture of Central China. The jades on exhibition are roughly divided into ritual jades, ornamental jades, burial jades and jades for enjoyment.	8 Nongye Road, Zhengzhou, Henan http://english.chnmus.net/
Hubei Provincial Museum 湖北省博物馆	Most of the jade in the collection of this museum is from the Neolithic period, the Shang dynasty, the Spring and Autumn periods, and the Song, Yuan, Ming and Qing dynasties.	156 Donghu Road, Wuchang District, Wuhan, Hubei http://www.hbww.org/index. jsp
Jiangxi Provincial Museum 江西省博物馆	This jade collection, totalling 754 items in all, was excavated from the Dayangzhou Shang Tomb in Xin'gan county in Jiangxi province, another significant discovery that followed the Anyang Yinxu and Guanghan Sanxingdui archaeological cultures. The collection can be divided into ritual jades, imitation weapons and decorative jades, which not only reflect the universal characteristics of Shang dynasty jades but also display their own cultural significance.	99 Xinzhou Road, Donghu District, Nanchang, Jiangxi http://www.jxmuseum.cn/ index.html
Jingzhou Museum 荆州博物馆	The permanent exhibition in the Jingzhou Museum displays the jades of the Shijiahe culture of 4600 – 4000 years ago located in the Jianghan (the Yangtze river and the Han river) plain. These refined and delicately manufactured jades include human figures as well as sculptures of different animals.	134 Jingzhong Road, Jingzhou, Hubei http://www.jzbwg.com/index. asp
Liaoning Provincial Museum 辽宁省博物馆	The large jade collection in the Liaoning Provincial Museum dates from the Ming and Qing dynasties. It is exquisite in quality and complete in types. The jade exhibition shows how jade manufacture reached a peak during the Ming and the Qing dynasties in type, form, decorative motif, practical use and the archaistic imitation of ancient styles.	363 Shifu Da Road, Shenhe District, Shenyang, Liaoning http://www.lnmuseum.com.cn/ index.do

Museum of the Mausoleum of the Nanyue King 西汉南越王博物馆	The tomb of the Nanyue King was one of the most important archeological discoveries made in China during the 1980s. Altogether 10,434 items were unearthed, mainly jades and bronzes. The jade shroud sewn with silk thread and the rhinoceros horn-shaped jade drinking vessel were the gems of the discovery. Other valuable items unearthed from the King's Coffin room demonstrate the significant role of jade in the Han dynasty.	867 Jiefang Bei Road, Guangzhou, Guangdong http://www.gznywmuseum.org/
National Museum of China 中国国家博物馆	Among the jade collection in the National Museum of China, more than 80,000 out of 390,000 items are ancient Chinese jades dating from the Neolithic times to the Qing dynasty, with some pieces seldom on public view.	16 East Chang'an Avenue, Dongcheng District, Beijing http://www.chnmuseum.cn/
Palace Museum, Beijing 故宫博物院	Jades account for a large proportion of the collection of 30,000 jades and stones in the museum. They can be divided into ancient jades ranging from the Neolithic period to the Yuan dynasty, and Ming and Qing dynasty jades. Most of the Ming and Qing dynasty jades are court and tribute jades, and fully reflect the process of jade manufacture and use as well as their cultural significance.	4 Jingshan Qianjie, Beijing http://www.dpm.org.cn/index1280800.html
Palace Museum, Taipei 台北故宫博物院	The Palace Museum, Taipei is well-known for its jade collection of over 12,104 items, including different jade forms dating from the Neolithic period to the Qing dynasty. Among these treasures are the world famous jadeite cabbage and Mughal style jades.	221, Sec.2, Zhishan Road, Shilin District, Taipei, Taiwan http://www.npm.gov.tw/npmwebadmin.jsp?do=index
Tianchang City Museum 天长市博物馆	The Tianchang City Museum has a permanent exhibition called the Tianchang Han Tomb Treasures which includes the most elaborate cultural relics of the Han dynasty, especially those excavated from the Han dynasty Sanjiaowei tomb complex in 1992. A jade exhibition hall displays a jade collection which is divided into ceremonial jades, funeral jades and decorative jades. The collection shows the distinct local features of Tianchang city in jade manufacture, carving and style.	131 Liangxi Road, Tianchang, Anhui
Tianjin Museum 天津博物馆	The Treasures of Hundred Years exhibition is a display of over 110 cultural relics, including jade, bronze ware, calligraphy etc. In an exhibition area of 600 m^2, articles chosen from over 200,000 items in the museum show how these objects were collected over the years, and reflect the characteristics and influence of this museum in the field of archaeology.	31 Youyi Road, Hexi District, Tianjin http://www.tjbwg.com/
Xuzhou Museum 徐州博物馆	Covering an area of 780 m^2, the Exhibition of Han Jade displays over 180 jade objects excavated from Xuzhou city. The jade collection is divided into four parts; ritual jades, funeral jades, decorative jades and jade utensils. The refined and delicate jades excavated from Xuzhou show the highest level of jade manufacture achieved in the Han dynasty with beautiful decorative motifs and exceptional craftsmanship. This exhibition is so far the only one devoted to jade in the Han dynasty.	101 Heping Road, Xuzhou, Jiangsu http://www.xzmuseum.com/
Yizheng City Museum 仪征市博物馆	The permanent Han dynasty exhibition in the Yizheng City Museum includes jade, primitive porcelain and bronze ware, etc from the Western and Eastern Han dynasties, and displays a panorama of Han culture.	201 West Jiefang Road, Yizheng, Jiangsu
Zhouyuan Museum 周原博物馆	The Zhouyuan Museum was built at the site of the large scale archaeological excavation at Zhouyuan. The museum has more than 10,000 cultural relics, including thousands of delicate and richly imaginative items of jade, such as necklaces, human figures and animals, ritual jades and imitation weapons. They fully reflect the produce, customs and political and economic situation of the Zhou people more than 3,000 years ago.	Famen Town, Fufeng County, Baoji, Shaanxi

Chinese Jade in Overseas Museums

Museum	Brief Description of Collection	Location and Website
American Museum of Natural History	The jades in this museum come from the Drummond Collection. They include two fine pieces, a nephrite jade vessel for incense and a jadeite jade carving of Guanyin (the Buddhist goddess of mercy), both in the 77th Street Grand Gallery.	Central Park West at 79th Street, New York, NY, USA http://www.amnh.org/
Art Institute of Chicago	There are a large number of exquisite Chinese jades from the Sonnenschein Collection in this institute. The collection was described by Professor Alfred Salmony in his 1952 book Archaic Chinese Jades from the Collection of Edward and Louise B. Sonnenschein.	111 South Michigan Avenue, Chicago, IL, USA http://www.artic.edu/aic/
Arthur M. Sackler Gallery	The Sackler Gallery contains a rich collection of jade objects spanning 5,000 years, including several hundred ceremonial jades dating from 3500 BC. to 200 AD, as well as animal carvings from the 10th to the 16th century.	1050 Independence Avenue, SW, Washington, DC, USA http://www.asia.si.edu/
Asian Art Museum	The China Collection Gallery houses Chinese jades from the Avery Brundage Collection that span 6,000 years of history—from the Neolithic period to the present.	200 Larkin St., San Francisco, CA, USA http://www.asianart.org/
Boston Museum of Fine Art	The museum's collection contains some fine examples of early and later Chinese jade but there is little on display.	465 Huntington Avenue, Boston, MA, USA http://www.mfa.org/
British Museum	The Chinese jade in room 33b is mostly on loan from the collection of Sir Joseph Hotung and shows its development from around 5000 BC to the modern period. The subtle variety of colours and textures of this exotic stone can be seen, as well as many different types of workmanship, ranging from long, smooth Neolithic blades to later plaques, ornaments, dragons, animal and human sculpture.	Great Russell Street, London, WC1B 3DG, UK http://www.britishmuseum.org/
Buffalo Museum of Science	The jades from the Chauncey J. Hamlin Collection span the Neolithic period to the Han dynasty, and illustrate changes in theme, advances in jade manufacturing and transformations in practical use.	1020 Humboldt Parkway, Buffalo, NY, USA http://www.sciencebuff.org/
Field Museum of Natural History	Amongst the museum's vast China Collection is the well-known and often studied sub-collection of 1,000 jade carvings mainly of the Qianlong reign of the Qing dynasty formed by A.W. Bahr in the early 20th century	1400 S. Lake Shore Drive, Chicago, IL, USA http://fieldmuseum.org/
Fitzwilliam Museum	The museum has a fine collection of Chinese jade, part of the personal collection of oriental art formed early in the last century by Oscar Raphael, its first honorary Keeper of Oriental Ceramics.	Trumpington, Street Cambridge, CB2 1RB, UK http://www.fitzmuseum.cam.ac.uk/
Freer Gallery of Art	The gallery houses a permanent exhibition of Ancient Chinese Jades and Bronzes which includes jades that illustrate the remarkable jade production of the Liangzhu culture (3300 – 2250 BC).	1050 Independence Avenue, SW, Washington, DC, USA http://www.asia.si.edu/

Harvard Art Museums/ Arthur M. Sackler Museum	The museum's Asian collection includes many Chinese archaic jades: over 700 jades dating from 5,000 BC to AD 200, considered by many to be the finest collection of such material in the world.	32 Quincy Street, Cambridge, MA, USA http://www.harvardartmuseums.org/collection/
Los Angeles County Museum of Art	Chinese art was one of the first areas collected by the museum. The collection spans more than 4,000 years and features extraordinary works such as ancient jade carvings. Items from the Chinese collection are now back on display and include some jade.	5905 Wilshire Blvd. Los Angeles, CA, USA http://www.lacma.org/
Metropolitan Museum of Art	Many of the ancient Chinese jades in the museum come from the Heber R. Bishop collection which includes sophisticated jade carving of the late Qing dynasty as well as Mughal jades. This is one of the finest collections of Qing court jades.	1000, 5th Avenue, New York, NY, USA http://www.metmuseum.org/
Minneapolis Institute of Art	The Chinese jade in the Minneapolis Institute of Art comes from the collections of Alfred F. Pillsbury and Augustus L. Searle . The Pillsbury Collection consists mainly of early ritual and decorative jades. The Searle Collection focuses on the 18th century, one of the peaks in the manufacture of jade in China.	2400 Third Avenue South, Minneapolis, MN, USA http://www.artsmia.org/
Musée Guimet	Chinese jade in this museum contains examples from the Neolithic to the 18th century and items from the Gieseler and former royal collections.	6, place d'Iéna, Paris, France http://www.guimet.fr/fr/
Museum Rietberg Zurich	The Museum Rietberg owns one of Europe's most important collections of Chinese art, with a focus on Buddhist sculpture, funerary art, and painting from the Ming and Qing periods (1368 – 1911). The Chinese jades are exhibited as a part of funerary art.	Gablerstrasse 15, 8002 Zürich, Switzerland http://www.rietberg.ch/en-gb/home.aspx
Norton Gallery	The Museum's collection of Chinese art has grown from 125 works acquired by Ralph Norton before his death in 1953, to about 600 objects. His acquisitions form two outstanding bookends to the Chinese collection: archaic jade and bronze and Qing dynasty (1644 – 1911) imperial jade and hard stone carvings.	1451 S. Olive Avenue, West Palm Beach, FL, USA http://www.norton.org/
Pacific Asia Museum	The museum's jade collection includes 150 Chinese works from the Neolithic period through the Qing dynasty, including a pair of jade earrings of extraordinary quality, believed to have been owned by China's last Dowager Empress, Ci Xi.	46 North Los Robles Avenue, Pasadena, CA, USA http://www.pacificasiamuseum.org/index.aspx
Pennsylvania University Museum	A large portion of the museum's collection is from China. Apart from the examples of Shang dynasty oracle bones, Shang and Zhou dynasty bronzes, visitors can also see the Neolithic jades.	3260 South Street, Philadelphia, PA, USA http://www.penn.museum/
Royal Ontario Museum	The Museum showcases more than 1,000 outstanding jade objects from the Bishop White Collection and the Menzies Collection, as well as donations from George Crofts, ranging from the prehistoric period to the Qing dynasty.	100 Queen's Park, Toronto, ON, Canada http://www.rom.on.ca/index.php
Seattle Art Museum/Seattle Asian Art Museum	The Seattle Art Museum's collection of Chinese art was started by Richard Fuller the founding director, a geologist with a lifelong interest in jade. It is particularly strong in jade, ceramics and sculpture.	1300 First Avenue, Seattle, WA, USA http://www.seattleartmuseum.org/

Index

O

octagonal star, pattern 45, 47
open-work see carving technique
ornamental jade 6, 9, 12, 13, 14, 15, 27, 31, 35, 37, 38, 39, 40, 41, 45, 46, 47, 51, 52, 53, 57, 59, 62, 65, 69, 71, 72, 82, 87, 88, 94, 97, 107, 108, 109, 115, 119, 120, 121, 122, 123, 125, 126, 127, 129, 131, 132, 133, 134, 136, 139, 142, 144, 154

P

Pangu 13
pendant set see jade pendant
petal, pattern 69, 75, 76, 151
phoenix, pattern 9, 31, 51, 52, 55, 57, 59, 62, 67, 69, 74, 76, 81, 86, 87, 94, 102, 103, 104, 105, 107, 109, 112, 120, 121, 123, 127, 131, 145, 147, 148
 double phoenixes 82, 115
pig-dragon 21, 47, 119
pine and crane, pattern 82
polishing see carving technique
pure lacquer black (color) see color

Q

qiaose see carving technique
Qijia (culture) see Culture
qilin 76
Qin dynasty 85, 102, 111, 153
qing (chime) 83, 85
Qing dynasty 27, 29, 31, 32, 33, 35, 37, 76, 79, 81, 82, 83, 100, 113, 114, 115, 117, 125, 145, 146, 147, 149, 151, 154, 155, 156, 157

R

raised, decoration or design 37, 46, 139
relief see carving technique
rhomboid, pattern 52, 65, 94, 98, 119, 132
ring (huan) 59, 65, 71, 119, 149
Rites of Zhou (Zhou Li) 14
ritual jade 49, 86, 91, 92, 93, 94
rosette, pattern 83
rush, pattern 66, 87, 88, 100
 rush square whirlpool 66
ruyi 81, 85, 148, 149

S

sacrificial jade 62, 102
 food vessel (dou) 145, 147
script
 clerical (lishu) 33, 145, 146, 147
 regular (kaishu) 100
 seal 103, 112, 115
scroll, pattern 75, 136
sculpting see carving technique
sea serpent (yulong) 71
seal (yinzhang) 61, 68, 69, 76, 111, 112
 (emperor's) xi 111, 112,
Shaanxi Longshan (culture) see Culture
Shang period 27, 49, 52, 54, 55, 102, 129, 136
Shijiahe (culture) see Culture
Shixia (culture) see Culture
Shuowen Jiezi 14, 16
silkworm, pattern 59, 60
Six Dynasties 62, 65, 66
snake, pattern 57
 coiled 61, 87, 97, 108, 117
Son of Heaven (emperor) 98, 101
Song dynasty 9, 14, 68, 69, 72, 73, 74, 91, 112, 123, 125, 126, 131, 144, 153
speckled black (color) see color
Spring and Autumn period 55, 86, 87, 94, 97, 102, 104, 108, 120, 139, 153, 154
"Spring water", design 71, 75, 117
straight line (pattern) see line
Sui dynasty 68, 73, 153
Suzhou 27, 34, 35, 79, 151
symbolic badge 90

T

tadpole, pattern 60, 61
Tang dynasty 6, 11, 15, 69, 71, 72, 73, 94, 131, 132, 141, 153
Taosi (culture) see Culture
taotie, pattern 52, 61
thunder, pattern 145, 146
 See also cloud, pattern
tiger, pattern 25, 45, 51, 52, 57, 65, 66, 75, 94, 112, 117, 129, 137
 hufu 85, 129
triangular, pattern 51, 52, 54, 66, 75, 94
trough, pattern 46, 88, 92
tuanhua, pattern 75
twisted thread, pattern 12, 47, 65, 67

V

vermilion bird see bird

W

Warring States period 6, 27, 57, 59, 60, 61, 91, 98, 99, 107, 108, 109, 117, 120, 121, 129, 153
water holder (shuiyu) 69
Wei dynasty 62, 66, 94, 101, 153
West Liao river 37, 38
Western Zhou period 9, 13, 15, 16, 25, 49, 51, 52, 53, 54, 55, 61, 86, 91, 94, 97, 98, 99, 101, 102, 104, 107, 108, 109, 117, 120, 125, 126, 127, 136, 137, 153
whirlpool, pattern 10, 51, 60, 61, 66, 67, 85, 87, 120, 122
white (color) see color
wine cup (jue) 145, 148

X

xi see seal
Xia period 13, 14, 49, 54, 98, 101, 153, 154
Xinglongwa (culture) see Culture
Xiuyan jade 21

Y

Yangtze 37, 43, 123, 133, 154
Yangzhou 27, 34, 35, 79
yasi qianbao see carving technique
Yellow River 37, 41
Yuan dynasty 31, 34, 68, 69, 71, 73, 74, 75, 133, 142, 153, 154, 155

Z

zun see jade wine jar